The Palgrave Macmillan Animal Ethics Serie

Series editors: **Andrew Linzey** and **Priscilla N**

In recent years, there has been a growing inter of animals. Philosophers have led the way, and now a range of other scholars have followed from historians to social scientists. From being a marginal issue, animals have become an emerging issue in ethics and in multidisciplinary inquiry. This series explores the challenges that Animal Ethics poses, both conceptually and practically, to traditional understandings of human–animal relations. Specifically, the Series will:

- provide a range of key introductory and advanced texts that map out ethical positions on animals;
- publish pioneering work written by new, as well as accomplished, scholars; and
- produce texts from a variety of disciplines that are multidisciplinary in character or have multidisciplinary relevance.

Titles include:

ANIMAL AND PUBLIC HEALTH
Why Treating Animals Better Is Critical to Human Welfare
Aysha Akhtar

AN INTRODUCTION TO ANIMALS AND POLITICAL THEORY
Alasdair Cochrane

THE COSTS AND BENEFITS OF ANIMAL EXPERIMENTS
Andrew Knight

AN INTRODUCTION TO ANIMALS AND VISUAL CULTURE
Randy Malamud

POPULAR MEDIA AND ANIMAL ETHICS
Claire Molloy

ANIMALS, EQUALITY AND DEMOCRACY
Siobhan O'Sullivan

SOCIAL WORK AND ANIMALS: A MORAL INTRODUCTION
Thomas Ryan

ANIMALS AND SOCIOLOGY
Kay Peggs

AN INTRODUCTION TO ANIMALS AND THE LAW
Joan Schaffner

Forthcoming titles:

HUMAN ANIMAL RELATIONS: THE OBLIGATION TO CARE
Mark Bernstein

ANIMAL ABUSE AND HUMAN AGGRESSION
Eleonora Gullone

ANIMALS IN THE CLASSICAL WORLD: ETHICAL PERCEPTIONS
Alastair Harden

POWER, KNOWLEDGE, ANIMALS
Lisa Johnson

The Palgrave Macmillan Animal Ethics Series
Series Standing Order ISBN 978–0–230–57686–5 Hardback
978–0–230–57687–2 Paperback
(*outside North America only*)

You can receive future titles in this series as they are published by placing a standing order. Please contact your bookseller or, in case of difficulty, write to us at the address below with your name and address, the title of the series and one of the ISBNs quoted above.

Customer Services Department, Macmillan Distribution Ltd, Houndmills, Basingstoke, Hampshire RG21 6XS, England

Also by Randy Malamud

A CULTURAL HISTORY OF ANIMALS IN THE MODERN AGE

THE LANGUAGE OF MODERNISM

POETIC ANIMALS AND ANIMAL SOULS

READING ZOOS: REPRESENTATIONS OF ANIMALS AND CAPTIVITY

T.S. ELIOT'S DRAMA: A RESEARCH AND PRODUCTION SOURCEBOOK

WHERE THE WORDS ARE VALID: T.S. ELIOT'S COMMUNITIES OF DRAMA

An Introduction to Animals and Visual Culture

Randy Malamud
Professor of English and Chair of the department
Georgia State University, USA

First published 2012 by
PALGRAVE MACMILLAN

Palgrave Macmillan in the UK is an imprint of Macmillan Publishers Limited, registered in England, company number 785998, of Houndmills, Basingstoke, Hampshire RG21 6XS.

Palgrave Macmillan in the US is a division of St Martin's Press LLC, 175 Fifth Avenue, New York, NY 10010.

Palgrave Macmillan is the global academic imprint of the above companies and has companies and representatives throughout the world.

Palgrave® and Macmillan® are registered trademarks in the United States, the United Kingdom, Europe and other countries

ISBN: 978–1–137–00982–1 hardback
ISBN: 978–1–137–00983–8 paperback

This book is printed on paper suitable for recycling and made from fully managed and sustained forest sources. Logging, pulping and manufacturing processes are expected to conform to the environmental regulations of the country of origin.

A catalogue record for this book is available from the British Library.

A catalog record for this book is available from the Library of Congress.

10 9 8 7 6 5 4 3 2 1
21 20 19 18 17 16 15 14 13 12

Printed and bound in Great Britain by
CPI Antony Rowe, Chippenham and Eastbourne

For Nina, my Bright Star

Contents

Illustrations

Acknowledgments

Portions of this book appeared in earlier versions in *The Chronicle of Higher Education, Five Points, Spring, Animal Encounters* (ed. Manuela Rossini and Tom Tyler, Leiden: Brill, 2009), and *A Cultural History of Animals in the Modern Age* (ed. Randy Malamud, Oxford: Berg, 2007); I thank the respective editors for their thoughtful contributions to my work.

I offer heartfelt gratitude to friends, colleagues, and administrators who have supported and enabled my work: Tom Tyler, Britta Jaschinski, Maria Esther Maciel, Philip Armstrong, Andrew Linzey, Linda Kalof, Cal Thomas, Audrey Goodman, Vas Stanescu, Alex Kafka, Lori Marino, Ken Shapiro, Matthew Roudané, Marta Hess, Carol Winkler, Lauren Adamson, Risa Palm, and Bill Long.

Series Editors' Preface

This is a new book series for a new field of inquiry: Animal Ethics.

In recent years, there has been a growing interest in the ethics of our treatment of animals. Philosophers have led the way, and now other scholars have followed, ranging from historians to social scientists. From being a marginal issue, animals have become an emerging issue in ethics and in multidisciplinary inquiry.

In addition, a rethink of the status of animals has been fuelled by a range of scientific investigations that have revealed the complexity of animal sentiency, cognition, and awareness. The ethical implications of this new knowledge have yet to be properly evaluated, but it is becoming clear that the old view that animals are mere things, tools, machines, or commodities cannot be sustained ethically.

But it is not only philosophy and science that are putting animals on the agenda. Increasingly, in Europe and the United States, animals are becoming a political issue as political parties vie for the "green" and "animal" vote. In turn, political scientists are beginning to look again at the history of political thought in relation to animals, and historians are beginning to revisit the political history of animal protection.

As animals grow as an issue of importance, so have there been more collaborative academic ventures leading to conference volumes, special journal issues, indeed, new academic animal journals as well. Moreover, we have witnessed the growth of academic courses, as well as university posts, in Animal Ethics, Animal Welfare, Animal Rights, Animal Law, Animals and Philosophy, Human–Animal Studies, Critical Animal Studies, Animals and Society, Animals in Literature, Animals and Religion – tangible signs that a new academic discipline is emerging.

"Animal Ethics" is the new term for the academic exploration of the moral status of the nonhuman – an exploration that explicitly involves a focus on what we owe animals morally, and which also helps us to understand the influences – social, legal, cultural, religious, and political – that legitimate animal abuse. This series explores the challenges that Animal Ethics poses, both conceptually and practically, to traditional understandings of human–animal relations.

The series is needed for three reasons: (a) to provide the texts that will service the new university courses on animals; (b) to support the

increasing number of students studying, and academics researching, in animal-related fields; and (c) because there is currently no book series that is a focus for multidisciplinary research in the field.

Specifically, the series will:

- provide a range of key introductory and advanced texts that map out ethical positions on animals;
- publish pioneering work written by new, as well as established, scholars; and
- produce texts from a variety of disciplines that are multidisciplinary in character or have multidisciplinary relevance.

The new Palgrave Macmillan Series on Animal Ethics is the result of a unique partnership between Palgrave Macmillan and the Ferrater Mora Oxford Centre for Animal Ethics, Oxford. The series is an integral part of the mission of the Centre to put animals on the intellectual agenda by facilitating academic research and publication. The series is also a natural complement to one of the Centre's other major projects, the *Journal of Animal Ethics*. The Centre is an independent think tank for the advancement of progressive thought about animals, and is the first institution of its kind in the world. It aims to demonstrate rigorous intellectual enquiry and the highest standards of scholarship. It strives to be a world-class center of academic excellence in its field.

We invite academics to visit the Centre's website www.oxfordani-malethics.com and to contact us with new book proposals for the series.

Andrew Linzey and Priscilla N. Cohn
General Editors

1
Introduction: Framed Animals

Consider animals in our world. Pandas from China are airlifted to zoos in Atlanta and Washington; Chilean sea bass (actually from Antarctica) grace restaurant tables in New York and London. Skins of baby seals, killed in Newfoundland, and newborn karakul lambs from Afghanistan are auctioned in Seattle, Toronto, Helsinki, and St. Petersburg, and the finished products are traded at fur fairs in Frankfurt, Hong Kong, Tokyo, and Montreal. South American chinchillas, African civets, and Amazonian parrots command exorbitant prices in the market for exotic pets. An African rhinoceros stars in a commercial for Dodge Durango, and a Bengal tiger in an ad for Dillard's department store. Amid these and a thousand other postmodern dislocations, the idea of an animal's habitat is becoming irrelevant, except as a historical curiosity. Instead, today, an animal's *cultural context* supplants its natural context. It used to be that a given animal existed in a certain place, its natural habitat, because this place offered attractive conditions for sustenance, comfort, safety, and reproduction. The animal was suited for this place, and we may assume the animal was happy in this place.

But lately overdevelopment, population explosion, and exponential increases in resource consumption have created a world predominantly colonized by human activity. Cultural media are becoming omnipresent in this world: more powerful, faster, cheaper, and more of a fixture in our lives. As archives and archival capacities grow, we become more comfortable with these media (and the representations they promulgate), and more dependent on them. Especially in the industrialized West, but also globally, people are spending more time engaged with these representational systems and expecting more of the world around us to conform itself to these systems and cultural infrastructure, and to fit inside their "frames" (the applications, the Web sites, the technological

configurations, and operating systems). New media may seem the obvious scapegoat, but other conventional and historical media are very much part of the same dynamic, the same phenomenon. While many of the ubiquitous cultural frames are screens (on smartphones, computers, HDTVs), these new media frames merely supplement and reiterate the hegemonies of the frames that have been around for a good deal longer in such traditions as art, film, photography, television, fashion, commerce, and captive display of living spectacles. My field of inquiry encompasses all these venues of visual culture.

With increasing rapacity, people are changing the conditions of life for every other species of animal. We are squeezing them out of their habitats, often because we are repurposing those habitats for living space or agriculture, timber harvesting or highways. And it is not only the animals' habitats but also the animals themselves whose "value" as resources makes them increasingly vulnerable to human control and commodification. The process of exercising this control, as I examine it here, involves people's framing of animals in visual culture. Just as we have come to prefer that so many other aspects of our lives should be transposed into visual culture, so, too, do we come to expect that animals should "live" in this realm, in this cultural context, which means displacing and transplanting them from their natural contexts.

In the past – perhaps 250 years ago, before the Industrial Revolution, when the world population was one-tenth what it is today – most animals could depend on being left alone by most people. Lacking the power and ability to resituate animals in significant numbers, people allowed them to stay where they belonged.

Even in this, retrospectively, Arcadian age, animals were not absent in human culture, nor did they escape implication in our cultural activities. There were leather coats and saddles; pigs bred for eating; artistically rendered horses carrying soldiers into battle. Think of the Bayeux Tapestry, in which stunningly arrayed ranks of colorful war horses, destriers, coursers and rounceys, black or brown, chestnut or red dun in hue, richly decked out in medieval trappings, stand with incontrovertible semiotic force at the center of panels as they bear Norman knights off to vanquish the English.

For as long as we have records of human culture, we have had animals in human culture, and we have used animals in human culture. But it is only quite recently – perhaps in the last century, perhaps just within the last generation – that the hurtling acceleration of our cultural activities has made our incursion into the world of animals exponentially more omnivorous (both literally and figuratively). On a scale

never before seen, animals suffer extinction, genetic mutations, habitat loss, diaspora, toxicity, and industrial and scientific exploitation. All this happens in tandem with their alienation from their own natural contexts, and their unfortunate displacement into our own world, where they are subject to the practices, habits, and desires of our cultural consciousness.

Contemporary culture resituates animals by positing that they belong anywhere, which is to say, they belong nowhere. They go where people put them: "go" not in the sense of having any agency or active volition in the process, but as one might say, a lamp "goes" nicely with a particular style of drapery – as an accoutrement, a prop.

Today animals in visual culture seem profoundly malleable, almost infinitely versatile. The absence of fixed, meaningful identities facilitates their dizzying transformation into whatever it is people want them to be. With the invention of zoos in the early nineteenth century, people began taking animals from where they belong and resituating them where they do not belong, but where it is more convenient for people to experience them. We have become habituated to overwriting authentic, natural animals with a script that amuses or benefits or otherwise satisfies our cultural cravings. An animal's existence today – its appearance, its life, its relation to people – is heavily attenuated by the frames imposed upon it and the tableaux arranged inside these frames. My task here is to deconstruct the frames and the tableaux (the canvases, the stages, the screens) inside those frames where these animals have been placed (painted, written, construed, digitized, arranged, stuffed, chained, trained, dissected, imagined) with an iron-fisted sense of entitlement and control on the part of the cultural hegemons – that is, us.

Animals are thickly enmeshed in human culture simply because people are so interested in them. We use them in a range of ways – some benevolent, some silly, some violent – in the service of our own cultural drives, desires, fantasies, and obsessions. When a person and a nonhuman animal encounter each other, the animal generally ends up somehow the worse for this meeting. In virtually every account of visual culture that this book explores, the animals did not choose to participate. Although our relationship to other animals in visual culture may not always necessarily involve exploitation and domination, we must at least always be attuned to that possibility. And just as the animals' consciousness and volition on their side of these interactions have been generally absent – overlooked, suppressed – on the other side, the human side, an ethical dimension is infrequently addressed.

My investigation of animals in visual culture combines close-up case studies and broader theoretical hypotheses about what these portrayals mean: how people create and process a range of image-texts, and how those images affect our attitudes, our behavior, our ecological sensibilities, and our cultural values and practices beyond the immediate moment of visualization. We are the way we are because we have created and accepted a set of depictions that represent our place in the world, and the relation of our place to the place of pigeons, elk, mice, spiders, and others.

This "place" to which animals are relegated is, in the human perceptual sense, threefold: it is

- a geographical place: spatial, political, ecosystemic, and quantifiable in terms of resources consumed and damage caused;
- a cultural place: replete with practices, traditions, and values constructed by communities, media, artists, consumers, and other cultural actors;
- an intellectual place, "a way of happening," in W.H. Auden's phrase: an ideological mindset that inspires and justifies, problematizes and restricts, our sense of ecological coexistence.

Other animals, too, have their own perceptual sense of place. Geographically, their sense of place may be compared with ours fairly easily. To be sure, animals regard their place with a very different set of values than we do. They hope for a geographical place that provides good nesting grounds, ample food, and other such requirements for stable existence, while we demarcate their spaces with more predatory and exploitative designs. People map other animals into places where it is convenient for us to hunt and harvest them; places where we deem them demographically undesirable and cull or restrict their populations; places where we like to visit them on camping trips; places where we facilitate their breeding to compensate for the other places we have corrupted. But though our geographical ideologies are divergent, one still could imagine how we might overlay our maps upon their maps to directly compare our sense versus their sense of geographical place.

In terms of animals' cultural and intellectual places, it is harder to align or compare their perceptions with ours. Some human interrogators – Jeffrey Masson, Marc Bekoff, E.O. Wilson, Temple Grandin, Olly & Suzi, and José Emilio Pacheco, for example – have made tantalizing

forays that broach ways in which people may understand how animals' worlds are culturally and intellectually constructed in their own consciousness. But while I emphatically acknowledge other animals' epistemologies of place, my plan here is to stick with my own species and investigate solely how *we* construct and understand, through visual culture, the place in which other animals exist.

This place is always framed, and people are the framers. Framing delineates a boundary that defines the realm in which we allow the framed creature to exist. This framing privileges the space *inside* the frame – here is where we will acknowledge you, it says; here is where we expect you to be when we come to look – and it voids the space *outside* the frame as inaccessible, irrelevant, out of bounds. In an art museum, paintings are framed to impose a categorical uniformity upon an otherwise diverse and eclectic set of images: lilies, nudes, cityscapes, meadows. The style, subject, and period of these paintings are different, but the frame is the unchanging constant. It signifies that someone has organized and curated these imaginative image-texts into a coherent collection. These framed paintings are arranged with a certain order in a given room, alongside other framed paintings, in an atmosphere in which light, temperature, humidity, noise, human traffic, and economic concerns are all carefully conscribed and monitored. The conscriptive bounding signified by a single frame recurs throughout the room and throughout the museum. We expect paintings to be framed as a sign of their readiness for our cultural consumption. I do not have any ethical concerns about the framing of paintings, but I do object to the framing of animals.

In *Frames of War*, Judith Butler discusses the epistemological problems raised by framing, which she calls "operations of power" whose aim is "to delimit the sphere of appearance" (1) and to function "as an editorial embellishment of the image" (8). The frame "implicitly guides the interpretation," which Butler associates with another and more explicitly nefarious connotation of the term: "to be framed" describes an innocent person who is "proven" guilty by false "evidence." Butler explains: "If one is 'framed,' then a 'frame' is constructed around one's deed such that one's guilty status becomes the viewer's inevitable conclusion" (8). The ethical rebuttal, Butler writes, is "to call the frame into question" and show "that the frame never quite contained the scene it was meant to limn" (9). Butler's paradigm illustrates how framed animals become disempowered, delimited, and found guilty (guilty, perhaps, of being wild, or dumb, or bestial, or violent, or simply nonhuman). The

penalty for their guilt is the abrogation of their freedom, their rights, their identities, their self-determination. Following Butler's praxis, my ethical response is to reevaluate the "evidence" against animals and to challenge the authority of the frames and the framers.

Human representations of animals in visual culture are inherently biased and self-serving, some more so than others. It is by these representations that we place animals (and note the imperial resonances of using the word "place" as a verb rather than a noun). It is difficult, if not impossible, to find in these human representations an objectively true account of who animals are. But we may productively engage with this cultural construction if we keep our "ethical caps" always on, despite the certainty that our perspectives and our insights are incomplete. We can appraise the creation and consumption of all of these cultural artifacts with one important standard in mind, a simple ethical question: do they do more good than harm?

What does a visual representation mean? What happens to an animal when it gets featured, or caught – framed – in visual culture? To start with the obvious: the animal is made visible. This happens representationally more often than literally. It is certainly possible that an actual animal will be literally present in a visual cultural artifact, but in our culture representational animals are more populous, more present, than literal animals, and we are more likely to encounter the "fake" (or "imagined" or "artificed") animal than the real one. Try this yourself and see: for a day, or an hour, count the animals you encounter, the ones you notice. You will likely see many more representations than actual animals. And even some animals that might at first glance seem "real" in visual culture, such as elephants in the zoo or dead chicken bodies in the grocery store, are more unreal than real, as they are profoundly decontextualized and the context they have lost as they have been rendered literally or figuratively inanimate is a fundamental element of their reality.

By definition, when people encounter a visual animal we look at him or her. Why do we look? What do we see? How do we respond? Again, not to belabor the obvious but to set out first principles: the visually cultural animal is acculturated. He or she (I will not say "it") is put into culture, framed, construed, transposed, into a film or a painting. Being put into a cultural frame means being taken out of a natural frame. One might argue that "natural frame" is a contradiction in terms, and perhaps it is: perhaps we should think of an animal's natural existence as frameless by definition. On the other hand, from a human perspective, we know that the idea of "nature" as we conceive it embodies its

own subjectivities and boundaries. So, in an imperfect semantic compromise, I posit the idea of an animal's "natural frame" as an antithesis to the cultural frame, and what I mean to denote by this concept is the place where we frame animals when we are not framing them, or when we think we are not framing them. If this sounds paradoxical, it is a concession I make to the limits of the human imagination.

Is it ever acceptable or desirable to remove animals from their natural frames and resituate them into cultural frames? If so, under what circumstances? What does the animal lose, and/or gain, under these conditions? What does the human viewer lose or gain? What pain is suffered? What enjoyment or education is reaped?

What does the phenomenon of visibility mean in terms of the human–animal power dynamics, and how might the visibility of animals diminish their ability to live authentically? Foucault explains in *Discipline and Punish* how vision of the subject equates to power over the subject. How do we see animals in visual culture? And what other (better) ways might there be to see them, or even more challengingly, to not see them? We envision ourselves as monarchs of all we survey,[1] and this mastery diminishes if we find ourselves unable to oversee all the beasts of the field. But our record shows that we are indeed *not* masters of the ecosphere, so a more accurate stance in our perceptual relationship to animals should, indeed, resist the universality and the omnipotence of our visual access to them.

How visible is the visual animal? Sharp, blurry, or pixilated? In color or black and white? Still or moving? Decontextualized or in situ? What are the conditions of visibility? Is the animal subject fully visible, or only partially? Is the viewing gratis, or for sale? Limited access, or 24/7? How do we compare the visual access of the cultural creator with that of the cultural consumer, and what are the implications of these possibly varying degrees of visibility, and varying degrees of implication in the process of acculturation? For example, how responsible is Edgar Degas for the way we think about horses? And how does that burden of responsibility compare to that of the curator of Impressionist art, or the museumgoer, or the cultural citizen who is not consciously familiar with Degas's representations but nevertheless confronts many visual horse texts that are somehow inflected by those of the nineteenth-century painter? Degas's horses are handsome, well-poised, proud, prominent on the canvases: thus we might conclude that he has ennobled the horse with his visual culture. On the other hand, they may be a little too pretty, too subservient to the humans with whom they share the frame, so perhaps we dock points for that. If Degas romanticizes his

horses, we may approve of how he inspired viewers to follow his imaginative admiration for their metaphysical force; or, we might complain that his images distract us from the more honest essence of the flesh-and-blood animal. In any case, we acknowledge that he was tremendously effective at drawing our attention to horses, for better or worse, and that his artistic success significantly affected how subsequent artists followed his lead in the business of framing horses. In one way or another, there are many horses romping around in the world (that is to say, "the world" as we see it in our cultural frames) that have been inflected by Degas, and my task is to calculate the impact of this and a thousand other such inflections.

My engagement with visual cultural animals will generate a series of stances and perspectives from which we may engage these representations in ways that increase our understanding of other animals and our coexistence with them. I retain a firm ethical conviction that a person who culturally confronts an animal in some significant way does that animal, and other animals, some good or harm; and that the viewer, too, is affected in some way that indirectly but meaningfully impacts the equilibrium of the world that all living beings share. A cartoon or an Internet meme may inspire viewers to treat animals more compassionately, or less so. It may educate its audience, or miseducate them. It may convince us that other animals are suffering profoundly because of our lifestyles and our level of consumption, or it may palliate us by suggesting that perhaps our dominion over nature is God's will, and God would not have invented chainsaws, Hummers, and factory farms if they were so dangerous to our long-term ecosystemic stability.

The deliberations I will generate from a survey of animals in visual culture send me back to questions that resonate when I look at Southern European Ice Age cave painting, the earliest extant art that features animals (indeed, by many accounts, among the first known human art of any kind). Why did the artist choose a certain shade of ochre instead of one slightly less bright? Was it simply a matter of which minerals s/he had available to grind into paint, or were there deeper aesthetic decisions in play? And if so, what were those aesthetic, stylistic, and cultural choices, and how were they made? Why was a certain animal depicted in a certain space on the wall of a certain cave?

Did the painter immediately think, when s/he first saw the bear, or lion, or horse: I want to paint you? Or did it take days, or years, to incubate the urge to depict? *Why* did s/he paint him? What was the incentive for a person to represent, and somehow to "capture," an animal imagistically? What did the cave painter's community think of the

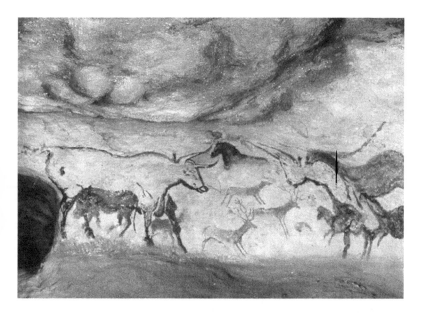

Figure 1 An auroch painted on the cave of Lascaux's northern wall, surrounded by horses and a stag. Wikimedia Commons

image? Did they manifest their approval or disapproval, their engagement or disengagement with this visual image? How? Would subsequent painters respond to earlier images, just as artists today are in constant dialogue with their predecessors? Did cave painters consciously develop and refine technique? Did they work to supplant an earlier painter's view with their own? How many times did the painter see the auroch or horse depicted on the cave walls? Was it the same horse s/he was looking at over and over, or was it a bunch of horses combined into one composite figure?

* * * *

"Bunch of horses": bad usage. Our rules of language instruct us to refer to a bunch of horses as a team or a herd of horses; a stable of horses, or a field of horses, is also acceptable. If we want to be more arcane, we may describe a haras of horses, or a remuda of horses. "Remuda": from the Spanish, according to the *OED*, meaning "exchange or replacement": one would want to have a remuda of horses, a bunch of horses, so that one could exchange a fresh one for a tired one when the need arose.

"Haras": etymology indeterminate – so much the better! Children revel in the dizzying array of different collective nouns for different animals, delighted at the idiosyncratically bizarre lexicon: a bloat of hippopotami, an army of herring, a cackle of hyenas, a leap of leopards, a bevy of larks, a parliament of owls. A flange of baboons. A flutter of butterflies, a congregation of crocodiles … .

All these words, and their usage and assignations, are of course made up by people. The terminology reflects our cultural conceptions of animals: the words mold our ways of envisioning. There is no inherent reason why the word used to describe fifteen butterflies should be different from the word used to describe fifteen larks. Nor is there any inherent reason why the word should be the same: I am simply noting a cultural choice here, a cultural habit. We may laud this usage as a way of recognizing the distinctness, the difference, of various types of animal groups. Or we may mock this linguistic habit as over-fussy and unnecessary, an impediment to our accurate conception of animal societies. Perhaps a big group of animals threatens or scares people: one ant in my kitchen, or on my foot, does not bother me, but a thousand ants in either place certainly would (a colony of ants, that would be, or a swarm of ants, or a bike of ants). Perhaps these different words for different groups of animals reflect a subliminal human desire to isolate every different group of animals – divide and conquer – and make it harder to portray, and thus to imagine, multiple species of multiple animals surrounding us, or attacking us.

These collective terms for animal groups testify to our compulsion for organizing, bean-counting, with an industrial precision – larks and larks alone comprise the bevy (unless it happens to be a bevy of quails, but that's a horse of a different color) – that runs against the grain of interdependence and interactivity which characterizes the natural world. Larks live alongside meadow pipits, and caterpillars (whom they eat), and owls (who eat them), and even the occasional poet (like Percy Bysshe Shelley, author of "To a Skylark": "Hail to thee, blithe spirit!"), but these other creatures are unaccounted for in the bevy of larks. The word "bevy" bespeaks a narrow, exclusionary census, subtly rendering invisible the lark's place, his context. The caterpillars, owls, and pipits are photoshopped out of the frame.

This multiple vocabulary for multiple animals helps indicate how people perceive and portray animals either as individuals or groups or both. Does a cultural incarnation of a single animal, as opposed to multiple animals, reflect our homage to his or her individuality, specificity, integrity, uniqueness? Or is the individual animal a token animal,

separated from its group (or herd, or bevy, or flange) and thus disempowered in its isolation? How does the individual animal relate to the group in its acculturated incarnation? And how does he or she do so in his or her natural existence? (How might a lark respond to the second line of Shelley's ode: "Bird thou never wert"?)

Many of the cave drawings, in fact, reflect multiple animals: animals in groups. Why? Is this a better approximation of their natural lives, or is it a manifestation of art-as-control simply aspiring to have more horses? The real animal is always multiple, according to Gilles Deleuze and Félix Guattari, and this makes intuitive sense because animals, including people, live in groups. Do these earliest artists from the caves and petroglyphic rockscapes depict the multiple animals as different individual animals, with different traits and lives, or do they simply reproduce the same animal over and over? There are a lot of real animals out there in the world: are we aware of their numbers, their prominence? Does our art lead us toward, or away from, a recognition of their profusion? However many animals may be depicted or suggested in a visual image – think of the large number of birds in Alfred Hitchcock's 1963 film *The Birds*, or the large number of apes in Franklin Schaffner's 1968 *The Planet of the Apes* – it is still always a smaller population than there really are in the whole world. Is the impact of visual culture thus reductive and diminishing with regard to animals, since it necessarily embodies less than the whole? Does it underplay other animals, undercount them, as our frames isolate them from their larger groups and from their life-force?

* * * *

With a focus on visual culture, I mean to invoke a range of ways of looking at (visualizing) animals, and to foreground the cultural frames in which we situate our visions of them. Culture is a place, a habitat – and not a very good one for the animals, but it is where we like to see them, where we like to meet them. As compared to animals' *natural* habitats characterized by various weather patterns, geological formations, migratory visitors, seasonal rhythms, floral displays, and so forth, think of their *cultural* habitats demarcated by such framing elements as:

- Names ("scientific" names, common names, nicknames, pet names, misnomers)
- Commercial franchises, advertising, and branding (the Atlanta Falcons, the Volkswagen Rabbit, Kentucky Fried Chicken)

- Caricatures (Donald Duck, Mickey Mouse, Charlie the Tuna, Smokey the Bear) and more serious, privileged symbols (the American Eagle, the Russian Bear, the mythic Phoenix, the caduceus)
- Fame and value (Seabiscuit, Laika, Dolly), which may derive from literary or mass media cultural renown (Sounder, Wilbur, Big Bird, Flipper) and which may blur the distinction between real and fictional animality
- Birdcages, pet stores, kennels, leashes, zoos, factory farms, and other creations of constraint that forcibly consign the animals to a human cultural place rather than their own natural habitat
- A proliferation of visual images (on the Internet, in advertisements, on cellphone videos, in children's books, in documentaries and feature films) that comprise our day-to-day perception of animals, displacing a sense of their existence beyond these framed cultural places.

When human prejudices, fantasies, fetishes, and misconceptions are inscribed on animals' characters, they reconfigure the attention we might direct toward their actual characters and nature. Living high on the hog; mad as a March hare; making an ass or a monkey out of someone; packed like sardines; crazy as a fox (or loon or coot or bedbug); full of bullshit. All these figures of speech initially suggest that we live in an environment marked by fluid cohabitation with other species, and that we conceive of our own behaviors as somehow related to theirs, analogous to theirs. We indulge in conceits of empathy, similarity, connection, but these are all merely cultural constructs. Sardines are not naturally packed like sardines until we pack them thus, cramming them into tins. Bulls have nothing to apologize for in their copious production of bullshit. A person inviting pity because he is sick as a dog is not actually anything like a sick dog. Some figurative animal images contain a grain of truth (yes, oxen are strong), and many do not, but in any case, such figures do more to distance us from other animals than to connect us with them. They reveal a misunderstanding (accidental, or willful) and intolerance of real bulls, monkeys, and loons. These figures – verbal figures, and just as commonly visual images – reveal our proclivity to frame and use animals for our own idiosyncratic cultural agendas, with minimal concern for how this transaction affects them in any meaningful or ethical way. In no way are the rights of animals, or the interests of animals, taken into account when they are transposed from their natural habitats to their cultural habitats. Animals in

visual culture thus suffer as a consequence of our habits of visualizing and acculturating them.

A similar argument concerns Native American mascots of American and Canadian sports teams. For many years, no one thought twice (with the exception of Native Americans themselves) about the branding images for the Cleveland Indians, the Florida State Seminoles, the Washington Redskins. It was an honor to the Native peoples, some believed. It was not a matter of ethical concern, others presumed, because a "Cleveland Indian" is irrelevant to a real Indian. After years of being thus objectified, caricatured, oversimplified, and trivialized, Native peoples began to speak back, to fight back. They objected to simplistic and often incendiary depictions of their otherness; to the cultural importance that might be celebrated in these isolated mascots ("tokens" of "honor"), which contrasted profoundly with the cultural degradations they experienced in so many other aspects of their lives in North America; to gratuitous images of violence, along with other offensive appropriations of their clothing, their chants, their dances, their physiological appearance. Some of these images still endure, defended vehemently by their cultural diffusers, while others are abandoned as sports teams acknowledge the insult caused by their inauthenticity. Universities have been retiring Native American mascots in significant numbers, following a 2006 directive from the National Collegiate Athletic Association. Native Americans fought back.

We look at acculturated animals as we look at cars and nudes and houses: inflected by the drives of acquisition, consumption, power, control. They are *free-floating elements* in culture whose "function," as people envision it, is to satisfy our various lusts for protein or companionship or competitive advantage or fur or other fetishes, cravings, and peccadillos.

"Free-floating": in culture, but not in nature. If they actually happen to be floating animals, like manatees or jellyfish, they float (in natural habitats) purposefully and with a biophysical intricacy and purpose that belies the aimless vulnerability lurking in the connotation of "free-floating animals" – free to anyone who lassoes the floater, traps the butterfly, cages the bird, shoots the duck, overpowers and transplants the polar bear floating on her ice floe to a non-floating, non-free zoo compound. I will return in a moment to the jellyfish.

The descriptor "free-floating" as applied to people connotes that they are unattached, uncommitted (to a cause, or a political party); they lack any apparent cause or focus. As they meander through their lives

of anarchic underachievement, they seem ripe candidates for being grabbed, chosen, converted: stripped of their (pointless, random) freedom and channeled toward some useful goal or other. Free-floating animals, even more so than free-floating human beings, practically demand to be yoked and harvested. Domesticated. Framed. Subjugated. Commodified. Extinguished (if they are floating in fields or biota where they complicate our plans for capturing and arranging other life-forms: for example, rabbits who eat *our* carrots and lettuce; badgers whose seemingly "free-floating" subterranean networks disrupt the harmony of *our* lawns and shrubbery).

Floating animals feature in Genesis 6–9. These are not free-floating animals, but rather, God-guided floating animals, arranged and collected according to the precise dictates of theological, mathematical, and biological science as promulgated by God and his human helper, Noah. The contexts of these animals – the conditions, the rules, the frames – involve reproductive-focused planning and an archivally exhaustive sense of arrangement and control. The dominion that God and Noah exert over the arked animals reiterates the dominion God assigns to Adam in Genesis 1:26, and anticipates the dominion that the Abrahamic religions will perpetuate for millennia afterwards. These are caught-floating, not free-floating, animals. The human cultural context for this caught-floating frame was profound corruption:

> And God saw that the wickedness of man was great in the earth, and that every imagination of the thoughts of his heart was only evil continually.
>
> And it repented the LORD that he had made man on the earth, and it grieved him at his heart.
>
> And the LORD said, I will destroy man whom I have created from the face of the earth; both man, and beast, and the creeping thing, and the fowls of the air; for it repenteth me that I have made them.

It is not clear what role the creeping and flying animals played in this corruption. The "creeping thing," the seductive serpent, is clearly a scapegoat, a projection for and a displacement of human guilt. But the entire menagerie of unlucky animals became implicated in human corruption; misery loves company. The ark was constructed with human-geometrical precision, according to human rules and regularities. It was built according to the hierarchies of human belief and ontology: God commands, Noah obeys. It was a big, floating, gopher-wood frame, 300 x 50 x 30 cubits, a frame of human metaphysical behavior and

beliefs – all of which were irrelevant to the hopes and dreams, the fears and instincts, of flying and floating animals, until they became caught up in the activity.

We see these animals by their mass, their data, their subservience to Noah's and God's plans. We see them arranged by "kind" – the beginning of a tradition of collecting and organizing that runs through Aristotle, Linnaeus, and Buffon, wherein animals are systematically arrayed on the (lower) rungs of a *scala naturae* or a "Great Chain of Being."

In the caught-floating animal collection, Noah receives just a brief injunction on biological care and nurturance of this spectacular menagerie he and God have assembled: "And take thou unto thee of all food that is eaten, and thou shalt gather it to thee; and it shall be for food for thee, and for them." Perhaps the animals should consider themselves fortunate that God gave this instruction, as opposed to not giving it, but the parable as a whole does not speak very evocatively to the awe of other species or the challenge of cohabitation with all the other creatures of the earth. Most of the Noah's Ark story is about God, about Noah and his family, about good people and bad people, about actions and consequences, and tossed in as a fairly trivial afterthought God reminds Noah of the human caretaker's relationship to the other animals: feed them. It is biologically imperative, to be sure, but hardly resonates with an awareness of spectacular interspecies communion that this story might have developed.

In Genesis 7, the animals ("beasts," a word that has today, as it had in the King James Version, a pejorative connotation of a more savage nature, lower status, and lower intelligence, compared to human beings) are separated, cataloged, bureaucratically organized and framed, numerically and prejudicially. Seven clean beasts, two unclean beasts. Here and elsewhere, the Bible reifies arbitrary prejudices. The sun is the greater light and the moon is the lesser light; therefore, day is better than night; a meat offering is better than a cereal offering, therefore Abel's sacrifice was found more favorable in God's eyes than Cain's. Clean animals – cattle, sheep, goat, deer (see Leviticus 11:3 and Deuteronomy 14:4–6) – are better than unclean animals – pigs, camels, mice, lizards, cats, bears, lions (see Leviticus 11:4–8). This reflects the cultural fortune of what these animals are going to be used for in human society: how they have been framed. If the point of God's distinction is the impact on human health of eating cud-chewing animals rather than bottom-feeders and carrion-eaters, this is another way of saying that the frame for animals' value is their presumed usefulness for

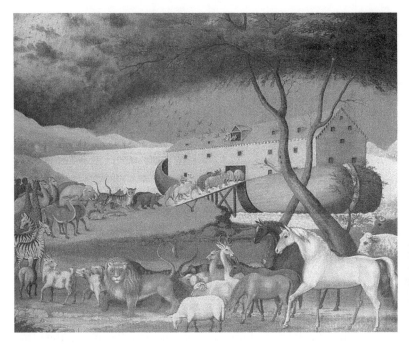

Figure 2 Noah's Ark by Edward Hicks, 1846. Wikimedia Commons

the human consumer. A rich tradition of visual culture has proliferated for centuries, as we see in caught-floating animal ark scenes reproduced and reinterpreted by Edward Hicks, Marc Chagall, Currier & Ives, and Gustave Doré, among copious others. In these images, we see the animals in their extensive volume, though with considerable range. Some representations are more voluminous than others, and all of them are less voluminous than the "actual" assembly must have been on the ark, and that assembly itself was drastically reduced, by God's intent, from the animal population of the world as a whole. Cultural contexts are inherently diminutive places compared to natural contexts.

It is inviting to smell this scene of Noah's animal collection, and to hear it, and to imagine the chaotic interaction, though most visual images do not offer scenes of ostriches snuggling up against camels, or spiders weaving webs in elks' antlers. God's strict categorization plays out in the separation, the clustering, of each kind of animal, contrary to the natural ecosystemic interaction of different species.

The story ends with a touch of human-frame irony (which from the animals' point of view must have seemed like random sadistic cruelty). The liberation scene in Genesis 8:19, in which "Every beast, every creeping thing, and every fowl, and whatsoever creepeth upon the earth, after their kinds, went forth out of the ark," includes the sacrifice of many of the ark-framed caught-floating animals:

> And Noah builded an altar unto the LORD; and took of every clean beast, and of every clean fowl, and offered burnt offerings on the altar.
> And the LORD smelled a sweet savour.

This animal massacre smells *good*! God's message to the animals, if God even thought that animals were capable of understanding his messages, seems to be: do not get too cozy here in this cleansed new world. You are still spiritually and practically subject to the dominion of any people who would like to start a fire and enjoy the smell of your death, as testimony to your subordinate status.

Subsequent cultural interpreters of the ark story emphasize the order, the two-by-two-ness, the implicit sense of human control (march onto the boat, out of the rain; we will save you). It is difficult to imagine the animals' point of view in this story, although a few writers and artists have lately begun to fill in this aporia. In *A History of the World in 10 ½ Chapters*, Julian Barnes presents a revisionist depiction of Noah – "not a nice man," in the voice of a woodworm, who snuck onto the ark when he was passed over because of his perceived insignificance. "I realize this idea is embarrassing," he tells a human audience, "since you are all descended from him; still, there it is. He was a monster, a puffed-up patriarch who spent half his day groveling to his God and the other half taking it out on us" (12). A German surrealist artist whose name fortuitously rhymes with Noah, Michael Sowa, has created his own visual text of the story, *Sowa's Ark*, which presents an ark narrative (along with other weirdly framed animals) with a dark chaotic energy in which human characters are disempowered, virtually absent – Sowa has erased Noah. But, with a few exceptions, there are almost no cultural critiques that probe why the story of *human* corruption in Genesis takes the form of an iconography populated almost completely by other animals. One never sees the ocelot with the quizzical look on her face, inquiring, why am I here? What does this have to do with me?

Ark-story images present an encyclopedic cornucopia, or catalog, testifying to the sense of ownership and consumption lurking beneath the surface. A few "star" animals are usually highlighted front and center, such as the raven and of course the dove (with a prop, the olive branch). There is a surprising homogeneity of animals depicted, what zookeepers call "charismatic megafauna": giraffes, elephants, lions. We do not see squid, rats, or mosquitoes in the processional. Visual culture spotlights the animals we prefer to think about saving, which is not all of them. Perhaps this helps explain why most people, today, tend not to get too bothered about mass extinctions of species. We have not been clearly given the message that it is incumbent upon people to try to save *everything*. Yes, God says to do so, but visual culture edits: the artists pick and choose. Farm animals (that is, animals we use copiously) are prominent in cultural representations of the ark. There may be a dash of exotica, but not in a way that really appreciates the diversity of animal life. We might expect in ark images meant for children – puzzles, games, storybooks – that the animals would all be the familiar ones from the canon of juvenile pedagogy (though we might also hope that such a trope would be a teachable moment in which some animals from off the beaten track, a wider variety, might be featured), but arks for adults, too, feature mainly the usual suspects.

Ark depictions are much more often accompanied by a rainbow than by the storms and floods of the Deluge. Artists direct our vision toward the happy ending rather than toward the dangerous elements that symbolize our own corruption and deserved suffering. The ubiquitous rainbow and olive branch signify the story's peace and the promise, sublimating the less savory aspects of ruin and destruction. Noah's Ark has remained an enduring trope, frequently invoked by zoos to depict people's benevolent care for other animals in circumstances of hardship. In zoo stories, too, the ruination of animals' natural habitats is elided from the representations because zoos want to tell a pleasant rainbow story that sidesteps the question of why animals need to be saved by an ark-man in the first place.

* * * *

Back to the jellyfish: the dozens of animals that populate the oeuvre of American poet Marianne Moore resonate with an idiosyncratic and eclectic style. Her pangolin, her octopus, her dock rat, are unlike other members of these species that readers previously may have encountered (in the flesh or in cultural representations). Moore's quirky and complex

poetry accounts for some of this uniqueness. It is keenly visual: appreciating Moore's poetry depends on seeing the animals and their behavior, their movements, their dynamics, as she depicts them.

On the page, her verse indentation is extravagantly odd, all over the place, as if it is pushing us out of our conventional, comfortable poetry-reading mode and cajoling us to jump around with her and her animals. Her poetry is difficult to decipher, a difficulty that mimetically reflects Moore's belief – which I heartily endorse – that it is difficult for people to see animals. This difficulty is partly due to the fact that animals usually do not want to be seen by people. They are scared of us, and they seem to realize it is safer for them to be away from us, to flee our attempted clutch. Further, our difficulty in seeing animals clearly, and in understanding who they are and how they live, is complicated by the dense cultural constructions we impose on them and the heavy-handed frames that exclude much of their habitats, their lives. Most animals are too fast for us to see in their natural lives, or too well camouflaged, or too reclusive, or too far away from us, so we retaliate against their impudent inaccessibility by framing them.

Moore deconstructs our presumptive and hubristic visual megalomania over other animals. A short 1909 poem, "A Jelly-fish," demonstrates her approach. I quote it here in full, with special admiration for the tension, the paradox, embodied in the two words of the first line:

> Visible, invisible,
> a fluctuating charm
> an amber-tinctured amethyst
> inhabits it, your arm
> approaches and it opens
> and it closes; you had meant
> to catch it and it quivers;
> you abandon your intent.[2]

The single-sentence poem is grammatically unwieldy, unsettling, like much of Moore's verse. Like Emily Dickinson, Moore enjoys putting her reader off guard, pulling the carpet out from under us with her syntactical twists and turns.

Visible, invisible: which? Sometimes visible, sometimes not? (If so, when visible and when invisible? Is it up to the viewer, or up to the jellyfish, to determine when visibility may occur?) Is the jellyfish somehow, metaphysically, visible and invisible at the same time? Do we see some but not all of the animal? (If so, what parts? Are there some parts that

we can always see, and some we never see? Or do the visible and invisible parts switch off?) What are the characteristics of the visual animal, and of its alter-ego, the invisible animal?

After being warned of the tentative and limited visibility, we proceed through the poem to encounter a few brief but tantalizing cues that make the reader *want* to visualize the animal. The jellyfish *fluctuates*. (How interesting – what is that like? Like a chameleon changing colors? Like a tadpole or caterpillar transforming into a frog or butterfly? Like a human being who fluctuates in mood, fortune, spirit?) Moore visualizes the jellyfish as a *charm*, which is compelling: I want a charm! What does it charm? How? What magical powers may lurk in this charm? She gives us a glimmer of color, melded colors (amber and amethyst), colors that evoke minerals, jewels, value. Again: I want this! Hence, my arm approaches. I draw near. I want to touch, to take, to own.

But in the poem's peripeteia, the animal quivers. It moves in a way that scares the reader, as many animals like bats, crickets, moths, and pouncing tigers frighten people with their movements. A bat's or jellyfish's nonhuman, suprahuman forms of movement demonstrate our inferiority to these animals, our inadequacy in chasing them, or in escaping from them. Quivers and pounces remind us that we are not like them, and they are not like us. Our modes of locomotion may be less potent, less versatile, than theirs. We try to compensate for this by building trains and cars to move faster, and planes to fly like birds. We envy their movements, but we cannot reproduce all of them, like the jellyfish's quiver.

Moore informs that "you" (us, me – the reader, the viewer, the person who sees and wants the jellyfish) "had meant to catch it" ... but this was not to be. Visible becomes invisible. The animal escapes – or, what is perhaps slightly different, "you abandon your intent." You decide you do not want to chase it any more, do not want to grab it, touch it. Perhaps because it scares you, perhaps because you realize you cannot grab it. It is, after all, jellied and squirmy. Moore is correct that it is hard, and dangerous, to try to grab a jellyfish. She suggests that we can see it just a bit – or, *she* can see it, and transmits this to us for a few lines, a few words ... *fluctuating, amethyst* – but not permanently, and not possessively. She warns us that unilateral visibility of other animals is not possible, not desirable.

The jellyfish in this poem is not, strictly speaking, itself an "animal in visual culture" – it is, like all poetry, a written text, not a visual text. But this text is also, like all successful poetry, imaginatively visual as it conjures a picture, brimming with form and color and movement. Visible,

invisible: this hypnotic, symmetrical near-repetition, this fluctuation, resonates in my mind. When are animals visible (and how are they visible? What are the conditions and the consequences of their visibility?), and when are they not? What charms, and values, and temptations, and instincts make us reach out our arms, and our eyes, to approach these animals? What quivers might come from the animals (and do we or do we not see and respect these expressions of animal agency?) to warn us away from the grasp?

2
Famous Animals

In the twenty-first century, human culture has become more powerful – and thus, more dangerous to nonhuman animals – than ever before. The scope of modern society is global and instantaneous. Ideas, beliefs, trends, and perversions are ubiquitously diffuse. The expansive reach of civilization's technological capabilities leads to global warming, habitat destruction, oil tanker spills, and radioactive and other toxic emissions. And such obvious (physical, chemical, spatial) threats to animals' well-being are accompanied by an array of less immediately apparent incursions into their lives. Ecologically, a sophisticated international infrastructure facilitates the rampant, gluttonous consumption of natural resources. Animals frequently figure as a resource – which is, of course, a cultural frame, and, from animals' point of view, as well as ecologists', a regrettable one. The consequence of constructing the animal-as-resource may literally involve eating, skinning, harvesting, or otherwise physically devouring the animal's body; but the construct may also denote a kind of visual cultural consumption – watching, framing, representing, characterizing, and reproducing the subject in a certain way – that may comparably devour animals.

Every element of our biosphere is susceptible to the whims and prejudices of human culture. It is a challenging time to be a nonhuman animal, buffeted amid the frenzy of human existence. It would be comforting to think, as some have propounded, that anguished environmentalists like me are oversensitive Chicken Littles: that animals are mostly oblivious to our cultures; that the so-called wild will survive as it always has; that forest clearings, ozone depletions, extinctions, and the like are insignificant blips, and it is only self-flattering narcissism that makes people presume that animals are affected by our cultural habits and practices. In *The Skeptical Environmentalist*, Bjorn Lomborg

rebuts widely argued beliefs that the global environment is progressively getting worse; he would have us believe that "the dogs go on with their doggy life"[1] much as they have ever done.

To some degree, for some animals, it may be true that our presence is benign. But it would be irresponsible to assume that animals are, in large part, immune from our cultural processes. Animals are intensely present in our cultural imagination – "Animals are good to think," as Claude Lévi-Strauss put it[2] (think about; think with; think through), and we have lately being thinking them voraciously. One might suppose that thinking them voraciously is less immediately harmful to them than, say, eating or hunting or vivisecting them voraciously, but I suggest that it is not, because in our world the way people *think* animals affects their fate dramatically. The conceptions and prejudices that filter through our cultural experience become hard facts, actions, and behaviors, which literally and bodily involve animals.

We visually experience, and *consume*, a dazzling panoply of animals that surrounds us in our world: animals we fondle and animals we hunt; animals who are movie stars and animals who are porn stars; animals who are isolated (from other animals) in elaborate cultural frames and animals living in compounds like puppy mills or factory farms or research labs, whose numbers are so vast and whose lives are so desolate as to overwhelm our sensibilities; animals we tune out, erase, rather than confront the moral problem they represent; animals we fetishize (exotic animals, expensive animals, illicit animals, charismatic animals); animals we subject to ridicule (tigers jumping through hoops; spectacles in zoos; subjects of "stupid pet tricks," a regular feature on late-night television entertainment); animals momentarily in vogue (Akita dogs, commercially overbred; emperor penguins, after a popular documentary; panda bears, amid geopolitical reconfigurations of Chinese and American supremacy), and animals who float through the ether of television and the Internet; animals who are inappropriately transplanted or escape into an ecosystem, running wild and causing ecological havoc; animals who are refugees from habitats that people have polluted or confiscated.

If we try to think about these animals outside the proscribed, subservient two-dimensional role to which they are almost always relegated in our culture, we may arrive at some interesting and insightful realizations about ourselves and about how much we do not know about animals. We may come to appreciate how much is obscured, spoiled, when people inscribe animals as subordinate elements of an anthropocentric narrative.

An Englishman, a Frenchman, a German, and a Jew are asked to write an essay about an elephant. The Englishman writes about "The Elephant and the British Empire." The Frenchman writes about "The Love Life of the Elephant." The German writes a large pedantic treatise on "The Toenail of the Elephant." And the Jew writes on "The Elephant and the Jewish Problem."[3] Is it possible for people to imagine elephants beyond ourselves as elephant-imaginers? How can we get beyond our own problems and contemplate theirs? Anthrozoology looks at animals, and at the people looking at animals. While it addresses the overlapping area, the intersection in a Venn diagram where the circles represent "people" and "animals," that area is not necessarily a common ground or a meeting place. In the visual cultural frame, animals tend to become distorted and people tend to become ecologically imperious. This place where humans and other animals overlap is not pervasively informed by symbiotic ecological considerations. Its tropes evoke a carnival barker – "Dancing bears! Counting horses!" – outweighing any ethical or rationalistic voice. The discourse of ecology is overshadowed by the discourses of commerce and imperialism. While it is generally acknowledged (thanks to Peter Singer's *Animal Liberation*) that the chickens in factory farms are miserable, and the runoff from agribusiness pollutes our water tables, the bottom line is cheap, plentiful meat until you pry this drumstick out of my cold dead hands.

Animal Liberation includes a few visual animals whose representations offer victim testimony, documentary evidence of human cruelty. These rough, indistinct images are far from the mainstream of visual animals in popular culture. We do not see them very often; they are not pleasant to look at. We may find such images on the Web sites and in the magazines of animal activist groups such as People for the Ethical Treatment for Animals (PETA), and occasionally on a niche documentary about the institutions of agribusiness (like HBO's *Death on a Factory Farm*, by Tom Simon and Sarah Teale, 2009, and *Fresh*, by Ana Sofia Joanes, 2009). In response to the threats that even these marginalized and rarely seen images pose to the status quo, several states have begun passing laws making it illegal to take images of animals on "farms." Legislatures have created bills making it a felony to photograph a farm without consent, claiming that visual representations threaten to undermine farm operators' intellectual property.

The obvious lesson here is that the visual animal may be subversively dangerous. If people see these images of what we do to animals, our ethical behavior will appear clearly and self-evidently brutal, and it will become more difficult to keep doing it. But such documentarily

truthful, ethically charged, disturbing, activism-inspiring images are much rarer than the types of image that flourish in the predominant panorama of visual animals. Britta Jaschinski's photography, discussed in the following chapter, is a notable exception. She presents a canon of visual images that tells the truth about animals, undergirded by a concise ethical focus. But Jaschinski's oeuvre and Singer's exposé are the exceptions that prove the rule. Most visual animals are constructed in ways that reinforce the status quo, showing and embodying our control over animals. The contemporary cultural history of animals shows that people do what we want with them, and we are lately coming up with cleverer ways of doing more and more things with them. We are a selfish species, and we are skillful in the mechanics of ecological abrogation. We take what we want.

There is a direct link between the visual animal and the famous animal. A famous animal's fame is in direct proportion to his or her visual existence. If there is a large number of visual images of an animal, widely disseminated, easily available, then that animal is famous. One easy way to quantify an animal's fame is Google Image search. The number of results directly correlates to the animal's fame, which is a consequence of his or her visuality. How does an animal become famous? The answer, simply, is that people make her famous. Fame, like so many other human constructs that animals are burdened with, is something that we concoct, in accord with our cultural logic, prejudices, and whims. A person makes an animal famous by looking at her and then culturally developing that gaze in some way. The imposition of fame is likely to be motivated by some sort of human profit, though conceivably the condition of fame may be more altruistic in intent.

An extremely small proportion of all the animals in our world are famous. I begin my survey with two well-known animals, one vilified and one celebrated. Topsy was featured in a technological crusade, famous for having been killed in Thomas Edison's 1903 short film *Electrocuting an Elephant.* A Coney Island circus elephant, Topsy had killed three people (including someone who had tried to feed her a lit cigarette), for which she was sentenced to death. After she refused to eat a cyanide-laced carrot, Edison suggested frying her. He had been publicly electrocuting cats and dogs with AC, alternating current, because he wanted to discredit that type of electric power, which his competitor George Westinghouse championed, and to advance his competing claim that DC, direct current, was more effective and less dangerous. The scene opens with a keeper leading Topsy to her execution. Copper electrodes are attached to her feet, and 6,600 volts of electricity are

turned on. Topsy becomes rigid and falls forward to the ground dead amid a cloud of smoke. The visual impact is troubling and cruel. "There was a bit of smoke for an instant," according to the *New York Times* account. "Topsy raised her trunk as if to protest, then shook, bent to her knees, fell, and rolled over on her right side motionless."[4] The animal appears as a misfit, a criminal, a danger: something to be exterminated, dispatched with all the power of modern technology. Edison showed his film around the country in his campaign against AC. (It suggests one more line for the old joke: The inventor writes about "The Elephant and the History of Electricity.")

Rin-Tin-Tin, star of cinema, television, and radio from the 1920s to the 1950s, had a happier experience on film than Topsy. The first animal superstar of the modern age, he was actually not just one animal, but a series of several German shepherds. When the "real," or first, Rin-Tin-Tin died in 1932, he was replaced by a stream of doppelgängers whom we might think of as his "legacy" or "dynasty," as Susan Orlean characterizes the successors in her biography of the famous animal.[5] The dog(s), thus, early subjects in the practice of mass media visual representation, illustrate a tradition of visual deceit. Several different dogs, similar in appearance, are characterized as *the same* animal, a single creature. The resource value of the commodity (acting dog) is increased and made more flexible. When the commodity expires, he is replaced with version 2.0. If one dog is having a bad day on set, or is pushed beyond his level of endurance, his double is waiting in the wings. Visual deception plays a key role in the ethics of overdetermining the discourse of the visual animal. This deception augments the power, and the convenience, of the human framer. What a tangled web we weave (though, of course, *we* do not actually weave webs – spiders do).

The original dog who played Rin-Tin-Tin was found in a bombed-out kennel in France near the end of World War I. Film mogul Darryl F. Zanuck saw him performing at a dog show, where the animal reportedly leapt fourteen feet into the air, and decided that he could be a star. The famous dog dined on choice tenderloin steak prepared by a private chef. At the peak of his career with Warner Brothers he received ten thousand fan letters a week and was considered one of Hollywood's top stars. Legend has it that he (or, one of "him") died in the arms of actress Jean Harlow. He has a star on the Hollywood Walk of Fame. Topsy and Rin-Tin-Tin represent opposite ends of a continuum that measures an audience's relative admiration or disdain for famous animals. They typify our proclivity to treat animals like gods or, alternatively, to destroy them in the pursuit of our own enterprises. Yet, as disparate as their lives

were, they had a common experience in terms of being enmeshed in human culture: a lot of people watched them. They were assigned roles, and these roles became their lives. These roles were keenly delineated by visual culture. Indeed, more simply, these roles were precisely identical with their visual cultural identities. These animals were depicted in a certain way, and their filmed/distributed identities became equivalent to their cultural identities. What you see is what you get.

The ways in which they were treated had nothing to do with their desires or their natures. People did with them whatever they wanted to do, and the animals bore the fame or infamy that people imposed upon them. They played their parts – happy, sad, or indifferent – pampered with haute cuisine or collapsing in a cloud of dust, amid the bizarrely unnatural narratives in which they were inscribed. Visually, their representations were striking, unique, memorable. As we will see again and again when we appraise the human experience of animals in visual culture, this keen visual presence overwrites the animals' actual nature and fixes them all the more firmly in a frame. The visual acculturation of animals is compelling to the human viewer, and the corollary cost to animals is the erasure of their actual being. Visual culture hegemonically monopolizes our modes of perception with regard to other species. The excessively pampered dog or the ingeniously tortured elephant supplants any inclination human viewers may have had to consider an animal more critically, more honestly.

The nature of a select few animals' fame suggests something about the animal as *individual*, which is a rare occurrence. While animals have a range of prominent functions in human culture, that prominence usually plays out in a way that is depersonalized (deanimalized) and in which the individual animal's integrity is effaced. Think of pigs whose valves are harvested for heart operations, or dogs who sniff out bombs. These animals do not become famous heroes. Fame is granted to so few animals – when it happens, what does it show about our relations with them, and with the multitudes of animals who can never make such an impression upon the human consciousness? What has enabled their visual foregrounding?

Many of the famous animals in modern culture are fictitious caricatures: Bugs Bunny, Mickey Mouse, Donald Duck, Porky Pig, and so forth. Their visual iconography is simple, funny, corny. It is easily reproduced (by teams of cartoonists in the early years of animated film, and by computer programs today). It is colorful and eclectic, though not in ways that very closely reiterate the colors or activities of actual animals. The cartooned-animal aesthetic, popularized in Disney, Warner

Brothers, and other studio workshops in the early- to mid-twentieth century, created a common and compelling style of animal representation that served to displace actual representational consciousness of animals. We have only so much space in our minds for thinking about animals, and the "easier," more seductive cartoon images supplant cultural awareness of actual bunnies, ducks, pigs, and mice.

Cartoon animals talk, they walk upright, and they engage in activities that are recognizably human, as opposed to authentically animal. Often they are depicted wearing some clothes, though not a full outfit: a sports coat, perhaps, but no pants; a tie, but no shirt. These visual cues suggest that they are supposed to be regarded as *somewhat* human – capable of donning some, but not all, of the accoutrements that real human beings wear. Perhaps the suggestion is that they aspire to natural, fully clothed humanity, but, being merely animal, cannot completely pull off the performance. They are second-rate. (One recalls here a common colonialist portrayal of the subaltern native who tries, sometimes ludicrously and usually unsuccessfully, to dress the part of the sahib.) The profusion of animal characters marketed to young children diminishes as they move into young adulthood, suggesting that animals are at the bottom of the scale, fitting for youngsters until their minds mature beyond this and they are ready for higher-level narratives about real people. Animal stories are just the warm-up act.

Alongside these cartoon animals, there are a gaggle of famous showbiz animals, in the mold of Rin-Tin-Tin, who have a slightly higher degree of reality than their animated counterparts. Animals like Flipper, Lassie, Mister Ed the talking horse, Francis the talking mule, and Babe the talking pig are media stars whose perverse existence, like that of cartoon animals, is shaped by the expectations and fantasies of the people who surround them. The subject of animals and language (their own language, and the possibility of a common language that would facilitate interspecies communication) could generate an extensive, fascinating anthrozoological deliberation. In the case of these famous talking animals, though, there is a striking absence of such interrogation. The animals just talk, and the people just watch.

Famous animals in visual culture may suffer brutally. In Chapter 7 I will discuss several artists who kill animals as an explicit element of their aesthetic. Such desecrations of animals in contemporary art grow out of the culture of taxidermy. Taxidermists stuff dead animals to preserve their forms as an eternal monument to human mastery over them, immortalizing them in visual culture. Just as the live animals were removed from wherever they lived, also in death they are

displaced, framed in living rooms or art galleries or curiosity shops. Taxidermy (like taxidermic art) both literally and figuratively sucks out animals' guts, their lives, while keeping them perversely and paradoxically "lifelike." A visual image is preserved, while the real animal is destroyed. Again, the visual culture lies. The visual image exactly contradicts the animal's reality. The image prospers, the animal suffers. The image contains value in human culture, but the animals themselves are disenfranchised from the human economy. The animals have suffered in the process of constructing these taxidermized artifacts, and they suffer again, metaphysically, as an artwork – a visual representations of their corpses, their suffering – denotes what people can do to animals. A few artist-murdered animals become famous, widely seen and discussed, like Damien Hirst's shark "preserved" in formaldehyde (though "destroyed" is a more ethically accurate description than "preserved"). But such famous animals are at the same time anonymous, as audiences do not really know anything about who they are (or were).

Some animals' fame derives from their roles in enterprises that are deemed vital to human society. In 1957 a dog named Laika became the first living creature sent into outer space, in Sputnik 2. She was a stray dog, probably a mix of husky and terrier, who had been found wandering the streets of Moscow – rescued from there, as Rin-Tin-Tin had been rescued from the bombed French kennel. The point of sending an animal up in a rocket was to show that a living creature could survive the launch and the weightlessness of outer space and to provide information on how living organisms react to space environments. She was the proverbial guinea pig. For decades, Soviet authorities had maintained that Laika lived for a week on the rocket, but more recently it has been acknowledged that she died, from stress and overheating, just a few hours after the flight was launched.

In the space race that became a major political and cultural battleground between the United States and the Soviet Union, Laika was a pawn. She became a hero, and monuments to her were erected across the Soviet Union. But from her own point of view, I imagine, she was a victim, a slave. What must it have been like for her to have experienced what she did? And if she truly was such a famous, heroic animal, why was the reality of her flight so different from the fallacious accounts that the Soviets propagated about her? Her experience must have been fascinating, and horrific, but what really happened was not the story that people wrapped around her. Science, we are told, is supposed to be predicated on the truth. The exploration of space is arguably the most enormous scientific endeavor of the twentieth century, and yet the story of the animal

most famously involved in it is false. The gap between the story of the Sputnik mission as proclaimed to the world and Laika's actual experience, which dribbled out as a footnote decades after the event, indicates how little animals really matter in the story of human progress. People regularly and unthinkingly inscribe our stories over animals' own experiences. Animals are convenient vehicles for human narratives, but their own actual stories, if they are even known at all, are irrelevant.

Another scientifically famous animal was Dolly, a Scottish sheep, the first mammal to have been successfully cloned from an adult cell. She lived from 1997 to 2003 and was named for Dolly Parton because the cloned cell was a mammary cell and Dolly Parton has famously large breasts. Semiotically, then, Dolly's name is inflected by the cultural spirit (sexism in the case of Parton, speciesism in the case of the sheep) that inclines men to ogle rather than to look honestly, equitably, unthreateningly, at something. In the case of male lechers, and also in the case of Dolly the sheep's cultural audience, such leering obscures the real nature of the body that is being ogled. In different ways, both Dollys are objectified bodily forms that serve a purpose for a lustful, desirous audience, a purpose that overwrites their lives just as the Soviet mythographers overwrote Laika's life. A female bosom is a fecund canvas for the creation of male fantasies, and abnormally large breasts practically invite the male gaze to run wild in the bosomy fields of imagination. And if the scientific gazers clone a sheep to graze in this field, well, it is all of a kind.

Dolly developed a debilitating form of arthritis at an unusually early age, leading some scientists to speculate that the cloning may have resulted in premature aging. Her parent was six years old when the genetic material was taken from her, so when she was born Dolly may have already had a genetic age of six. Dolly's case inflamed ethical controversies about cloning. Scientists' limited understanding of the applied genetics suggests, some believed, that they should not attempt to control so many genes at once. The untested process of cloning, many feared, whether animal, plant, or human, opened up a Pandora's box of so many potentially ignorant or nefarious ways of tampering with nature and the possibility of wreaking havoc on the equilibriums of our ecosystems.

Like Laika, Dolly was a pioneer. Her sponsors celebrated her, as Laika's did, as the figurehead of a brave new world and claimed that her "creation" promised to bring about medical breakthroughs via genetic engineering; preservation of near-extinct species; advances in reproductive technology for the infertile; and even the possibility of bringing back

to life replicas of beloved Fluffies and Fidos. Others saw her as a hapless victim of hubristic human meddling in a sci-fi tableau where she was the fodder for our fantasies. Her actual identity was overwritten by these fantasies and by the narrative scientists disseminated with no less gusto than their inventions of the genetic technology itself. Artists, too, have created many visual icons and visual narratives of Laika. Pavel Medvedev's 2008 sculpture, which stands outside the Moscow military research facility where the flight team prepared the space mission that killed her, shows her standing atop a rocket. The tableau seems oddly askew, as Laika traveled and died trapped *inside* the machine, and it would have been literally impossible for her to stand on top of the rocket, either on the launching pad or in space. But metaphorically, viewers are meant to conceive of the rocket as Laika's pedestal – the construction upon which her fame is based. In the cast metal sculpture, the dog looks firm and fixed, which is probably not how she really looked *inside* the rocket.

On a 1957 Romanian postage stamp, a striking, serious likeness of Laika's head in profile (eyes poised, ears cocked, nose alert) is counterpoised with an image of the Sputnik. The aesthetic is Soviet propaganda: intense, heavy. The image of Laika's head is the same size as the Sputnik on the stamp, which distorts their real-life relationship, symbolically suggesting the equivalency of their fame, the animal and the rocketship. Laika's image (again juxtaposed with the rocket) is much more commonplace, unspectacular, on the front of a pack of Soviet Laika cigarettes. Here she just looks like a pet dog, a neighborhood mutt, but with an authentic resonance of spirit and personality that the stiff Moscow rocket-statue image lacks. Her image is manipulated, visually and historically, in various ways as she is used to sell various products and ideologies. Different audiences probably find the different images compelling in different ways. My own favorite images of Laika come from Nick Abadzis's 2007 graphic novel, *Laika*, in which the dog's story (alongside the rocket's story) appears in a way that dignifies her as a character and a living being rather than a symbol. Unlike most other incarnations of Laika in visual culture, Abadzis's Laika explicitly confronts his audience with the ethical ramifications of her story and the tensions between human ambition and animals' sacrifices. His drawings of Laika are simple, lively, engaging. They convey a compelling quotidian honesty antithetical to the dog's mythic incarnations that historically have predominated.

Laika's remains are in the spectral dust orbiting the cosmos; Dolly's, stuffed, may be seen in Edinburgh's Royal Museum.

The image of Elsa, an African lion, is forever preserved in celluloid, while a visual likeness of Balto, a husky, stands in a statue by Frederick Roth in New York's Central Park (and the dog's body itself is displayed in the Cleveland Museum of Natural History). Balto was the lead dog on the final leg of a 1925 serum run to Nome, Alaska, carrying diphtheria antitoxin from Anchorage. The annual Iditarod dog sled race commemorates that run. A deadly diphtheria epidemic threatened Nome's children, and the only serum that could halt the outbreak was in Anchorage, a thousand miles away. Medicine could not be flown in because the planes had been dismantled for the winter, so officials decided to bring it in by sled dog. More than twenty mushers took part, facing a blizzard with temperatures of –50°C. The trip garnered worldwide news coverage.

After a week-long run, Norwegian Gunnar Kaasen drove his team, led by Balto, into Nome. Balto and Kaasen became celebrities, though more than a dozen other mushers and their teams participated. This individual celebration of Balto recalls the visual presence of Rin-Tin-Tin(s), in that, again, many dogs become one dog. Balto and his more anonymous teammates toured the United States until their fame waned, at which time they were sold to a vaudeville organizer. When Cleveland residents raised $2,000 to purchase the animals from this sideshow, Balto and six companions were given a permanent home at the city zoo in 1927, where they received a hero's welcome. After Balto's death in 1933, at the age of eleven, he was stuffed and mounted. The corpse returned for a "visit" to Alaska in 1998, and Alaskan schoolchildren have recently been lobbying to have his taxidermic body permanently returned to their state.

Although his name and his story are famous, still, Balto's fame is a consequence of his service to people. And the reward for his heroism was being relegated to a sideshow, then a zoo, before being mounted and put on display. It seems impossible for an animal, however famous, to avoid concomitant conditions of ignominy, or to parlay that fame into something that might be meaningful and fulfilling on his own terms.

Elsa, an African lion, became famous in books and film: her story was told in Joy Adamson's trilogy *Born Free*, *Living Free*, and *Forever Free* (1960–62), the first two of which were made into highly popular films (by James Hill in 1966 and Jack Couffer in 1972). The Adamsons found Elsa when Joy's husband, George, a game warden in Kenya, shot a lion who attacked him. The lion had three cubs, of whom two were sent to zoos. The Adamsons kept Elsa, deciding when she was three years old

to teach her to live in the wild. Elsa was at first unable to prosper on the reserves where the Adamsons brought her but eventually managed to join with the other lions and adapt to her new life. She mated and had three cubs; the Adamsons kept tabs on her well-being and, after her death, kept contact with her cubs for a while.

Adamson's work touched a chord: she made people care about wild animals. She crafted an engaging narrative around the life of an animal, which is a hard thing to do. She made people aware of environmental challenges to wildlife habitats and to animals (though certainly to some extent Joy and her husband, who killed Elsa's mother, were part of the problem as well as part of the solution).

The movie's theme song, *Born Free*, popularized by Andy Williams and rewarded with a 1966 Academy Award for Best Original Song, was a paean to freedom: "Born free, as free as the wind blows/As free as the grass grows/Born free to follow your heart." It popularized the idea that animals, like people, cherish their freedom, and that their lives may be worth living under felicitous circumstances but not under constraint. There is rampant anthropomorphism in the story and the song, but this was necessary to bring an ecologically attuned consciousness about the importance of an animal's freedom to a wide cultural audience. *Born Free* is one of the most famous contemporary cultural narratives about animals and their lives, and about animals' complex relations with people. It anticipates a tradition of documentaries that bring people direct visual experiences of what we might call real nature. The Adamsons were very intrusive in the lives of their animal friends, however well intentioned, and their experience raises concerns about whether human interaction with animals is inherently meddlesome and what our motivations are for connecting with animals. Still, overall, Elsa was arguably one of the most famous animals whom people saw in a relatively authentic way. Through Adamson's depiction of the details of Elsa's development and her struggle to live in the wild, people got to know much more about her than they did about Laika. And she lived out her life without having been objectified as Balto was. Elsa paved the way for a more honest cultural relationship between people and animals, inspiring at least a dawning realization of the fact that animals might have desires and value in their own lives that are independent of people's relationship to them.

In these postmodern times, we might expect that the cyberculture would generate some digital approximation of taxidermy. Oolong, a rabbit, exemplifies the new electronic version of fetishizing the animal form. (A brief digression on animals' names: Oolong is inexplicably,

irrelevantly, named after a variety of tea. Laika, Balto, Oolong, and others are all names imposed upon animals by people, wholly meaningless to the animal subjects. I use these names as a necessary convenience, though they are simply one more layer of disguise for these animals, who are so enmeshed in human culture and language that their real identities are virtually inaccessible. Trent Reznor, the front man of the band Nine Inch Nails, named his cat Fuckchop. Mark Twain had cats he called Beelzebub and Satan. President Franklin D. Roosevelt had a dog named President, and General George Patton had a dog named William the Conqueror. Frequently, people give animals strange and stupid names, and we should think about why we do this, what it signifies, and how we might find better names, better ways to identify and address our animal companions.)

Oolong became a famous animal when Japanese photographer Hironori Akutagawa created a Web site[6] featuring hundreds of photographs of the rabbit balancing things on his head, an activity Akutagawa called "Head Performance." These objects include tea cups, an apple, an orange, a carrot, a piece of dried seaweed, a sesame bun, a book, a compact disc, a teakettle, a lit candle, a camera lens, a sprig of an evergreen, even a rabbit skull: things random and meaningless. The most famous of these photographs depicts Oolong balancing a pancake on his head, bearing the caption: "I have no idea what you're talking about... so here's a bunny with a pancake on its head." The site caught the media's attention and became a widespread Internet meme. Oolong died on January 7, 2003; Akutagawa's photographs of the rabbit's last moments appear on his Website.

What does this mean? What is the nature of Oolong's so-called fame? Millions of people have seen Oolong's image and know who he is. What is the import, the currency, of this attention? Do his cultural audiences really know him? What do they know of him? People like to look at animals and like to make animals do weird things. Elephants are made to paint pictures with paintbrushes taped to their trunks, chickens are made to play the piano, monkeys are made to do acrobatics and parachute jumps. In the age of mechanical reproduction, people reproduce animals a great deal. This may be regarded as an abrogation of the animals' fecundity, especially with regard to rabbits, whose reproductive prowess is a central aspect of their cultural reputation. Oolong's fame, then, embodies a kind of semiotic theft. What often happens when people engage animals is that we identify, and then steal, their spirits – their authenticity, their traits, their very animality.

Figure 3 "I have no idea what you're talking about...so here's a bunny with a pancake on its head." © in almost every picture #8 / kesselskramer publishing.com

In Asia, poachers harvest the penises of tigers to make potions that putatively prolong and intensify men's sexual pleasure and virility. Thus, they have taken the animal's power, its sexuality, its reproductive potency. They are stealing from not just the one animal, but all his progeny as well, who, because he has lost his penis, will not come to be. The poachers and penis-consumers have abrogated the fecundity and virility that they have denied the animal. People club baby seals, take their beautiful pelts from them, sew them together, and wear them: so then *the people* have the pelts, the beauty, instead of the seals. It is *schadenfreude*: people take pleasure from the deprivation of others.

In the case of Oolong, too, the viewer has something that the subject no longer has. Precisely what it is the viewer has is complicated and elusive, but important. A rabbit, or any animal, has as his natural birthright a kind of integrity, a control over himself that involves a certain relationship to his environment – his nest, burrow, or hive; his tree or field – and an imagistic authenticity. There are certain ways that a rabbit can naturally be, and other ways that are artificial.

To the extent that an image retains the authenticity of the rabbit's context, background, and frame, the subject preserves a good deal of control over his life, his well-being, his habitat, and his existence. The abrogation of this authenticity of representation – a consummate example of which is a representation of the animal with a pancake on his head – indicates the loss of the animal's natural and ecological harmony.

And what has the human viewer gained in this transaction? The person gains the power to displace the animal from his ecological well-being and, implicitly, the person has colonized for his own use the ecological space from which the rabbit has been evicted. There is, thus, more space – physical and geographical space, natural space, imaginative space – that the human being himself may inhabit: space where the person no longer has to compete with the animal for occupancy. It is irrelevant whether or not we actually need this space, or whether we can even use it. It is not necessarily the case that we have used up all of our ecological space, but it is simply a cultural fetish that we want more of it anyhow.

We want to expand – it is our Manifest Destiny. We want to have control, dominion, over as much space as possible. By displacing the rabbit from his nature, and from nature, per se, we have gained at least the potential to subsume the resulting vacancy. By stripping the animal of his bodily control, and of his natural dignity, we have gained the potential to arrogate to ourselves that much more of what we perceive as the zero-sum cache of biological and ecological control and dignity. The less the animals have, the more we might have.

This mode of representing animals is a process of taking from them and adding to our own cultural store, our inventory. Fame is itself a trope of displacement. Most animals are not famous, and when we isolate and celebrate a single rabbit or dog as a famous animal, we implicitly relegate the rest to a heightened obscurity. Certainly most animals would prefer to be obscure. But the human cultural prejudice is that fame is good, a sign of success and power, and so the hordes of anonymous animals confirm their own cultural insignificance. The famous animal is always singular, individual, while, as Deleuze and Guattari write in *A Thousand Plateaus,* the real animal is always multiple: part of a pack;[7] one element (incomplete as an individual) of a much larger group, an ecosystem. The cultural construct of fame strips the animal of his or her peers, his or her society, as it sets the animal who happens to become famous apart from the others.

Another popular Internet site that reproduces displaced animals is called The Infinite Cat project.[8] Creator Mike Stanfill explains:

> It all began innocently enough when a user on an Apple help web site posted a picture of his cat, Frankie, contemplating the beauty of a flower. Shortly afterwards another user posted a picture of his cat bristling at the image of Frankie on the monitor. I decided this was too much fun and advanced the concept as The Infinite Cat Project which is, simply, cats regarding cats regarding cats in an electronic milieu. If you like this web site then thank your lucky stars that the world is populated with cats, Macs, and people with wayyyy too much time on their hands.

The site features thousands of images of cats: a cat looking at a cat on a computer screen who is looking at a cat on a computer screen who is looking at a cat on a computer screen, ad infinitum. A typical photograph is titled: "Boris watching Baby watching Nina watching Widget watching Cloudy watching Ada watching Sammie watching Bo watching Cojo watching Boomerang watching Pfefferminze watching Titch watching Kuplung." We make them look at each other through *our* technological portals. If it is the bane of our lives that we are tied to our computers (rather than, as Freud argues in *Civilization and Its Discontents*, living our fantasies of running free and exuberantly through the forests and urinating on campfires), then we drag these cats down with us. Again, as in the case of Oolong's fame, cultural producers are tapping into the perceived fecundity, the infinitude, of the animal kingdom – cats are everywhere. Anyone can get one, free, anytime, anywhere: *Cats free to good home.* But the infinitude of an "infinite cat" is ironic: while there are indeed quite a number of cats here (a clowder of cats, or a glaring of cats, or a nuisance of cats – as unlikely as these terms seem, they are indeed authoritative), it is hardly boundless in quantity. Ultimately, each cat is keenly isolated – *finite* – in his or her Internet frame. These framed cats exemplify the human proclivity to deny a veritable sense of the vast infinitude of nonhuman life and supplant that with an oxymoronically "limited infinity."

The photos are funny because the cats are looking at computer screens and we know that they do not really want to do this, do not have to do this, to look at other members of their species. But in fact now, they *do* have to do this, because we are making everyone (even other animals) look at animals the way *we* look at them, as mediated

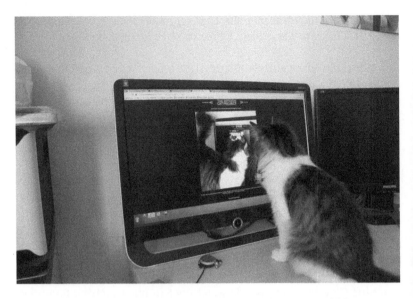

Figure 4 Cat. #1723: "Xaiohei pondering Lucas watching Bernard." Image courtesy of Infinitecat.com webmaster Mike Stanfill and Yuntao Zhou

by our technological and cognitive frames. It is the logical culmination of what Edison did when he represented Topsy (in the medium of film) confronting, head-on, the technology of electricity. The force of the electrical image here is not as manifestly lethal to these cats as it was to Topsy, but it is still dangerous.

Animal Planet, a cable television network, illustrates another type of frame for fame, organizing animals' lives into a series of half-hour blocks that parallel (through the programmers' contrivance) the cultural paradigms of our own existence. Consider the following program notes:

- *Animal Cops*: When a much loved pet is savaged by another dog, the Animal Cops are brought in to investigate and emotions run high in the courtroom.
- *Planet's Funniest Animals*: Take a peek into the hilarious lives of the world's most talented and entertaining individuals – animals! It's like having a million crazy pets right in your own living room – only you don't get as much hair on your couch.
- *Emergency Vets*: An English springer spaniel ingested a quart of safflower oil and a pen.

- *Animal Miracles*: The tie between man and dog is tested when the dog falls into a river; a dolphin inspires a disabled child; a dog reveals a talent for sensing heart attacks; a guide dog risks his life to save his owner.
- *Pet Psychic*: Can humans actually communicate with animals? Can we know what animals are feeling? Sonya Fitzpatrick, a modern day Dr. Doolittle, thinks so. The Animal Planet's Pet Psychic believes they communicate with pictures and feelings that they send telepathically to each other and to her.
- *Ultimate Zoo*: There's a new African Savannah in Canada! Hippos are thriving in Missouri! Giant Pandas are in Atlanta! Follow Animal Planet's exploration of the most advanced zoo exhibits in the world. Watch as architects, zoo keepers, and vets recreate their habitats.[9]

I would respond that there is *not* actually an African savannah in Canada, and hippos are *not* really thriving in Missouri.

How strange all this is. Animals are reconceptualized to fit into our world – they have cops, doctors, psychics, and so forth, just like us – and their authenticity, their nature, is stripped from them as we remove them from their own world. "It's like having a million crazy pets right in your own living room – only you don't get as much hair on your couch," promise the producers of *Planet's Funniest Animals*. What is so funny about the planet's funniest animals? Are we laughing with them or at them? Why would anyone want to have a million crazy pets in his own living room? One would not, really, but audiences embrace this faux sense of animal infinitude in which the viewer is like a king with a whole court, a whole planet, full of jesters. If there are a million of them, maybe *one* will really be funny. And there is no hair on the couch: yes, animals are a pain, are they not, when we bring them into our lives, our frames, our rooms? Remember, they did not *ask* to be here, and hair on the ground was not a problem when they lived in nature. As we exploit them, still we complain about how troublesome the ingrates are.

Cats looking at cats, rabbits balancing pancakes. It is supposed to be funny to people (odd, unexpected), and the animal subject is apparently oblivious. The animal is a prop, the sideshow star who is completely unaware of how funny he is, and that makes it even funnier. He is at the same time the center of visual attention, and wholly absent. As Marianne Moore put it, "visible, invisible."

Oolong is trained – most rabbits will not do "head performance," but this one can do something delicate, deliberate, and completely pointless.

This is important. We can, of course, train animals to do some things that at least are arguably useful (to us) – guide dogs for the blind, police horses – but it is also important for people to train animals to do things that are meaningless, simply because we can. This testifies to our absolute cultural power over them, to make them do whatever we want, whether there is a reason for it or not. And so Akutagawa made Oolong sit there, under a pancake or a glove, day after day, and took picture after picture, which he broadcast to the world, to show Oolong's (and by extrapolation, potentially, any animal's) subjugation, humiliation. Day after day, it remains – what? Funny? Compelling? Sadistic? Bizarre? Akutagawa exemplifies an obnoxious cultural habit: people put things on animals.

In these tableaux, when something is on top of animals, the animals are underneath, subaltern. It may be a person atop a horse, or an elephant, or a camel, riding the animal, racing the animal, or it may be a harness, or a pancake, a weird semiotic evocation of the human. But essentially, it is something nonanimal, something irrelevant to the animal that is represented as surmounting the animal.

In our cultural history of animals, there is a great deal missing: a *natural* history of animals; animals when we are not seeing them, not petting them, not dressing them up and making them jump through the proverbial hoops. In other circumstances, happier circumstances for them, animals have greater self-determination and a more natural existence, but we are interested in animals mainly in terms of what they can do for us – how they can please, or amuse, or satiate us – and their own freedom and integrity are diametrically opposed to our ability to do with them what we will.

* * * *

Animals in the news exemplify another kind of fame, transitory media attention. Some animals, fulfilling Andy Warhol's prophecy, will be famous for fifteen minutes. The biggest news stories grow out of threats, or perceived threats, that animals pose to people, such as swine flu, avian flu, killer African bees, the possible origin of AIDS in monkeys. These stories portray animals as the dangerous other – though a more rational analysis shows that the real problem is not the animal itself, but rather, the human–animal interaction: people grinding up animals to feed to other animals, for instance, generating what we dub mad cows, as we project the pathology onto the animals.

Commonly, ironically, when people address the threats to human beings that anthrozoological relations engender, attempts to confront and solve the problem may only worsen it. In 2005, for example, a program was begun to vaccinate billions of chickens in China as a barrier to avian flu, but some observers suggested that the people tramping from farm to farm to deliver the vaccinations actually increased the risk of spreading the disease. People like to think we are in control and know what to do to fix the problems that result from our interactions with animals, but our track record shows that this is wishful thinking. The fears that emanate from our relationship with animals suggest a guilty awareness that we have done considerable harm to other species, and ultimately we will get what we deserve.

In addition to the major animal-threat stories, news media regularly feature bizarre, quirky, and often troubling stories about animals. Here is a representative sampling:

GUILTY: MAN TAPES FRIEND WHO DIED HAVING SEX WITH HORSE
Man Died of Perforated Colon
Seattle – A man who was videotaping a friend having sex with a horse when the friend died pleaded guilty earlier this week to trespassing at the Enumclaw, Wash., farm. The 54-year-old man was given a suspended jail sentence and fined $778. The man told police he and others often sneaked onto a neighbor's farm to have sex with animals. Kenneth Pinyan suffered a perforated colon July 2 and died from his injury. The King County prosecutor's office said no animal cruelty charges were filed because there was no evidence of injury to the horse.[10]

One reads this story with a mixture of disgust and fascination. I cannot suppress my lurid desire to imagine how Pinyan conceptualized his relationship with this horse. (Documentary filmmaker Robinson Devor, too, was transfixed by Pinyan's story, which he explored in his 2007 film *Zoo*.) Why was Pinyan's friend videotaping the encounter? What was the meaning of this visual document? Was it meant to be salacious? Testimonial? (Zoophiles frequently form communities characterized by a cult-like degree of self-righteousness and pride in their transspecies adventures.) What are we looking at? Is there no limit to how voyeuristically perverse anthrozoological relations can get? Apparently not.

HUNDREDS CELEBRATE GIANT PANDA WEDDING
Zoo Hopes Animals Will Mate
Chiang Mai, Thailand – Hundreds turned out to celebrate the wedding of two giant pandas at a Thailand zoo Wednesday. Officials are planning to have the two pandas, Chuang Chuang and his female partner, Lin Hui, start mating. But the zoo wanted them to be married first. To celebrate the day, two mascots dressed as pandas and took the vows on behalf of the bears. Thailand has rented the two pandas from China for 10 years and hopes the pair will be able to produce offspring.[11]

Is this the flip side of the horse-copulating story? Did zoo officials wanted to make an honest panda out of Lin Hui? Why do people impose our habits, our cultural rituals, on animals? Why is it popular, and newsworthy, to impose irrelevant human institutions upon animals? Should we expect that someday *all* animals will be encouraged to get married before having sex?

EMILY THE STOWAWAY CAT TRAVELS HOME FROM PARIS IN STYLE
Milwaukee – Emily the cat is back – after flying home in the lap of luxury. The curious cat who wound up traveling to France in a cargo container touched down at the Milwaukee airport on Thursday, greeted by her family and a horde of reporters. A Continental cargo agent handed her over to the cat's owners. Emily meowed and pawed at reporters' microphones as the family answered questions…. Emily vanished from her Appleton home in late September. She apparently wandered into a nearby paper company's distribution centre and crawled into a container of paper bales. The container went by truck to Chicago and by ship to Belgium before the cat was found Oct. 24 at a laminating company in Nancy, France. Workers there used her tags to phone her veterinarian, who called the owners. Continental offered to fly the cat home from Paris after Emily's tale spread around the world and she cleared a one-month quarantine. "This was such a marvelous story, that we wanted to add something to it," Continental spokesman Philippe Fleury told AP Television News at Charles de Gaulle airport.

After one Continental employee escorted Emily from Paris to Newark, N.J., cargo agent Gaylia McLeod accompanied the cat aboard a 50-seater from Newark to Milwaukee. "I know it's close to the holidays," a tearful McLeod said. "I'm happy to be a part of reuniting

Emily with her family." On her flight home, Emily passed up a menu of peppered salmon filet and "opted for her French cat food" and some water, an airline spokeswoman said.[12]

Emily's option of peppered salmon filet recalls Rin-Tin-Tin's tenderloin steak; famous animals, apparently, qualify for haute cuisine. Her airline adventure illustrates how animals get sucked into globalism – global commerce, communication, public relations. It is common, as we survey a range of famous animals, for people to make a tremendous fuss about one animal, an individual animal, a token star, who is thus alienated from every other animal. We see the powerful sentimental pull of animals, as the airline employee uses the cat as a prop in her holiday story. We see the proliferation of animal stereotypes, here, the *curious cat* who made her way from Wisconsin to Europe. How much of this has to do with the animal, and how much with our own human constructions? Certainly cats are curious, probably some more so than others. I believe that sharks are curious too. And moths. But we have room for only one curious animal in our bestiary of metaphors, and "cat," like "curious," begins with "c," so *quod erat demonstrandum.*

A news story that seems more promising in terms of people's relationship with animals was headlined "It's Sensitive. Really. The Storied Narwhal Begins to Yield the Secrets of Its Tusk."[13] The function of the narwhal's tusk, which can grow to nine feet, has long been a mystery. Scientists have made the "startling discovery" that the tusk – actually a tooth – "forms a sensory organ of exceptional size and sensitivity" that "lets the animal measure minute changes in water temperature, pressure and makeup." An electron microscope revealed the subtleties of dental anatomy inherent in the tusk, which contains ten million nerve endings that give the whale unique insights into its environment.

People are finally learning, piecemeal, how amazing animals are. The narwhal, a rare whale native to the Arctic Ocean, had a storied cultural history because of its tusk, which had been thought to serve the function, possibly, of breaking ice, spearing fish, transmitting sound, poking the seabed for food, wooing females, defending babies, and establishing dominance in social hierarchies, among other things. People thought many things about what these tusks were for, and they were all wrong. Now, at last, we know. (Maybe.)

In the past, these tusks had been "sold as unicorn horns … often for many times their weight in gold since they were said to possess magic powers. In the sixteenth century, Queen Elizabeth received a tusk valued at £10,000 – the cost of a castle. Austrian lore holds that Kaiser Karl

the Fifth paid off a large national debt with two tusks. In Vienna, the Hapsburgs had one made into a scepter heavy with diamonds, rubies, sapphires and emeralds."

The cultural currency – the visual iconography, the mythology – of something like the narwhal's tusk is powerful. When we finally learn the truth about the tusk's function, that does not necessarily undercut the accretion of people's earlier beliefs about its purpose. Discovering things like this about animals may, indeed, inspire people more generally to learn the lessons (about biology, physics, nautical science, and many other things) that animals can teach us, and which can enrich our own lives and experiences without overwriting or diminishing theirs. We might try to discover and appreciate the essence of who they are, and *how* they are.

Human myths and guesses about the narwhal are good things, I believe, but only until the point where those fantasies inspire people to start harvesting narwhals for their tusks and fetishizing them, detusking them, and trying to abrogate the animals' magic for ourselves. Encrusting the tusk with jewels and making it into a scepter does *not* show an authentic sense of the animal's essence. Rather, it shows what people can do to the animals, what we can take away from them. The Hapsburg scepter illustrates both the fascinating pull of animals' power and our proclivity to profane it, to overlay our own cultural value systems upon the artifacts of animals (which are, obviously, no longer the actual animals themselves: those creatures are long vanished, a waste product of the bounty we reap). Underlying an icon like this scepter, one can see people's wonder toward animals, but loaded thickly on top of that is our tendency to colonize for humanity the animals' essences.

That colonialist attitude is dangerously disrespectful for animals, as well as deceitful for us. People may like to think of the appropriation and bejeweled reconfiguration of a tusk, or of some other animal bone or tooth or pelt, as a homage to animals, but it is actually a desecration. Ecologically, it is a symptom of our heedless imperial harvesting of any and all baubles of nature, which leaves the ecosystem as a whole poorer and more fragile. Why can we not admire the narwhal's tusk *on the narwhal?* Some people have been able to do this, and some have not. Perhaps this recent news about narwhals makes us more prone to do so. I idealistically hope that more knowledge will lead to saner ethics. Now that we understand what the tusk actually does, and realize that detached from the animal and decoupaged with gems, it can no longer do this, we may be more inclined to leave it where it belongs.

In the aftermath of the Enlightenment and the Industrial Revolution, the age of empire, and the world wars, our anthropocentric praxis is starting to show cracks. We have created a cosmology that shamelessly celebrates our importance in the universe. We have reified human progress – framed in terms of commerce – and Baconian science, expansion, and consumption, as the consummate expression of our meaning in the ecosphere. And still the planet is not at peace, but in a state of turmoil, and the environment is unstable, and the nonhuman world is manifestly displeased with us. As W.H. Auden described the corruption of society in "Spain": "The stars are dead; the animals will not look."

So, we begin to interrogate our unexamined presuppositions about our relation to other species. There are more things on heaven and earth…. Some characterize our era as posthuman, which means, perhaps, that we are becoming aware of having overvalued our significance. Our skimpy consciousness of other animals is retrograde. "The others" – Paul Shepard's eloquently simple descriptor for nonhuman animals[14] – are more important, ecologically and spiritually, than we have acknowledged. They are more independent than we have presumed them to be, and more sentient than we ever imagined.

The others have voices that people have strained to ignore, relegating these tongues to pretty catchall terms such as *birdsong*, words like *meow*, but never dreaming that these were languages full of experiences and imaginations as vital as our own. All the things we have thought about animals are lately revisited as visual constructs, caricatures, distortions, that have sustained our own hegemony. The horse upon which a heroic general rides in eternally bronzed conquest; the cartoon coyote who collapses for the thousandth time as an anvil falls humorously on his stupid coyote head; the funniest home videos of cats crashing into glass doors and slip-sliding across the room on banana peels; the commodified dots of color swimming around in pet superstore tanks, in clear, pointless water, moving nowhere except in front of our eyes. The national symbols: the bald eagle, the proud buffalo. The metaphors: the wily fox, the curious cat, the dumb bunny, the proud lion. The stuffed animals in museums, and, rattier, in garage sales. The very words: ratty; catty; batty. What *is* it like to be a bat?

These highly acculturated famous animals I have assembled here are token evocations of the myriad animals that we shuffle through our cultural circuses. I wonder, what do they, the others, think of all this? What would they be doing if we had left them alone? What sorts of visual self-representations would they create, if they wanted to? *Do* they want to do this – create their own self-images? Why or why not? How

can we see, through all the culturally bastardized images, and in spite of them, beyond them, to the real animals who are all but obscure in their frames (that is, in *our* frames)?

Deleuze and Guattari's formulation of "becoming-animal" represents an ideal for the ecological and cultural prosperity of animals. It is a trope that envisions animals dynamically. In *A Thousand Plateaus*, Deleuze and Guattari describe a consciousness that challenges the conventional segregation between human and animal sentience. This consciousness invokes a fluidity between and among species, a permeability that eschews the boundaries between human and nonhuman. While their discussion begins by discussing the prevalence of interspecies transformations and metamorphoses in the genre of myth, they assert that the transformations they envision are not merely metaphor. "Becomings-animal are neither dreams nor phantasies. They are perfectly real."[15]

Deleuze and Guattari privilege action and intensity over mere form. Becoming-animal is about the whole animal and its life rather than its iconically reductive cultural representation. "The wolf is not fundamentally a characteristic or a certain number of characteristics," they write, "it is a wolfing. The louse is a lousing, and so on."[16] Steve Baker explains Deleuze and Guattari's "suspicion that in handling animal form, [most conventional] artists are merely *imitating* the animal from a safe distance. Mere imitation has nothing to do with the intense and thorough-going experience of becoming animal."[17] Becoming-animal describes an apotheosis, an epistemological epiphany about the nature of life, experience, and identity, which both human and nonhuman animals may experience. Human beings are, of course, already animal, technically, but Deleuze and Guattari would have us interrogate, and learn from the ground up, our inherent animality. An animal trope, lines of flight, describes the becoming-animal's transcendence of its two-dimensional subjectivity. These are the paths along which people must learn to see animals and to follow them. The lines of flight highlight the animals' mobility and agency. They are paths of escape from the captivity and inertia – the *frames* – that plague animals in so many of their modern cultural incarnations.

In *Fear of the Animal Planet: The Hidden History of Animal Resistance*, Jason Hribal reconstitutes a historical continuum of animals' own expressions of their determination for freedom. He recounts numerous transgressions, lines of flight, that captive animals have enacted – two recently publicized cases involve Tilikum, an Orca who lethally attacked her trainer at Sea World in 2010, and Tatiana, a Siberian tiger who escaped her cage and killed a spectator at the San Francisco Zoo in

2007. Hribal discovers an enduring tradition of resistance, a struggle that "begins and ends with the animals themselves," in which "Captive animals escaped their cages. They attacked their keepers. They demanded more food. They refused to perform. They refused to reproduce."[18]

Becoming-animal is an escape from human cultural constructions of the animal. The attack by the tiger, Montecore, during Siegfried & Roy's Las Vegas circus extravaganza offers an illustration. In 2003, during the act, the tiger famously lunged at his trainer, Roy Horn, and dragged him offstage – which most of the audience thought was part of the show. Montecore crushed Roy's trachea and left deep puncture wounds on the back of his head. Comedian Chris Rock offered this commentary on the attack: "Everybody's mad at the tiger. 'Oh, the tiger went crazy.' No, he didn't. That tiger went *tiger*. You know when that tiger was crazy? When he was riding on a little bike with a Hitler helmet on. That's when the tiger was thinking, 'I can't wait to bite somebody.'"[19] Rock illustrates a textbook example of the liberatory power of becoming-animal when he says, "That tiger went *tiger.*" It seems pretty clear to me, though Roy himself has remained in denial about this, that the tiger probably hated being a White Tiger of Nevada (as the animals were billed on the marquee) and performing twice a night on the strip, and this was how he manifested his feelings. It might seem inhuman (a word that probably needs to be revisited as we reevaluate the nature of humanism) to say this, but I believe that it is fitting to cheer the tiger who becomes a tiger, the animal who fights back against his cultural oppressors, as Montecore did.

The chimps in Will Self's *Great Apes*, the pigeons in Patrick Neate's *The London Pigeon Wars*, the richly fascinating idiosyncratic animal characters in José Emilio Pacheco's poetry collection *An Ark for the Next Millennium*, are becoming-animals. The canvases of Olly & Suzi, in which the animals join together with the artists to mark the artwork, depict becoming-animals, as does the photography of Britta Jaschinski in which the animals subversively resist the frames, the focus, the lighting, the cages that people have imposed upon them for so long, and appear instead with forms, appearances, and contexts that are so radically different from the simple creatures we are used to looking at that they are sometimes hardly recognizable.

There are also failed (stultified, perverted) becomings. Dracula exemplifies a bad becoming-bat, too heavily overwritten with Bram Stoker's and the audience's xenophobia and sexual anxieties. In H.G. Wells's *The Island of Dr. Moreau*, Moreau's beast folk, like Dracula's vampire, bring readers tantalizingly close to the human–animal boundary,

which aids our understanding of becoming-animals. People have traditionally sublimated the closeness of this species divide, and we should venture closer. But, as in *Dracula*, the antagonist's sociopathic insanity degrades the potential of Wells's text as a manifestation of becoming-animal. Rainer Maria Rilke's poem "The Panther" (1907) epitomizes the failure of an inchoate becoming-animal, as poet and audience poignantly recognize this animal's intensity and his soul, but remain powerless within the text to celebrate this, or to ameliorate the animal's constraint. There are no lines of flight here, as the panther is trapped in a cage at the zoo. There is no panthering. There is no emotion possible other than pathos.

Animals caught in the Internet become *something*, but they are not becoming-animals. New media pixilated creatures like Oolong and the infinite kitties become *meme* – reproduced, but not fecund; not empowered. They are just more efficiently a subject of fetishistic voyeurism. While Deleuze and Guattari write that the becoming-animal is multiple, the multiplicity of the cybercultural animal is mere volume: mass of kilobytes, without meaningful content. The multiplicity of the animal is a necessary but not sufficient condition for becoming-animal. The Web sites and animal channels are merely new and glitzy frames that inside encompass, restrictively, the same old animals. To see the *new* animal on the frontier, we must revisit and reform our own received ideas and habits. Our new understanding of the narwhal's tusk stands as an example of our receptivity to the becoming-animal.

Many contemporary cultural accounts of animals involve a degree of fear. *Dracula* exemplifies the trope for this, seen in van Helsing's fear of Dracula's bite (after the Transylvanian count has become-animal) that ruins the victim. Such texts as *Dracula* and *King Kong* illuminate our fears about animals who turn on us, who hate us, and who attack us. We are afraid of a lot of animals: mosquitoes who carry West Nile virus, sharks who attack us when we are on vacation, pit bulls, deer ticks, bears, bats, spiders, rats, snakes, killer bees, mad cows, and on and on.

Perhaps these fears could, paradoxically, lead to improved relationships with animals. In Joseph Conrad's *Heart of Darkness,* the text's primordial fear – "the horror, the horror" – signified the death knell of Eurocentric global exploitation and forced readers to confront the power of the subaltern Africans (and the ethical abominations to which they had been subjected), who had been tamed, stylized, and marginalized, throughout the imperial enterprise. So, too, human acknowledgment of our fears of animals can empower us to recognize and internalize the reality that there is actually something to be scared of

(*contrapasso*: we have done poorly by the animals, and we may expect our acts to redound back upon us). Embracing our fears could help us accept the power of animals, all the different kinds of powers they have that we have suppressed. Given the subordinate fixities with which we have tried to construct animals in our world, it is indeed terrifying to imagine the chains, the bars, straining and breaking under the pressure exerted by the captives, the wronged prisoners.

The fearsome animals, as we deconstruct our fears, can be vehicles for our awareness of becoming-animal. We may realize that we are of them, and that – as Stoker's English readers with their ideas of racial supremacy were so loathe to accept – our fluids mix with theirs. And a scary scenario becomes a teachable moment in a larger ecosensibiltity. We are all part of the same biosphere, and we are all in this together. As Barry Commoner says, Everything is connected to everything else. Nature knows best.

3
Photographic Animals

Britta Jaschinski's photography generates more questions than answers, but they are good questions, and perhaps she realizes it would be presumptuous to suggest unilateral answers about the issues she addresses. What does an animal look like? Where does an animal belong? What happens to animals when we try to look at them through our own cultural frames? What are we looking for? The viewer must work diligently and ethically to resolve the conundrums represented in her provocative images.

Born in Bremen, Germany, educated at Bournemouth Art College, and now based in London, Jaschinski works throughout Europe and globally. Her first collection, *Zoo* (1996), depicts zoo animals from around the world; her second book, *Wild Things* (2003), offers an ecological meditation on animals and habitats. Since 1999 I have collaborated with Jaschinski on projects involving museum exhibitions, articles, Web sites, and interviews. She is one of the premier contemporary photographers engaged in the work of representing other animals, alongside such figures as Frank Noelker, Candida Hofer, Gregory Colbert, Joe Zammit-Lucia, and Garry Winogrand.

The animals Jaschinski selects to photograph acquire the prominence of being seen and contemplated by a wide viewership, like many of the famous animals discussed in the previous chapter. But Jaschinski's audience is more likely than most to leverage the animals' fame into empathetic understanding and critical, even subversive, cultural deliberation. The animals in her images are not glamorized or airbrushed. They are not ripe for fetishistic exploitation. Indeed, they actively resist such implication in conventional culture. They often seem pensively sad, which is not usually what we like to see when we look at animals. Jaschinski's images force us to think in ways that uncomfortably, and

50

Figure 5 Polar bear, New York, Britta Jaschinski, *Zoo*

sometimes brutally, interrogate our perspective as viewers, as people. Many of the images are somehow difficult to see, which contrasts with the conventional expectation that an animal subject should be easy to grasp. An otherworldly darkness permeates her work, a troubling philosophical depth that touches both the animal inside the frame and the human spectator who is outside looking at the creature. A sense of uncertainty resonates in her photography – uncertainty about the animal's context, the animal's sentience, the animal's feelings. This sense of the unknown, however aesthetically rich it is, challenges the human audience's habitual expectations of omniscient insight with regard to other animals.

In *Zoo*, one image shows a polar bear in captivity in a New York zoo. In many of Jaschinski's zoo photographs, the apparatus of captivity prominently frames the image in the form of the cages, the unnatural habitat, the weirdly intrusive perspective into which she places the viewer with respect to the animals, and the dreary, deadened milieu that her photography embodies technically. In this photograph, however, although we know because of its inclusion in *Zoo* that the polar bear is in captivity, the image itself gives few indications of this: we see only a bear in water. It is possible (for us – is it also possible for the bear, I wonder?) to pretend, for a moment, that the bear is free. The play of

light gives the animal a keen glow, augmented by a magical stream of bubbles emanating from his body through the water. The bear's form is sleek and seductive. He seems simultaneously to be moving and still, which is after all typical of the photographic trope in which action and stasis coexist.

The bubbles suggest the animal's keen hydrodynamic efficiency. The arms and legs give a sense of propulsion, yet they are at the same time relaxed. The bear is suspended, floating in the water, as if at rest, yet obviously capable of large, powerful movement. He is calm, yet at the same time he is a bear, and thus dangerous. His fur looks dry, though it is obviously wet. He is captive and yet perhaps also, metaphysically, somewhat free. (Do we grant the bear a metaphysical consciousness? I do.) The photograph suggests the bear has internalized the contradictions of its existence, that he retains a nobility of spirit amid his deprivation.

I believe (and I think Jaschinski believes) that it is wrong for us to see the bear in the way we are seeing it, in a zoo, or even in a photograph from a zoo, and yet it is also mesmerizing. Is the bear as fascinated by his spectators as we are of him? What does he think of us? We cannot know. The energy that Jaschinski's image conveys is both profound and profane. The longer we regard this bear, if we learn anything, it is how much we *cannot* know.

Our relationship with nonhuman animals is rich, intricate, and troubled. People are fascinated by animals and respond to them in ways that are at times full of homage and awe, and at other times oppressive and perverse. We are prone to appreciate, or to fetishize, animals in isolation as discretely framed specimens (in a zoo, or as a pet, or a meal, or a toy) distanced from their groups, alienated from their contexts. But still they are there, all around us. The images Jaschinski presents – shocking, disturbing, fascinatingly engaging – sometimes make me feel as if, despite the ubiquity of animals in our world, I have never really seen them before. Despite our extensive history of interaction with other animals, it seems rare for people to look at these creatures directly and honestly.

Jaschinski's photographs present strangely framed animals. What is wrong here? What is missing? Where is the viewer situated in relation to the subject? What is the connection between imagining and exploiting animals? What has the photographic aesthetic done – and what have *we* done – to capture, and to betray, these creatures?

Zoos are obviously bad for animals, cruel to animals, but beyond that, they are bad places for *people* to learn how we relate to the other

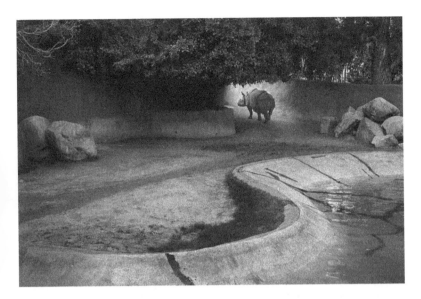

Figure 6 Indian rhinoceros, Los Angeles, Britta Jaschinski, *Zoo*

creatures with whom we share the planet (a point I develop at greater length in Chapter 6). Zoos are a case study of people's environmental short-sightedness or, less politely, people's environmental ignorance. On a micro level, these institutions themselves are undesirable; on a larger macro level, the institutional history of zoos reveals then as a vivid symptom of our anthropocentrically degraded environmental epistemologies. On the micro level, supporting zoos means kidnapping and tormenting and imprisoning animals, putting them in stinky boxes, and applauding ourselves for being so environmentally engaged. And on the macro level, after and beyond the experience of zoo-going, people behave like imperious emperors toward the rest of the world, over-consuming, unsustainably harvesting plants, animals, minerals, oil, land, and yet remaining in denial about our impact on the planet. Our disregard for animals, our displacement of them, betokens a larger environmental hubris, or blindness. Zoos promote sloppy, imperial animal-looking and animal-thinking, which generates a sloppy, self-serving, inauthentic environmental sensibility. To confront overarching questions about how people construct and interact with "the environment," a consideration of zoos offers a good ingress. The cultural history of the zoo is a history of human assaults upon other animals, and upon

the rest of nature. Zoo-going is a model of imperial exploitation of the natural world, and Jaschinski's first book of photography grows out of this consciousness.

Seeing zoos in Jaschinski's photographs makes the viewer feel shabby and somehow complicit in the tableau. People who have seen these photographs must find it difficult to go to a zoo afterwards. The more I look at these images and think about them, the more troubled and angry I get about how people treat animals and, more broadly, how we relate to the world around us. Jaschinski has worked extensively to document the sad and scary world of captive animals in zoos.

Her portraits of these animals are poignant and often pathetic. Dark, disjointed representations of creatures in concrete and metal compounds convey the displacement that characterizes their existence. Sometimes the animals are barely present in the frame. Sometimes there is no animal visible at all, but only a piece of a cage, or a dark and cold compound, or a scrubby piece of land that seems obviously alien to any zoo inmate.

Zoos exist because people want to make animals "convenient" – conveniently accessible and visible – but there is nothing convenient about wild animals. They are complicated, enigmatic, entropic. Jaschinski's photography embraces this complexity and subverts our urge to simplify and reduce their lives. She went to dozens of zoos to take the photographs in *Zoo*, entering into this "convenient" display, but she found the animals profoundly inconvenienced, which is what her photography conveys. Many of the images are simply difficult to see – unfocused, oddly composed – which rebuts the conventional expectation that an animal in a zoo should be easily visible. That is the rationale that zoos have created and embraced as a *raison d'être*: animals are difficult to see in nature, which is what supposedly justifies putting them in cages.

Jaschinski's images convey loneliness, alienation, displacement. A photograph of a Sumatran tiger (except it is not a Sumatran tiger any longer; now it is a London tiger) reveals the pain of an animal in captivity, the pathos of the situation, the injustice we exercise. The animal is still, silent, stuck. A pervasive human geometry defines the tiger's space. If we can infer any sense of emotion or sentience from the creature depicted in a room of sterile white tile, it is resignation, defeat, anomie. It is hard to imagine anyone responding ethically to this picture in any other way than condemning the voyeuristic mistake, the misvision, of the people who flock to look at this animal in this cage. What could they be thinking? What motive, other than sadism or *schadenfreude*, could be informing the spectator? People have a propensity for gawking

at subjugated otherness – for example in freak-shows or on reality television – as a way of reifying our own primacy. In the nineteenth century Londoners used to go to Bedlam (St. Mary Bethlehem Hospital) to stare at the lunatics. For a penny one could peer into their cells, and laugh at their antics, generally sexual or violent. Entry was free on the first Tuesday of the month. Visitors were permitted to bring long sticks to poke the inmates. In the year 1814, there were 96,000 such visits.

Jaschinski shows us that animals are misplaced, and displaced, in our sight lines. Her images strike the viewer as corrupted, badly cropped, weirdly focused, decentered, which evokes how people see animals in zoos and how little of the zoo animals actually endures. Her photography features individual animals in settings that are disorienting because they are unnatural. These animals are starkly alienated from their natural context. The aesthetic exacerbates viewers' sense of disorientation as we look at images that are grainy, or blurry, or silhouetted, or otherwise weirdly lit and brusquely framed.

In some ways, these photographs are portraits of animals, with a sense of connection to the subject. They show an insightful expression of the animal's identity and individuality and an almost devout fascination with the animal's spirit. But at other times they resemble mugshots: images of trapped and unhappy creatures at their worst moments of

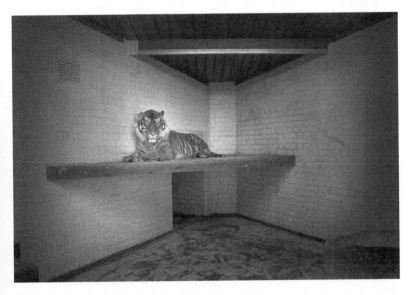

Figure 7 Sumatran tiger, London, Britta Jaschinski, *Zoo*

suffering, caught and fixed in the harsh frame of the image (and metaphorically evoking all the other sorts of frames people create for non-human animals). Paradoxically, sometimes a single picture may evoke these seemingly disparate sensibilities simultaneously: both a homage to the animal's nobility and an angry protest at his constraints.

These photographs provoke lots of questions and demand ethical responses, which Jaschinski means to provoke viewers to undertake for themselves rather than spoon-feeding us the proper answers. What are these animals doing as we look at the sliver of their existence that is frozen and framed in the moment of each photograph? What kinds of movements, instinctual urges, behavioral patterns are suggested in the picture? And more to the point, what sorts of movements, instincts, and behaviors are suppressed in these images? A large "negative text" pervades Jaschinski's photography. We are asked to see many things – habitat, activities – that are *not there*; we are confronted with their absence.

What are the animals thinking at the moment we "see" them in these pictures? Are the black macaques from the Chessington World of Adventures Resort, a zoo and theme park south of London, sad and confused? Are they stoic? Are they afraid? They seem to have, perhaps, a calm stillness, but this might be just because they are captured in a still photograph. What do they think about the place in which they find themselves? They belong in a tropical rainforest, not a cheesy amusement park on the outskirts of London. Probably they are thinking about the trees and sounds of where they are not. In another photograph, an Asian elephant seems to be thinking something along the lines of, "What the hell am I doing in Hamburg? How can I get out of here?!" As I look at a brown bear from the Münster Zoo, I cannot even venture a guess at what he's thinking; some thoughts do often lie too deep for tears.

Viewers are asked to confront our own relationship to nonhuman animals in ways that invoke the Foucauldian dynamics of power and visualization. Where are we positioned as we look at these animals? Where are we literally, physically, spatially? And also, where are we politically, in terms of our control over them? What happens to animals when we try to look at them through our own cultural frames? Why are we looking at them – what do we hope to see? Would we know if we saw it? Recall Ludwig Wittgenstein's assertion that "If a lion could speak, we would not understand him." What are we looking for? Are we looking at animals hoping to see something about ourselves? Our power over them? Our abrogation of their wildness as we have squandered our own

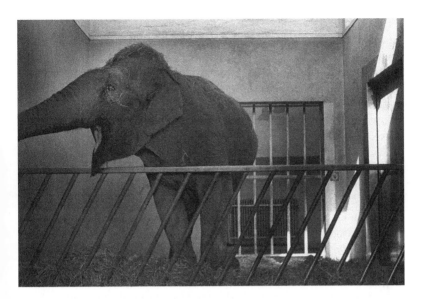

Figure 8 Asian elephant, Hamburg, Britta Jaschinski, *Zoo*

wildness? Our fixations on our own bodies, which we hope to salve, somehow, by looking at theirs?

Who speaks for these animals? Jaschinski does not presume to do so; none of us can. But her images, as we extrapolate their ethical implications, at least point us along the way toward imagining what these animals might think about their relationship with us: Who *are* these creatures, clothed and intrusive, staring, menacing, possessive? Why are they looking at me? How can I live with them? Or, how can I escape from them?

Perhaps all this is self-flattery, and the animals do not spend as much time as I imagine thinking about me, wondering about me. We cannot know – despite the claims of animal behaviorists – what is in their minds. We can train them to salivate at bells and play with language blocks, but we should not delude ourselves that this is the same as knowing what they are thinking. But while we cannot *know* who they are, that does not stop us from wondering. Jaschinski's photography brims with her own sense of wonderment at animals and inspires us to share in it. It taunts us, at times, with our lack of total power over their minds and lives. But also it inspires us to grapple with the force that draws us to these animals, again and again, however clumsily.

In Jaschinski's second book, *Wild Things*, animals more effectively escape the frames, the focus, the cages that people have imposed upon them for so long. These are "becoming-animals," following the concept described by Deleuze and Guattari. In *Zoo*, the animals are profoundly unbecoming: they cannot become. Becoming-animals possess intensity, dynamism. They are philosophically resplendent and fecund. They are transcendent, beyond boundaries, beyond frames, beyond cages. They move, they travel, they flock, along what Deleuze and Guattari call "lines of flight," embodying a process of life, of experience, of authentic being. The animals' becoming enables human insight, as the zoo does not – the zoo enables only oppression and constraint, which hinder insight. "Becoming" happens with movement, engagement, ecosystemic interactivity, which is the opposite of an animal trapped on a shelf in a cage.

Wild Things represents human imagination of animals that have action, not just form. It is not a mere imitation or representation of animals from a safe distance, but an interactive engagement with other species, in a space where both the human and nonhuman animal are enlightened and rewarded. The notion of "becoming-animals" helps us understand, when we see bad animals (not that the animals themselves are bad, of course, but animals to whom bad things have been done, animals who have been constrained), that we can characterize this as a lack of becoming, and, on the other hand, when we encounter cultural texts of animals in which the creatures may prosper beyond the bounds and frames in which people conventionally fix them, it makes sense to talk about these as a group as becoming-animals.

Jaschinski's latest project is called "Dark." The series offers an intriguing visual experience, compelling and confusing at the same time. On the one hand, it promises frank insight and a connection with nonhuman animals. On the other hand, the images are especially elusive and impressionistic, and they – both the living subjects, and the photographic images themselves – resist our approach.

Jaschinski has always worked to inspire her audiences to discover new ways of seeing other animals. Her photographs assert – by their stark contrast with conventional representations of animals – that although those conventional animal images are somehow comforting, or useful, or otherwise convenient for the human viewer, they are untrue accounts. Jaschinski is too humble to claim that her own photographs embody truth and authenticity, which are in any case dubious quantities in our postmodern times. But certainly they effectively challenge

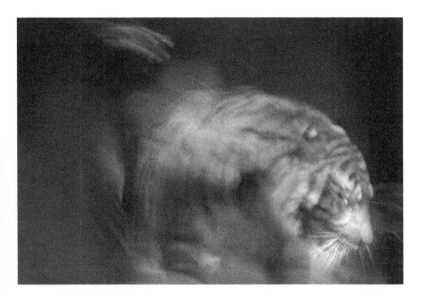

Figure 9 Tiger, Britta Jaschinski, *Dark*

people's unexamined presumptions about animals' subaltern role in our anthropocentric cultural fantasies.

Animals play a conscribed role, generally a subservient role, in the human imagination. But in Jaschinski's photography we may "meet" some of these animals as if for the first time, and we can start to learn who these animals really are. We see these creatures shorn of the cultural baggage, the frames and stereotypes, the fixed ideas that surround animals in our modern sensibilities. While it is hard to see Jaschinski's animals clearly in the "dark," we may reflect that, indeed, it is also hard to see them as we find them in the more common "light" of contemporary culture – to see them through the static, the distortion, the artifice of our world. Perhaps it *should* be hard to see animals clearly, because a clear line of sight from the human to the nonhuman animal facilitates our aggressive and exploitative assault on the animals' happiness and safety.

Like the subject of Marianne Moore's "A Jelly-fish," discussed in Chapter 1, in Jaschinski's dark photographs the animals quiver. The images are not static – they seem more alive, more active, than what we might think we would get from the fixed moment of a photograph. In the dark, these animals defy the sense of constraint that one would

expect to see in a "captured image." Their quivery presence radiates a sense of life. This animal life that we perceive dimly as we look at these photographs *may* embody – I use the tentative, conjectural construction intentionally, because we cannot know for sure – a sense of safety, control, wisdom, agency. It may, on the other hand, embody some sort of pain or fear. Probably it is some combination of these, and in addition other states of consciousness, at different times for all these different animals.

Some of these animals are more easily identified than others. The photographs portray an orangutan, two bears, a sloth, a lemur, a gibbon, three large cats. We see some details, some aspects of these animals' corporeal existence: teeth; a bushy pelt; ears. But much is also missing – context: parts of their bodies; their eyes, and the clarity we might have if we could see these animals eye to eye. There are hints, and we make inferences, of their movements, their consciousness, their existence in their own worlds. They are perhaps, in these images, listening for foes (or friends); or smelling for food (or something else); or preparing to spring (or flee); or resting peacefully (or anxiously). Again, we do not know for sure.

It is as if we have come upon these creatures in some realm (of nature – or magic – or consciousness – or aesthetics – or, let us say, a combination of all these) in which we are paradoxically blessed with some special eloquent sense of perception and at the same time denied full access, full experience. It is as if we have come upon them in the dark. Dark: obscure, unknown; hidden from view. According to the Bible, the dark of night is inferior to the light of day. Metaphorically, in Western enlightenment ideology, to be "in the dark" is to be in a state of ignorance, of intellectual or spiritual absence. The dark is supposed to be evil, foul, wicked, iniquitous, atrocious. It is gloomy, sullen, scary. Things are concealed, indiscernible, hard to understand. Note that it is easier for many other animals to see in the dark than it is for people, as animals may have "night vision." The idea of the dark is not absolutely alien or wicked for other animals, some of whom are nocturnal. The binary opposition of light/dark as good/bad is a human construct.

The medium of photography itself comes from the dark. Light imposes upon a dark surface, and then, in the dark, in a darkroom, elements of darkness are chipped away like the mass of stone that the sculptor removes to produce the ultimate artifact. The finished photograph offers form, color, light: light that has escaped from the dark. Jaschinski's creatures come from the dark into the light, at least a little, but mostly, they are still in the dark. Perhaps they like the dark, because

it offers them protection from the voraciousness of light, of day. If they are somewhat obscure, unknown, indiscernible in the dark of these images, so much the better for them. They preserve then some of their lives, some of their integrity, which would shrivel if we caught them in full direct light. Darkness may offer animals a degree of protection from the harsh spotlight of the human gaze.

* * * *

Jaschinski represents an ethically potent endpoint of animal photography, an aesthetically wrenched confrontation of animals in visual culture. Moving backward, I want to look now at the beginning of this tradition, the nineteenth-century animal photography of Eadweard Muybridge.

Before the animal- and human-motion studies for which he was best known, Muybridge had already achieved prominence with other photographic projects documenting the settlement of the American West. A spectacular overview of his career featured at Washington's Corcoran Gallery in 2010 (and subsequently in San Francisco and London) reminded audiences of his centrality and his fascinating achievements in the field of early American photography. A viewer who did not know anything about nineteenth-century American ideology, ambition, and development could deduce it all pretty comprehensively from this exhibition and the published accompanying catalog.

The Corcoran exhibition, "Helios: Eadweard Muybridge in a Time of Change," took its title from one of the several aliases that the photographer (who started out, in England, as Edward James Muggeridge) assigned himself. He signed his early work Helios, Greek for "sun," signifying the importance of light in his profession – photographs were sometimes called "sun drawings" – and also indicating his outsized ego. Photographs are comprised of a combination, a balance, but also a contest, of light and darkness. It is not accidental that the two photographers I focus on in this chapter, whose ethical relationships to their animal subjects are diametrically opposed, embrace in their aesthetics these opposite polarities: Muybridge is the sun king, while Jaschinski locates herself and her subjects in the dark.

Muybridge was a central figure in this "time of change" that the Corcoran exhibition's title denotes. He embodied America's geographical, industrial, and scientific evolution from a rough and immature upstart into the powerhouse it became since then. His stop-motion sequences, facilitated by technologies he created to document instant-

by-instant movements of living things, are the germ of cinematography. Thomas Edison, who met Muybridge in 1888 to discuss possible collaborations, conventionally gets credit for inventing moving pictures with his 1894 Kinetoscope. But Muybridge's earlier work provided the basic foundation, technologically and conceptually, for transforming still images into moving ones. The zoopraxiscope, or "animal action viewer," he invented to present moving images made him a pioneer. Fashioned out of crude wood and metal, gears and screws, it evokes a Rube Goldberg contraption, so unlike the sleek, compact design of today's cameras and iPads. But its improvisational quirkiness does not diminish its innovative brilliance.

"The Horse in Motion" (1877–78) was Muybridge's triumph. Periodicals worldwide published his astonishing images of the animal's gait. Indeed, some viewers found the photographs literally *incredible* documents of visual culture, doubting their authenticity. A tireless self-promoter, Muybridge attracted large audiences on the lecture circuit for many years, starring in his own venue, the Zoopraxographical Hall, at the 1893 Columbian Exposition in Chicago.

Lavishly supported by the University of Pennsylvania in the 1880s, Muybridge continued his motion studies with hundreds of subjects, human as well as nonhuman animals. The human tableaux (many nude) are rigidly gendered. The men are athletic and virile, boxing, running, working. Women sweep, dust, and scrub floors; as Marta Braun writes in the exhibition catalog, "they spend a remarkable amount of their time with cups, bowls, jugs, and vases."[1] Given the contemporary interest in phrenology, anthropometry, and eugenics, Muybridge's motion studies became data for the scientific and anthropological debates about the nature of the human body and the extent to which physiology determined the human condition.

But my anthrozoological focus here draws me to Muybridge's animals and inclines me to be suspicious of his perspective and his motives in capturing these creatures' animating force. If Muybridge's contextualization of his human models reifies the prevailing hegemonies of gender, his animal studies even more profoundly perpetuate the anthropocentric prejudice that other animals exist to serve our own higher purposes.

Some Native Americans believe that to take someone's image involves actual usurpation of the living spirit. Lucy Lippard's *Partial Recall* details the anxieties tribal people felt in the early twentieth century when white photographers came tramping through their worlds, turning the subjects into a kind of inventory. Their pictures turned up on

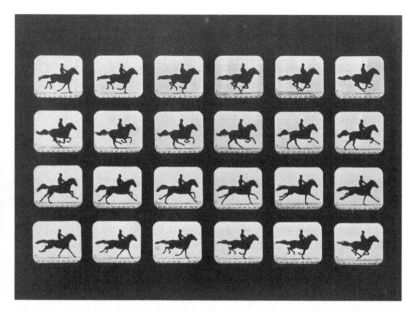

Figure 10 Eadweard Muybridge "Phayne L. Running Stride, 19 ft., 9 in., plate XVI" gift of Mary and Dan Solomon. Image courtesy of the National Gallery of Art, Washington

postcards with racist captions, or in government offices where visual evidence of "savage" costumes and rituals helped advance a genocidal agenda. Examining the colonizing power of photography – what Malek Alloula terms the "vivisector's gaze" – Lippard quotes Hopi photographer Victor Masayesva who "sees the camera as a weapon" that can "violate the silences and secrets so essential to our group survival."[2] Lippard explains: "Photographers were called 'shadow catchers' by some tribes (the shadow referring to death, or the soul of the dead). The transfer of a black-and-white likeness to paper meant to some that a part of their lives had been taken away, to others that their vital power had been diminished."[3]

I find similar incursions in Muybridge's animal pictures, which violate the secrets so essential to animals' survival. At first glance they seem innocuous enough. A horse running a course with 12 tripwired cameras, triggered by the wheels of the racing cart it pulls, crossed a track completing electrical circuits and thus recording its discrete changes of physiology from instant to instant. Leland Stanford, the mogul who was Muybridge's patron, wanted to discover whether all four legs of a

horse leave the ground in a gallop. The naked eye could not discern this, so he hired Muybridge to find out.[4] (They do.)

The plates show a faint sense of motion, though hardly noticeable, in the horse's mane and tail. The torso, too, appears relatively still in the multiple images. It is the legs that draw our attention. A foreleg is straight as a pole in one shot, then half bent in the next frame, and almost impossibly tucked in under the breast in the following. The front and back sets of legs are identically coordinated in one frame, but completely different from each other, askew, in another. The complexities of locomotion – the biophysics, the spectacle of speed and energy – are frozen in each of these images, and recreated as the viewer regards the entire sequence.

People usually have an agenda when they engage animals, involving some literal or imaginative value they want to harvest from the animal. John James Audubon's oeuvre typifies this cultural exploitation. In his encyclopedic quest to paint every native bird, he killed thousands of them, since they are, of course, easier to paint if they are not flying around. *The Birds of America* was a stunning and lucrative achievement for Audubon, though less beneficial for the titular creatures. Part of Stanford's agenda was improving the competitive performance of his beloved stable. In an anticipation of bioengineering, Stanford believed a deeper understanding of equine locomotion would help him breed faster racing horses. More intricately, Philip Brookman suggests that another motivation for dissecting the details of *animal* locomotion was to propagandize for the controversial enterprise of *mechanical* locomotion, that is, the railroad.[5]

Stanford was a kingpin in the Central Pacific's transcontinental railway, which had been completed with the famous ceremony of the golden spike at Promontory Summit, Utah, in 1869. Some lauded the achievement that dramatically quickened travel from New York to San Francisco. The train journey of under a week replaced an 18,000-mile sea voyage around South America. Ralph Waldo Emerson praised the railroads' expansion, thrilled that distance had been "annihilated." He foresaw a national American cultural assimilation that would efface provincialism – "local peculiarities and hostilities" – and offered Americans "increased acquaintance...with the boundless resources of their own soil."[6]

But others were wary of the steam engine, which was frequently caricatured as a fiery dragon. Its noise and smoke offended sensibilities, as did its intrusive effect on the landscape. Forests were felled to stoke its engines, consuming vast resources. Some believed that human beings

simply were not meant to travel at the inconceivable speed of 35 miles per hour. And there were fears, which we can now appreciate as completely valid, that the railroad network would engender a homogenized and hyperindustrialized national culture.

Muybridge was clearly an apologist for the railroads. Landscape shots of tracks running through Western mountains are composed to evoke an elegant formal balance, not a disharmony, between the rails and the land. His photographs of railroad sheds, tunnels, and trestles convey an industrial eloquence. But it is the horse motion photos that most cunningly advance this agenda. The horse, reimaged as a machine, became "a powerful metaphor for the escalating transportation markets and accompanying industries that Stanford controlled," Brookman writes. "The implied equation between the mechanics of industry and that of nature linked the speed and power of the locomotive to the gait and beauty of the racehorse." (Central Pacific engineers helped Muybridge develop the technical foundation for "The Horse in Motion.")[7]

In his earlier career, too, Muybridge used photography to abet the dominant expansionist sensibilities of the time. A series of time-lapse photographs of the construction of the San Francisco Mint from 1870–72 – anticipating his interest in watching how a physical form advances through time – celebrates the imposition of neoclassical federal grandeur in the "Wild West." An 1875 tour of Central America (for which he became Eduardo Santiago Muybridge) generated pictures of coffee plantations as agricultural industry in all its stages of production. Besides offering another foreshadowing of Muybridge's interest in breaking down an activity into its constituent parts, as the motion studies would do, the photographer, Brookman writes, was "most interested in conveying the image of profitability in a land of promise and tranquility, a stand that upheld the colonial character of his patronage."[8] The Pacific Steamship Company, Eduardo's sponsor, stood to profit from increased trade in the region.

When the 1868 purchase of Alaska, known as "Seward's Folly," proved unpopular, the government sent Muybridge to record its splendor. He sailed to Sitka in the month that Congress bought the territory, returning with photographs of the coastal landscape, native peoples, and new American military installations that convinced audiences of Alaska's spectacular value. Another commission sent Muybridge traveling with the army in 1873 to the Lava Beds at Tule Lake in Northern California, where the Modoc tribe was fighting for its survival. His photography served both to document the harsh landscape to aid army maneuvers in the area, and also to suggest "mission accomplished," although the

campaign was not in fact progressing well. One photograph, of a Native American military scout "lying in wait for a shot," falsely identified the man as a Modoc brave, indicating Muybridge's willingness to deceive viewers. (He frequently retouched photographs. Sometimes, if a negative was dark due to underexposure, he painted a moon on it and pretended it was night.)

Muybridge's oeuvre celebrates the brash, vast execution of American expansion, and the domination of the landscape. In images from the California coast and Yosemite Valley, Muybridge celebrates the stature of nature, giving viewers a tantalizing new perspective, and implicitly surveying it in preparation for colonization (involving removal of troublesome Natives), industry, transport, and urban development. A pious admiration of nature resonates in his photography, though if a tree hindered the desired composition he would cut it down.

His animal images are in keeping with that perspective. Muybridge's photographs starkly alienate animals from their natural context, exuberantly reframing them in his own amazing new technological discourse of visual culture. The animals appear against a backdrop of numbered scales and grids, the more convenient to chart and graph them. It is undeniably fascinating to see these birds, boars, greyhounds, oxen, bison, and horses move, to see how each individually captured stance combines to reveal the flow of motion. And if it is stunning today, imagine how much more amazing it must have been in its own time. Viewers were shown something that they had seen but never seen. It must have seemed miraculous. But do these images displace the actual movement of the actual horse? Have we taken motion from the animal? Having penetrated the animal's secret, its force of speed, do we exert some kind of control over it?

The animals are curiously reduced, caught in the mechanics, the physics, of photography. They are comprised not of flesh and blood and hair, but of silver albumen and paper. There are so many of them in the hundreds of motion studies that after a while, we cannot really see them at all. We certainly cannot hear them, or smell them, or feel (as we do in proximity to a real horse) awesomely dwarfed by them. Broken down by Muybridge and his apparati, they do not do anything but run and run. Their force and motion no longer seem their own, but Muybridge's, and ours. Something of their nature has been trapped, isolated, and abrogated by the viewer. Although the human viewers learn much more about the horses, I believe the horses themselves lose something in this transaction.

A contemporary review in *The San Francisco Call* confirms that Muybridge's audiences believed they were seeing "apparently the living, moving horse. Nothing was wanting but the clatter of the hoofs upon the turf and an occasional breath of steam from the nostrils to make the spectator believe that he had before him genuine flesh and blood steeds."[9]

Rebecca Solnit, in *River of Shadows: Eadweard Muybridge and the Technological Wild West,* describes Oliver Wendell Holmes's sense of how "photographs of the material world seemed to eclipse their subjects." In an 1859 essay, Holmes wrote: "Give us a few negatives of a thing worth seeing, taken from different points of view, and that is all we want of it. Pull it down or burn it up, if you please…. We have got the fruit of creation now, and need not trouble ourselves with the core."[10] In 1977, art critic John Berger wrote in "Why Look at Animals?": "The image of a wild animal becomes the starting-point of a day-dream: a point from which the day-dreamer departs with his back turned." Once we have the picture of something, that thing itself loses its value to us. Berger writes of the "reduction of the animal."[11]

In a similar vein, Anat Pick describes the correlation "between diminishing wildlife and animals' enhanced visual presence. Fussed over, tagged, screened, projected, and surveyed, exhibited, simulated, incarcerated, conserved, even manufactured and invented, nature and animals are gaining an exclusive kind of cultural visibility" (105), which is to say that as culturally framed animals are becoming ubiquitous, they are overshadowing and overwhelming naturally framed animals.

Walter Benjamin, in his 1936 essay "The Work of Art in the Age of Mechanical Reproduction," writes that "the reflected image" technology offers "has become separable, transportable. And where is it transported? Before the public."[12] Extrapolating Benjamin's analysis, I continue: *From* what has the image been separated? From the animal.

Audiences were, and still are, inclined to value simulacra above reality. The ability to create and present such images highlights the brilliance of technology as it impinges upon the relevance of the original object itself. Horses are expensive to keep, and they will die, but the image of the horse is conveniently possessed and reproduced infinitely. Over the coming decades, the same phenomenon occurred in other media. Recorded disks replaced symphonies, and a silver screen supplanted the presence of real human performers in drama. Nineteenth-century Americans, enabled by those railroads that Muybridge celebrated, chopped up animals not just visually but also corporeally,

removing them from people's proximate experience and repackaging them, stripped of their own animate integrity and transformed into artifacts for human consumption. The meat-packing industry relocated hogs and cattle from ubiquitous local farms into more isolated production-line Midwestern slaughterhouses, where their carcasses were efficiently converted into standardized cuts of meat that were transported across the country.

The commodification consequent from nineteenth-century factory farming bears an ideological affinity to the dissections of Muybridge's motion studies. Did Muybridge's animals suffer pain as they moved past his lens? At least one did: sadistically, the photographer set a Philadelphia zoo tiger loose on an old buffalo to record a motion study of an actual killing. Many of Muybridge's specimens came from the zoo, so they were already displaced. The bottom line is that animals caught in the sight lines of technological innovations suffer for the encounter, as people come to devalue the integrity, the inherent and authentic animality, of creatures who get sucked into human culture.

Muybridge keenly influenced other artists from his own time to the present. Edgar Degas, after seeing Muybridge's photographs, realized that he had been painting horses incorrectly and revised his subsequent representations accordingly. Thomas Eakins, who befriended Muybridge in Philadelphia, conducted his own motion studies and his nobly sculpted horses, too, reflect Muybridge's insights. Marcel Duchamp's 1912 painting, *Nude Descending a Staircase, No. 2*, obviously reiterates Muybridge's technique, as the single figure takes on a multiple presence through the sense of sequence and motion.

Francis Bacon explicitly invokes Muybridge in many paintings, such as his 1961 *Paralytic Child Walking on All Fours (From Muybridge)*, which represents one of the most disturbing motion studies Muybridge conducted. Brookman finds inscriptions of Muybridge's imagery in *The Matrix* and in U2's music video for "Lemon," and I also see connections to Andy Warhol's multiple silkscreens of Marilyn Monroe, Campbell's Soup, and other subjects. In Philip Glass's entrancing 1982 music-drama *The Photographer,* sequential reiterations of pulsing musical phrases parallel Muybridge's motion studies, images from which are projected on background screens. In all these cultural productions we are doused with the fecundity, the infinite expansion, of a single concept – a horse, a chord, a nude, a can of soup. Muybridge realized, and these later artists confirmed, that audiences crave more – more detail, more dynamics, more dimensions. One horse becomes twelve horses, though it is still

the one horse (*e pluribus unum*), but with a twelve-fold "improvement" of our cognitive experience.

Certainly, on some level, this profusion of sensory data has the potential to enlighten us. I am in the knowledge business, after all, and inclined to affirm that greater understanding is good. But when epistemological technologies such as Muybridge's engage nature, too often the interaction is a zero-sum game. More knowledge for us means less for the "victims" of our knowledge. Animals are worse off, more encroached upon, than they were at some time in the past – let us say, in the time before the invention of photography, film, and all these other media that so voraciously generate the visual cultures that compete with, and come to overshadow, natural cultures. Equitable and ecologically intelligent engagements with animals emanate from societies that treat their cohabitants well, and "animal-positive" cultural texts encourage continued good behavior. But representations that imaginatively or literally rip animals out of their worlds and resituate them as subalterns, or fetishes, or "resources" in our world, spell trouble for our furry cousins. Muybridge's complicity in his era's expansionist and industrial fantasies means that his photography was ultimately destructive to the animals he so keenly observed. In seeing a horse as a vehicle to make railroads more palatable, he undercut the horse's essential horsiness.

4
Film Animals

No animals were harmed in the making of this book.

That may seem like a trivial claim. It is probably not even true, considering the habitat damage caused by emissions from the electricity plant whose turbines power the computer I used to compile these ideas, and the trees harvested to produce the physical object you are holding. But if I can have the benefit of the doubt, I would like to suggest that simply writing about other animals *may* engage them in a way that leaves them none the worse off for the encounter. And this harm-neutral encounter is an improvement over the usual state of affairs. Our imperious presence, our industrial infrastructure, our social networks, and our cultural activities encroach upon the safety and integrity of other species.

People imprison and torture animals in factory farms, research laboratories, and pet stores. We displace them as our cities and suburbs expand. We poison them as we dump toxins into their food-ways. But even when we take a break from such active physical assaults, we are prone to engage with animals in ways that hurt their spirits and impinge upon their welfare. The consequence of most human–animal encounters is the expression of harm via the pathways of power.

For decades, the American movie industry has taken the initiative to assert and verify the converse: that is, many films carry a disclaimer in the credits stating, "No animals were harmed in the making of this movie."

It is a pleasant thought, so common that we may not even notice it or think about how and why animals *might have* been harmed in the making of a film. The certification comes from the American Humane Association's (AHA) Film and Television Unit, which sponsors animal safety monitors on film sets to ensure adherence to its guidelines for

the treatment of animal actors. The AHA began monitoring the safety of animals after an outcry provoked by Henry King's 1939 film *Jesse James*, in which a horse was forced to leap to his death from the top of a cliff. In the process that has evolved since then, the association reviews scripts preproduction and enjoys unlimited access to the set during filming that involves animals. The phrase "No animals were harmed in the making of this movie" was first used in 1989, and has since become a registered trademark.[1]

Some films, not many, are deemed questionable or unacceptable. Here are a few examples of what a film might do to get an unacceptable rating: In Ruggero Deodato's *Cannibal Holocaust* (1979), a documentary team journeys to the South American jungle to search for cannibals. During the making of this film, an opossum was slit with a knife; the shell was ripped off a turtle; and a monkey had the top of its head sliced off. Francis Ford Coppola's *Apocalypse Now* (1979) was found unacceptable because a water buffalo was hacked to pieces. In Robert Bierman's *Vampire's Kiss* (1989), star Nicolas Cage admitted in print that he ate two live cockroaches during the filming, earning that movie an unacceptable rating.[2]

AHA acknowledges that its seal of approval may appear in movies with scenes that seem to convey an attitude that "cruelty to animals is okay." Their purpose, they explain, is "to safeguard animals on-set, regardless of whether the scene being portrayed conveys an animal-friendly message. The objective of our monitoring work is the welfare of the live animals used in film production, and to that end, we refrain from commenting on content. If we refused to monitor a film because we did not agree with its message, we would risk there being no protection at all for the animals involved."[3]

Indeed, some approved movies contain extremely violent scenes with animals. The Humane Association explains: "Filming techniques, controlled stunts, special effects and post-production editing can make complicated battle scenes appear realistic without injuring animals or human performers…. Animals used in filmed entertainment are well-trained to perform specific stunts (such as falling down on cue), and the rest of the illusion is created by the filmmakers."[4] So even AHA assurance that no animals were harmed does not protect against a rhetoric of violence and cannot guarantee an ethically palatable expression of visual culture.

Given this campaign to monitor animal welfare in the film industry, one might reasonably assume that there is a proclivity to harm animals in the movies, a proclivity for audiences to watch the harming of

animals – and thankfully, there is a watchdog organization that works to mitigate this harm. But why might filmmakers want to harm animals in the first place? And, more broadly, what do audiences want to see when they are looking at animals in films?

Animals in visual culture are often disguised in some way – costumed, or masked, or distorted, or disfigured. Mockery of animals is another harbinger of disguise, as is decontextualization. These are all disguises because they prevent us from seeing the authentic animal beneath the cultural frippery. Animals are disguised perhaps because the authentic animal would be too depressing, or too scary, or too boring, for the viewer to endure.

There is a continuum of integrity, or respect, that audiences and cultural creators accord to animals in visual culture. Toward the bottom end of this continuum, there are dancing bears, rabbits pulled out of hats, chimps on parade, stupid pet tricks, and so forth. That is: animals doing silly things for the audience's amusement – things they do not usually do, and have no reason to do. Perhaps viewers are so engrossed in these vaudevillian farces because people are ashamed to look animals in the eye, ashamed to confront what we have done to them. We do not like to think much about wild, natural animals because we have just about extinguished wildness and nature. We prefer our animals framed, domesticated, dressed up for our spectacles.

Even further down the spectrum at this endpoint of the continuum, there are "crush films": amateur sadistic/fetishistic pseudo-pornographic footage of erotically costumed women stepping on insects, mice, cats, crushing them in stiletto heels. *Smush*, by Jeff Vilencia (1993), one of the best known in the genre, is an eight-minute long film depicting a woman sometimes in high heels and sometimes barefoot crushing dozens of earthworms.[5] "Among the many obscure and bizarre sects of fetishism," writes Jeremy Biles in "I, Insect, or Bataille and the Crush Freaks," few remain so perplexing or so underexamined as that of the "crush freaks." At the cutting edge of the edgy world of sexual fetishistic practices, the crush freaks are notorious for their enthusiasm for witnessing the crushing death of insects and other, usually invertebrate, animals, such as arachnids, crustaceans, and worms. More specifically, crush freaks are sexually aroused by the sight of an insect exploded beneath the pressure of a human foot – usually, but not necessarily, a relatively large and beautiful female foot…. The crush freak typically fantasizes identification with the insect as he or she masturbates, and savors the sense of sudden, explosive mutilation attendant upon the sight of the pedal extrusions. Jeff "The Bug" Vilencia, the foremost

spokesperson for crush enthusiasts, describes his ecstasy thus: "At the point of orgasm, in my mind all of my guts are being squished out. My eyeballs are popping out, my brain comes shooting out the top of my head, all my blood squirts everywhere…. What a release, that imagery really gets me off! Seeing that foot coming down on me, coming into my stomach and pressing all that weight on to me till I burst! Wow!"[6]

At the extreme, a crush film represents one possibility, one disturbing example of how some people look at and perceive animals in visual culture. But the capacity for extreme violence toward animals lurks throughout our visual cultural appetites and fantasies, and perhaps the literal harm enacted upon animals in crush films is not so fundamentally different from the figurative harm visited upon so many other animals in visual culture as they are "crushed" by being rendered inauthentic.

But while most harm meted out to animals in movies is not so blatant, still, the fact that so many animals are denatured, enmeshed, and victimized in so many diverse media – while at the same time we are facing mass extinction of species around the globe – raises deep psychological and ethical concerns. Is this obsession with having animals disguised and demeaned in film, television, and YouTube a compensation for all the animals that are not there any more in reality? A film clip of an animal, a parody of an animal, a meme of an animal, all seem to carry more prominence in visual culture, and in our collective consciousness as consumers of visual culture, than real living animals. The actual creature is displaced by a caricatured and objectified entity.

Visual culture increasingly blocks out the world beyond-people: the world outside, the world of forests and fields and water and fish and squirrels. Billboards get bigger and brighter, more profuse, more electronic and dynamic, obfuscating more of the landscape. Cyberspace becomes more addictive, more compulsory, luring our gaze away from nature. Computers and HDTVs and iPods and digital cameras and DVRs and GPSs and cell phones, with their little green and red lights and chimes and vibrations that are *always on*, consume more energy, generating more of the toxic garbage that endangers habitats and decimates animal communities.

All these beeping, blinking, omnipresent media supplant a direct engagement with the natural world and its creatures. They mediate the contact between people and our environment, and we become entranced, hypnotized. In a textbook example of hegemony, the dominant media reinforce their own power at the expense of our engagement with the world beyond the screens. A panoply of *monitors* (as

the screens are called, with a darkly accidental Foucauldian/Orwellian irony) fills our homes and offices, monitoring our attention to the infinite realms of digital content accessible via these portals, and screening out the corresponding diminution outside. Undigitized creatures (that is, actual animals) are haplessly flailing at the margins of this brave new world. The simulacrum-animals – that is, the animals on parade, animals in disguise, animals in visual culture – proliferate *ad infinitum*, *ad absurdum* inside the framing monitors. In doing so, the simulacra usurp much of the space we might have allocated in our minds to the consciousness of real, living animals.

In "Visual Pleasure and Narrative Cinema" (1975), Laura Mulvey defines what she called the male gaze. She argues that the viewer at the movies is in a masculine position (and quite possibly a voyeur or a fetishist as well), deriving visual pleasure from a dominant, sadistic perspective. The object on the screen is the object of desire – paradigmatically, the objectified woman. Viewers are encouraged to identify with the protagonist, who is usually male, and female characters are there simply "to-be-looked-at." She writes: "The determining male gaze projects its phantasy on to the female form which is styled accordingly."[7]

The gaze directed at animals in visual culture keenly parallels Mulvey's formulation of the male gaze. Call it, instead of the male gaze, the *human* gaze, and replace woman with "animal." In so doing, I think about Carol Adams's association between the oppression/consumption/disembodiment of women and that of animals. She and other ecofeminists have shown how the exploitation of women and the exploitation of animals occur along similar pathways. It is a smooth extrapolation to characterize Mulvey's male gaze (upon the filmed female creature) as a human gaze (upon the filmed animal creature). Mulvey describes "The image of woman as (passive) raw material for the (active) gaze of man,"[8] and I simply transpose this to characterize the image of the animal as passive raw material for the active gaze of the human.

The phenomenon of looking at animals in visual culture is predicated upon the assumption that the viewer is human and the object is animal. This is perhaps not a particularly profound observation in and of itself, but, thanks to Mulvey's work we realize the political import of this construction. The practice of consuming visual culture embodies an unbridled omniscient lust ensuring the visual object's absolute subalternity. The animal is rendered vulnerable, free for the taking, in whatever way the human viewer chooses.

Feminist critiques showed how women under the male gaze were profusely objectified, essentialized: two-dimensionally caricatured in

a good girl/bad girl dichotomy, angel/whore. Nonhuman animals, too, are cast in this mode. In the movies the angels, the good animals, are pets and helpers who adulate their human keepers, including such stars as Lassie, Flipper, Old Yeller, Sounder, Elsa, Rin-Tin-Tin, and Francis the talking mule. The whores are monstrous others, animals who earn our scorn, and who serve the purpose of allowing people to satiate our sadistic drives toward animals by hating or destroying these creatures. Think of King Kong; the shark in *Jaws*; Ben the rat in *Willard*; Orca, the killer whale; Alfred Hitchcock's birds.

This kind of objectification is dangerous not only because it is out-moded from a scientific and social perspective, but more fundamentally because it is reductionist. It circumscribes animals' existence in relation to the human gaze, appraising them only in terms of their usefulness or threat (to us). Such a perspective confounds an ecologically ethical ideology in which all members of an ecosystem are interdependent and no single species is inherently privileged above any other.

The animals we look at in film, on the Internet, in advertisements, are prized for their cuteness – in a way that is feminized, and deroga-torily so. Cute animals are like "dumb blondes," and again, note the parallelism between the male gaze and the human gaze. Animals are celebrated for their subservience, their entertainment value, and the extent to which they affirm an anthropocentric ethos: the unassail-able conviction that it is all about us. House cats, dogs, pleasantly furry sheep, and symbolic creatures like the American Bald Eagle rank high in this cultural economy. Pigeons, carp, cockroaches, starlings, and feral cats do less well.

We may pay lip service to the independence and rights of animals in visual culture, and films like *Born Free, Free Willy*, and *Finding Nemo*, about animals' deep-seated desires for self-determination, illustrate such higher instincts. But this noblesse oblige is all conditioned by our own desires and emotions. The point of the film animals' freedom seems largely motivated by the vicarious experience we enjoy of our own sense of freedom while watching them. Audiences may try to tap into and connect with animal otherness, as in the old *Tarzan* movies, and more recently, in films like *Whale Rider, Horse Whisperer, Dances with Wolves*, and *Grizzly Man*, though still we are much more interested in ourselves than in them. Such interaction is finally just another way of harvesting something from the animal object.

Note the titles of all these movies, which purport to offer (and in some ways *do* offer) intricate portrayals of human sensitivity to ani-mals. They all, at first impression, *seem* to highlight animals. And while

there are indeed animals in all of them, in each case what might have first seemed like an animal reference actually turns out to be a human being. Timothy Treadwell is the Grizzly Man in Werner Herzog's odd 2005 documentary. Kevin Costner's character, an ex-Civil War officer who escapes into the nature of America's Western frontier, is given the name "Dances with Wolves" as he becomes enchanted with animals and Native American culture in the 1990 film he directed and starred in. A twelve-year-old Maori girl is the whale rider in Niki Caro's 2002 film adaptation of Witi Ihimaera's 1987 novel. These characters develop alongside animals, but they are still ultimately very much human identities. The human beings trump actors of other species, who are merely supporting cast, swimming or galloping in the background. When people look at animals, what we see most clearly with the human gaze, is, unsurprisingly, ourselves. Mulvey makes a similar point about the objectified woman: "What counts is what the heroine provokes," she writes. "In herself the woman has not the slightest importance."[9]

In visual advertising, the human gaze reveals an explicit commodification of the animal, but it is really just a more blatant iteration of all the other animals we look at. Morris the Cat, Charlie the Tuna, Joe Camel, the MGM Lion, Toucan Sam, the Energizer Bunny, the Budweiser Clydesdales – all these animal images are designed to advance consumer culture, to co-opt a perverse sense of biophilia (our connection to nature, our need for nature) in order to encourage us to do things that do not really help animals in any way, nor help us understand animals, nor help us understand our relation to them. The animals are merely props, and as we pimp them in the discourse of visual advertising, they are hoist with their own petard, victims of their own animality. Charlie the Tuna adorns the outside of the StarKist tuna fish can, eagerly inviting you to eat him. Smiling pigs on the sides of barbeque joints pose happily, without a touch of resentment, encouraging customers to order up a plate of ribs. These animals are figuratively devoured by the human gaze as an anticipation of their subsequent literal consumption.

Indeed, in visual culture we are deluged with images of animals that do not call out to our higher ecological consciousness. Instead, these images affirm received ideas. Animals are ubiquitous, interesting, and engaging under the right circumstances – and we must coordinate these circumstances ourselves, as we do in all these movies and ads. Left to

their own devices, animals would not naturally serve our purposes, nor make a very strong claim on the human gaze.

This human gaze has been trained on animals in visual culture for a very long time. Certainly Eadweard Muybridge's career, discussed in the previous chapter, tapped into this proclivity. And, I must note, Muybridge would have not qualified for the Humane Association's seal of approval: animals *were* harmed in the making of his visual displays. Derek Bousé in *Wildlife Films* describes Muybridge's photographic record of a tiger killing a buffalo as the beginning of a tradition in wildlife films of "kill scenes" that serve as a "guarantor of authenticity."[10]

In any case: more than 130 years after Muybridge's zoopraxiscopic technology, we are lately looking at more and more animals – as there is more porn on the Web, there is more animal porn. As YouTube proliferates, there are more amateur videos of animals, infused with an "amateur" (that is, minimal) sense of interspecies ethics. As branding increases, so do branded animals. As cable television expands, we get more channels such as the Discovery Channel and Animal Planet, which claim, perversely and oxymoronically, to be programming "reality tv" about animals. But "reality" and "television" are contradictions in terms. Animal Planet facilitates and expands our consumption of animals, culturally and otherwise, but it does not bring the people who look at animals any closer to the reality of these animals.

Certainly it is possible for visual media to teach us about animals – a documentarian, or even a mainstream feature filmmaker, may spend years gathering footage that insightfully depicts, with ecological accuracy and sensitivity, the lives of animals. I discuss some examples of such films below, films that go to where the animals live and look at them in their own habitats.

But nature films often impose a human narrative, a human cultural aesthetic, upon animals. The films may be flat-out deceptive, following in a rich tradition of nature-film fakery. Chris Palmer's *Shooting in the Wild: An Insider's Account of Making Movies in the Animal Kingdom* details the contrivances and deceptions that are common in the industry, such as filming rented animal actors from a game farm and placing candy inside an animal carcass when the director wants to depict a feeding scrum. *White Wilderness*, Walt Disney's 1958 Oscar-winning documentary, includes a well-known scene supposedly showing lemmings committing suicide, jumping off a cliff to a watery death in the Arctic Ocean below. But animals were sadistically harmed in the making of

this movie. The lemmings were actually thrown off the cliffs by the filmmakers – which took place in a river near Calgary, not the ocean – as revealed by a 1983 Canadian Broadcasting Company documentary called *Cruel Camera.*

Even when there is no explicit attempt to deceive, still nature films may mislead and miseducate viewers by making animals seem too accessible, too easily present, which distorts the reality that most animals prefer to live hidden away from us. Animals' reclusiveness is self-protective, and our intrusion, even via the mediation of a documentary film crew, may breach an important barrier between ourselves and many other animals. For example, Luc Jacquet's *March of the Penguins* (2005), about the emperor penguins' annual journey to their breeding ground, and Jacques Perrin's *Winged Migration* (2001), a stunning account of birds' global journeys, are two beautiful and eloquent films about the lives of animals who live far from the world that most of us inhabit. As captivating as I found both these films, still, I wonder if it is right for us to see such lives: if somehow the human gaze in any form, however carefully exercised, still inevitably enacts human power over other animals, leaving them, thus, powerless. Are viewers reaping awe from these film animals just as Muybridge did in his animal motion studies? Millions of people have seen these films, crossover blockbuster hits. This testifies to our increasing interest and concern for other animals, but it also raises the question of whether we have dragged these creatures down to the level of mass entertainment, which trends anti-ecologically.

In *Green Cultural Studies*, Jhan Hochman warns that a nature film may render viewers "separate and superior to film-nature even as it brings them into proximity. Nature becomes, then, prop(erty) and commodity."[11] As physics teaches us, the act of observation changes the phenomenon being observed. And as Foucault theorized, vision facilitates a power that the seer exercises over the seen. I refer to these films as "Luc Jacquet's *March of the Penguins*" and "Jacques Perrin's *Winged Migration*" – the fact of human ownership and control over these animal images is inescapable. To restate the obvious, people make these films, and people make money from making these films. People watch these films. Where, in this nexus, does the animal come in? Do the animals profit in any way from this interaction, from the human gaze? Can they? Should they? Even if no animals were harmed in the making of these movies, is that the best we can hope for? Were any animals *helped* in the making of these movies?

In *Watching Wildlife*, Cynthia Chris writes, "The wildlife film and television genre comprises not only a body of knowledges but also an institution for their containment and display, similar to those institutions that Michel Foucault described as heterotopias, which through their collection of normally unrelated objects, life forms, or representations expose visitors to worlds beyond their own reach." Heterotopias are real places, places that do exist – in contrast to utopias, which are idealized and unreal. A heterotopia might be a botanical garden, for example, or a zoo, or a theatre, or cinema. But "the knowledge within the heterotopia," Chris writes, is "selected, framed, edited, and interpreted, according to an array of social forces and cultural contests over meaning," and these places are "absolutely different from all the sites they reflect and speak about."[12]

> Turning on the television any day, one might flit from views of sharks off the coast of southern Africa to polar bears in Manitoba, rattlesnakes in Florida, crocodiles in Queensland, and pandas...in Sichuan Province. The images of animals and their habitats, natural or artificial, found through television, are representations of real places and the creatures that live there, but they are "absolutely different" from those real sites and their inhabitants, constructed as they are by conventions of representation...the economics of the film and television industries, and geopolitical conditions concerning the state of the environment.[13]

Anyone who has watched the wide array of nature films, television shows, and documentaries knows how many different styles and ideologies may be invoked to depict the animals that are framed within by human technology and human cultural prejudices. In *Reel Wildlife: America's Romance with Wildlife on Film*, Gregg Mitman characterizes a range of representations and misrepresentations of filmed animals. Disney's *True-Life Adventures* from the late 1940s was a prominent series that established many of the conventions for decades to come, which he calls, "a genre of sugar-coated educational nature films."[14] And even today, in our supposedly more enlightened and more ecologically attuned times, still, the Discovery Channel's *Wild Discovery* series has a "penchant for tacking happy endings onto tales of ecological disaster,"[15] Mitman writes.

Along the lines of how Cynthia Chris invokes Foucauldian heterotopias, Mitman explains that in many nature films "fabrication made

the line separating artifice from authenticity difficult to discern." He detects an inherent tension, a contradiction embodied in nature films. They "reveal much about the yearnings of Americans to be both close to nature and yet distinctly apart."[16] This gets at the crux of the problem, which I would identify as an ethical aporia: the problem of perspective, of positioning, of self-awareness. We do not know where we are in relation to other animals. We do not really know where we want to be, where we should be, in this relationship, which results in a fundamental inability even to formulate, much less resolve, the ethical dilemmas concerning our coexistence with other animals. Many other anthrozoologists have expressed variations on this key contradiction, this conundrum, that Mitman explains so succinctly here. We want to be in two mutually exclusive kinds of relationships at the same time – close to nature, and apart from it. How, then, can we hope to act ethically, if ethical reasoning is predicated upon knowing the precise actual truth, the single accurate reality, of where we are, who we are, at the moment we conduct our ethical deliberations?

Deep within the bunkers of capitalism, Hollywood productions look at animals in ways that are inflected by the economics of the mainstream film industry. In *Green Screen*, which examines nature in Hollywood films, David Ingram argues that the kinds of realism and environmentalist aesthetics that might best convey the stories of animals authentically and informatively are at odds with the genres and aesthetics that are Hollywood's forte.

Ingram identifies many pervasive Hollywood tropes that a mainstream animal movie is likely to embrace – such as the circle of life, the cult of pristine nature, man's domination over nature, the action plot (which may resist a perceived sense of passivity in nature), ecological Indians and the myth of primal purity, the imperial narrative, profoundly anthropomorphized animals, the therapeutic tendency toward environmental concerns – and he shows how images of animals are transmogrified to fit the Hollywood mold.

For example, in Michael Apted's *Gorillas in the Mist* (1998), the biopic about Dian Fossey's work with mountain gorillas in East Africa, Ingram compares the gorillas as Fossey describes them in her 1983 book – practicing "infanticide, masturbation, incest, fellatio and cannibalism" – to the animals in the movie who are "idealized figures possessing the redemptive innocence typical of the Hollywood wild animal movies."[17] The portrait of the human being (played by Sigourney Weaver), too, is "highly selective of the biographical and historical evidence available

on Fossey's life and work."[18] In the Hollywood film industry, Ingram writes, "environmental sensibilities are always likely to be moderated by its vested interest in promoting commodity consumption as a social good."[19] These films avoid questioning the central place that consumerism enjoys in American society.

The recent blockbuster *Avatar* (James Cameron, 2009) raises anew the question of how audiences view animals on film, and especially how changing technologies will inflect the cinematographic animal. In January, 2010, PETA honored *Avatar* with a Proggy (signifying "progress" in the animal rights cause) Award for Outstanding Feature Film. PETA cited the film's "inspiring message ... which stresses the interconnectedness of nature and the importance of treating all living beings, no matter how 'strange' or 'alien,' with respect and dignity." The organization highlighted "the movie's stunning special effects, which beautifully illustrate how unnecessary it is to subject animals to the stress of a film production." PETA senior vice president, Lisa Lange, stated, "We hope viewers will come away from *Avatar* with a new way of looking at the world around them and the way we treat our fellow earthlings."[20]

In response, the AHA issued a demurral in a press release titled: "Think 'No Animals Were Harmed'® in the Making of *Avatar*? You're Right. Think No Animals Were Used in the Making of *Avatar*? You're Wrong." They dispelled the presumption that computer-generated imagery (CGI) meant that actual animals were not involved in the filming. In fact, for the depiction of the six-legged horse-like creatures featured in the film, "motion capture technology" demanded the use of horses. People, too, were animated with the assistance of captures, as actors wore body suits that enabled computerized motion sensors to provide a template for gestures, movement, and expressions.

> But animals need to be "captured" differently because of their body shapes, fur and other characteristics. To prepare the animals for having their motion data recorded, trainers shaved small areas of fur or hair where the movements would be recorded, such as near joints and on the face. Velcro pads were attached to the shaved spots with a nontoxic, nonirritating silicone adhesive. White light-reflective balls were placed onto the Velcro to capture the motion data onto the computer.... Throughout the film, horses are seen outdoors standing or being ridden at a walk, canter or gallop. We also see people mounting, dismounting and falling off horses. These scenes were all filmed inside the capture studio. Horses were given ample room to

start and stop running.... For scenes in which horses appear to be near fire, trainers cued them to "dance" or act skittish or afraid – the horses were not actually agitated nor were they ever near fire.[21]

While AHA monitored these activities, still, they felt compelled to announce that real animals, if not harmed, were nevertheless used in the film production. Although it might be nice to imagine that CGI potentially obviates the demand for animals in films, this is not the case. The new technologies merely induce audiences – and even PETA – to presume the industry can transcend their historical record of animal use (and sometimes abuse).

The message of *Avatar* has received mixed responses from animal-concerned audiences. On a basic level, such viewers are inclined to applaud the film's moral that all nature is connected and people should not destroy habitats for profit. But the PETA blog also recorded some more critical resistance. Several commentators objected to what they judged as the hypocrisy that while the film's protagonists, the Na'vi humanoids, conveyed an ecological sensitivity toward habitat preservation, they simultaneously engaged in the domination and consumption of animals, aggressively controlling the will of flying creatures and killing other animals for food in a brutal hunting scene. As one blogger wrote,

> Jake's avatar and Neytiri shoot an arrow through an animal's larynx, finishing him off with a knife to the throat. Just because they say "it was a clean death," add some mumbo jumbo prayers right after, acting as if they did it out of "respect to animals," does not make it any less cruel and unnecessary. The Na'vi do not mentally "become one" with the creatures they plug their organic USB in, they literally brainwash them. I say this because if there were actually some kind of symbiosis involved the animal would have its say. And it doesn't. It just blindly follows everything "the rider" tells it to do.[22]

And Stephanie Ernst, writing on an animal rights Web site, argues that the film suggests "humans have the right and the duty to dominate, 'tame,' and make use of animals – that nonhuman animals are resources and tools."[23] Ernst is especially offended by Jake's interaction with the pterodactyl-like animals, which she finds "chillingly reminiscent of a rape scene." The Na'vi protagonist Neytiri, tells Jake that to become a

complete warrior in her culture (as he aspires to do) he must choose one of these "ikran" as his own.

> He will know the ikran he is meant to bond with on sight – and he will know that the ikran chooses him too if the ikran fights back and tries to kill him ("no means yes" and "she'll fight you, but you know she really wants it," anyone?). It is Jake's duty, while the animal fights him off, to "bond" with the animal by overpowering him, tying him up, climbing on top of him, and inserting a part of his body into the body of the animal while his victim desperately fights him off. Once he has done that, once he has successfully dominated the animal and physically inserted himself into his conquest, the ikran is defeated; the ikran goes still and quiet, and Jake wins. "That's right – you're mine!" Jake boasts. The animal has been successfully dominated, his will and spirit broken – and the defeated being now belongs to Jake…. This was not a scenario in which each party sought out the other, for mutual benefit. The being in power dominated/raped the "lesser" being while the victim fought him off – and that we (and Jake) were essentially told, "if your victim fights you off, it means he wants it" was beyond sickening for me. It far too closely parallels the "you know you want it" mindset and words of real-world rapists.[24]

Ernst's response suggests that the human gaze, and the male gaze that lies beneath it, retain an enduring and haunting resonance, however much filmmakers try to transcend it – or, perhaps, simply pretend to attempt such a transcendence. In *Avatar*, as in all films, the presence of other animals, even in treatments that might seem ecologically enlightened on the surface, invites a critical and skeptical analysis as to whether the filmmaking industry and its audiences are truly becoming more concerned about ecosystemic speciesist inequities, or are merely reiterating the same old anthropocentric prejudices under the cover of a flashy new veneer.

Audiences should be cautious about assuming that the extravagant technological novelties embodied in the film's computer animation and visual three-dimensionality accompany a comparable advance in its ethical dimensionality. If ecologically and independently sophisticated representation of animal presence may be metaphorically envisioned as a third dimension, then *Avatar* remains mired in the same old flat, two-dimensional rut that has afflicted animals in visual culture.

Ever since Eadweard Muybridge and his zoopraxiscope began creating and diffusing novel ways of looking at animals, the human gaze(r) has become more voracious, more pleased at an omnipowerful intrusion into the world of animals. Whether we construe this world as "the wilderness," or "nature," or "the jungle," it is ultimately almost always merely a backdrop for the dazzling human action that takes place in the foreground. We need to be more careful than ever before, as we appraise the ramifications of our citizenship in this brave new world of visual culture, when a feel-good eco-parable that has become the world's most profitable film ever masks, at its heart, the ideology of the rapist.

* * * *

What sort of contact zones between human and other animals do visual media create? How are we seeing these creatures we have "captured" on film? The implications of this capture are not just metaphorical. What are the consequences of the ways people look at animals in visual culture? How *are we not* looking at animals in visual culture? How *might* we look at them more intelligently, more fairly?

I hope that visual culture might help us more accurately locate and situate ourselves in relation to other animals, rendering a truer vision of our place, and their place, and our actual conditions of coexistence. A range of more complex ethical questions follow from this: what should we do with these animals once we have gotten them in our clear, accurate, ethical sight lines? Or, if "what should we do with them?" sounds too paternalistic, then instead, how shall we behave toward them? We *should* treat animals better than we have done, and our visual cultural representations of animals significantly affect, positively or negatively, people's propensity either to revise and improve our patterns of behavior, or, on the other hand, to continue along the path of the status quo with our piercing human gaze of speciesism, encroachment, and imperial dominance.

Why look at animals? John Berger raised this enduring question in his famous 1977 essay. It is a good question, an important question, a simple, basic question, and though Berger launched into fascinating rambles about all the dysfunctional and improper ways in which people looked at animals, I do not think he ever resolved his basic initial query. He concludes by noting that because of increasing urban/industrial development and the disappearance of animals from people's lives, any meaningful gaze that there might once have been between people

and other animals "has been extinguished," and we as a species have "at last been isolated."[25] So, now we are not really looking at animals, he posits. But, still, even if it is "only" a "philosophical" question: why look at animals?

It is a question I have been wrestling with, or perhaps dancing around, throughout this book. I believe it is definitely a question we should be asking but, perhaps, as Berger may have discovered, it is a question we *cannot* answer. Indeed, there is a tradition of unanswered and unanswerable questions people ask about animals. From Thomas Nagel: "What is it like to be a bat?" From Jeremy Bentham: "Can they suffer?" From Jacques Derrida: "And say the animal responded?" From Michel de Montaigne: "When I play with my cat, who knows whether she is not amusing herself with me more than I with her?" From the comic pages: "Why did the chicken cross the road?" And to carry this meditation a step further, if indeed we cannot answer the question "why look at animals in visual culture?" does that imply, on some ethical level, that we should therefore *stop* looking at them in visual culture? If we cannot clearly explain and defend our gaze, does it then behoove us to stop looking at other animals? I do not know – that is another unanswerable question.

Let me put forth a related but certainly not identical question: Why look at animals in nature? Here I am talking about real animals, in real, actual, spatial proximity, as opposed to looking at animals through the mediation of visual culture. The naturalist Richard Conniff describes the pleasures and importance of watching real animals. In an essay entitled "The Consolation of Animals" he writes that looking at animals is what "makes me almost sane. These encounters with the lords of life...pull me up out of the pettiness and stupidity of my workaday life.... Watching animals fills some larger...appetite in much the way that reading poetry does, or listening to music."[26]

This may be no more than a subjective matter of taste and temperament, but I believe that what Conniff describes here embodies an admirable sensibility that involves meaningful and equitable interaction with other species. Though this is an overgeneralization, I would suggest that a visual cultural experience of animals is prone to be lazier and more voyeuristic than what Conniff describes. The difference, the deficiency in looking at animals in visual culture as compared to really looking at real animals, stems from the basic fact that viewers at the movies or surfing the net are not in real proximity to the animal, not out in animal habitats, but rather, comfortably ensconced, isolated, in

their own world. And animals do not fit well into this world. I believe that our perceptions of animals in visual culture, as mediated by the artifices of our culture, cannot be as authentic as when we are looking at real animals. In visual culture, animals are edited, framed, commodified, and somehow reduced. As Akira Lippit writes in *Electric Animal*, "Technology and…cinema came to determine a vast mausoleum for animal being."[27]

On the other hand, though, remember my contention that when a person and another animal come into contact, the other animal almost always ends up the worse for this encounter. Perhaps that argues *against* looking at real animals and in favor of cultural mediation – the protective distancing, from the animal's perspective, of the human viewer.

Consider two independent films that pointedly avoid the cinematic status quo for documentaries, *The Lord God Bird* (George Butler, 2008) and *Silent Roar: Searching for the Snow Leopard* (Hugh Miles and Mitchell Kelly, 2007). These films elucidate an interestingly unconventional relationship between the human viewer and the animal subject. Both these films explicitly recount how hard it is to find the animals they seek. Butler's film is about the ivory-billed woodpecker, one of the largest woodpeckers in the world, colloquially known as The Lord God Bird because according to tradition those who saw it spontaneously cried out, "Lord God! What was that?" The bird may or may not now be extinct: reliable, confirmed sightings have not been made for decades, though some people featured in this film believe they have seen this elusive woodpecker more recently.

The Lord God Bird wonderfully frustrates its viewers as it features an animal that we may not be able to see because we have probably eradicated from the earth – if not completely, then pretty nearly. The audience waits hopefully to see it throughout the film, and perhaps we do, in a brief blurry and disputed clip, but we certainly do not get a good, clear, satisfying look at it. This teaches us the vital lesson that we are not omnipotent emperors who can look at any animal whenever we choose. Despite the absence of the animal referred to in the title, this film intensely conveys a sense of the bird: its history and ecology, its legendary resonance. Butler shows that we can think richly about an animal without necessitating its literal appearance in our line of sight. The "human gaze" as a trope is troubled, subverted, in this film.

Silent Roar, too, is about an animal that is very difficult to see, the large Himalayan cat that inhabits the mountains just below the peak of Mount Everest. The cinematographers strenuously try to capture the snow leopards on film – and finally, with stealthy remote

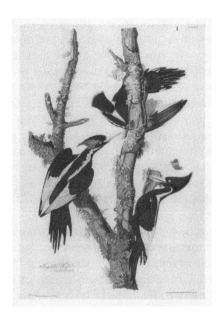

Figure 11 John James Audubon "captured" the ivory billed woodpecker in his nineteenth-century *Birds of America*. In the twenty-first century, filmmaker George Butler's visual imagery represented this species' absence rather than its painterly hyperpresence. Wikimedia Commons

sensor-activated cameras, they get a few short and fuzzy shots of the leopards. But mostly, in this film as in *The Lord God Bird*, we *do not* see the animals we have come to see. Once again, the filmmakers' implication is that we are not meant to see this animal. Its world is mutually exclusive with our own. Snow leopards live too far away from us, too high, and their habitats are too remote. The journey that the film takes to approach them reinforces their distance from us.

And though this may annoy audiences of animal-lookers who have come to expect that they *can* see any animal they want to, still, the film lets us down easily. *Silent Roar* – the title itself is a nice paradox. We expect to *hear* a "roar," we fetishize this mode of animal expression, but it is withdrawn from us, *silenced*, at the same time it is offered. *Silent Roar* depicts people trying as hard as they can to see snow leopards, with all the possible technology available, and the keenest sense of adventure, but still, as they fail, we may come to terms with the insight that perhaps we simply cannot see everything that is out there in the world. And *Silent Roar* still leaves audiences with a very beautiful

and memorable film about the region, the place, through which snow leopards sometimes move (just not when most of us can see). I endorse encounters like these in visual media: experiences that do not flatter our omnivisual fantasies but instead suggest what we are *not* meant to see and explain why.

In the world of art, a growing canon of painting, sculpture, photography, and other performative works reinforces this retreat from the anthropocentric omniscience that has traditionally characterized the human gaze. In the vanguard of this (counter-)movement are artists like Britta Jaschinski, Sue Coe, Olly & Suzi, Mark Dion, and Joseph Beuys, all of whom Steve Baker discusses in *The Postmodern Animal*. These artists resist a traditional sentimentality toward other animals in favor of a more nuanced engagement with them, a more ecologically informed and reasoned interaction. As Baker puts it, they are forging "new models of the human and the animal"[28] in the service of "an imaginative reassessment of the role of animals in human thought,"[29] which includes a postmodern skepticism about "culture's means of constructing and classifying the animal in order to make it meaningful to the human."[30] These artists aspire to a holistic ecological sensibility that rejects the conventional Cartesian dualism we have constructed to define our relationship with the animal. They realize that the future of the human "is so intimately and creatively bound up with that of the animal" that "the classic dualism of human and animal is not so much erased as *rendered uninteresting* as a way of thinking about being in the world."[31]

"Nonhumans Benefit from Responsible Representation," according to the title of an essay by Marc Bekoff. Describing a group of media artists "whose work has been influenced by the growing wealth of knowledge on animal behavior, cognition, creativity and consciousness," he writes of a dawning aesthetic tradition based on "the idea that animals might possess emotional, moral, cognitive lives," a sensibility that has been "in the past, either dismissed or associated with metaphorical or symbolic approaches." One representative work Bekoff cites, Lisa Jevbratt's "Zoomorph,"[32] directs viewers to look at a colored drawing on a board and then, on an iPad, select an animal to see how the colored image would look to them. "What a wonderful educational tool for getting people to see how animals see the world,"[33] Bekoff writes.

We may call these visual cultural texts postmodern, or posthuman, to indicate a transcendence over the ethos that humanity has indulged in for so many centuries. That unsustainable ethos, however, will not carry us forward for many more generations. We cannot rely upon the profusion of new media technology to generate what we need to see

when we look at the world around us, and at the other species who share this world with us. We need to seek out new, less harmful, ways of looking at animals, and we need to understand that sometimes, we all (human and nonhuman) would be better off if people did not look at other animals at all.

* * * *

I find that lately when I am at the movies with my kids I am more hopeful than usual about the possibility that we might be moving toward a better relationship with the other living creatures in our world. *Ratatouille* (Pixar/Disney 2007, directed by Brad Bird) is a recent animated movie that makes me think Hollywood can help inspire Americans to improve our ecological sensibilities. It is a feeling I have had often over the last few years, while watching *Chicken Run, A Bug's Life, Finding Nemo, Antz, Madagascar,* and *Happy Feet,* among others. In a culture that generally treats animals as subservient, these movies represent their cartoon characters with an integrity that invites viewers to value animals' rights, emotions, desires, and family/social networks. The protagonists have compelling narratives that unfold and resolve independent of the human ideologies that so often take precedence (in our cultural expressions) over animals' experience.

To put it bluntly, I could not imagine better propaganda for my cause if I created it myself. The central challenge of anthrozoology and ecocriticism is to resituate the natural world from the margins and backdrops of our cultural expressions, decentering "man as the measure of all things" and attending to the entire range of life, along the lines of ecology. Our ideologies and operating practices as a species are increasingly dangerous to other animals, and part of the problem is how we think about animals – or even worse, fail to think about them at all, simply going about our business as if we were the planet's only living inhabitants.

So these films hearten me when they show that animals have stories and experiences as important and as interesting as our own. We are invited to come close, and to understand that animals' lives are intermingled with our own. The prosperity of the human race ultimately correlates with the prosperity of other species, because we are all in this together.

Ratatouille is especially radical in terms of its depiction of the human–animal relationship. Its conceit is absurd, impossible to imagine actually happening in real life. Remy, a rat with a gift for brilliant culinary

creativity, dreams of working in the famous Parisian restaurant that had flourished under the late great chef Auguste Gusteau. Remy was inspired by Gusteau's book, *Anyone Can Cook*. The great thing about *Ratatouille* is that "anyone" is not limited to people, but...well, *anyone*, including rats.

With the assistance of a human compadre, Linguini – a menial kitchen worker who initially resists but eventually cooperates – Remy fulfills his dream, and the interspecies duo collaborate in what becomes a stunningly successful enterprise. At first the rat is very much a silent partner but eventually Linguini, determined to give his furry friend due credit, reveals Remy's role in the operation. In the end, with just a small deception necessary to fool the rodent inspectors, the heroes create a brilliantly innovative restaurant staffed by a brigade of hundreds of rats.

It is a wonderful story, full of richly complex characters (human and nonhuman), ironies, tensions, and comedy. But beyond that it has a potent allegorical kick. Remy's character has an emotional and moral depth that we rarely acknowledge in animals. Animals probably do not really have burning desires to cook in upscale restaurants, but they certainly have strong feelings about other things, whether or not we can figure out what they are, so a movie like this is a good vehicle for helping us realize the importance of attributes that people are not inclined to notice in other species.

Ratatouille teaches about the limitations of the human animal, and the necessity that we work with others. With Remy's help, Linguini achieves a triumph that neither he nor any other human chef could have accomplished without the rat's collaboration. And Remy, too, accomplishes something that no rat could have done without human help. Ecologically, this message of interdependence is more than just important, it is the *truth*, and one that our culture is pretty good at sublimating in a fantasy that *Homo sapiens* reigns over all the dumb creatures splayed beneath us on a Great Chain of Being.

The food that Linguini and Remy offer up is so good, beyond anything previously imaginable, precisely because the creative forces behind it are not the same old human-white-male-French chefs who churned out paté after paté in the past. The hegemonic tradition is stale, exhausted, and can be recharged only by a multicultural infusion of the previously marginalized subalterns – it is the usual postmodern/postcolonial manifesto, except *Ratatouille* expands the conception of diversity to include animals.

The cooking scenes are especially dazzling. Hiding under Linguini's toque, Remy pulls the young man's hair to direct his hand movements, generating a choreographic tour-de-force with knives swirling, zucchinis flying through the air, herbs and spices wafting into the soups, wines and sauces coursing sumptuously across the screen, signifying the vitality of the animal–human relationship that these two characters create and the transcendent result of this collaboration. The point is that we have to figure out a way for people and animals to work together. It is difficult and weird at first but eventually, Remy and Linguini illustrate, we learn how to do it, and once we have accomplished this it is immensely valuable.

Both Linguini and Remy are initially reluctant to acknowledge to the other members of their own species how important this enterprise is to them, and how much they need the other, but when they finally do it is a glorious epiphany. Animals and people interact in ways that would until recently have been proscribed by our anthropocentric prejudices. Rats (of all animals!) are depicted as smart, sympathetic, engaging animals who – as long as they wash their little rat hands before cooking – are perfectly congruous with high culture and haute cuisine. The bond of trust and friendship between a man and a rat forcefully deconstructs our conventional "dominionist" model toward animals.

At the end of the movie, all's right in the world. Linguini's romance flourishes, an evil chef is destroyed, a bitter critic is redeemed, and Paris enjoys a new level of gourmet ecstasy. And this happy ending is a direct consequence of the ecologically inspired affiliation between man and rat. In a very different style from Al Gore's *An Inconvenient Truth*, but with a similar point, *Ratatouille* promotes our need to take seriously the claims and the virtues of the world beyond ourselves. On our own, we will stagnate, just as Gusteau's restaurant had been in decline for years. To save ourselves, to move forward, we need to look at life as a joint enterprise. We need to revise our misconception that the rest of the world exists simply for our benefit, and to deflate our presumptuous fantasies that we stand above the rest of nature.

Animated animals of the past were dim-witted, inarticulate blustery clowns: stuttering pigs bumbling around half-clothed; not-so-wily coyotes getting creamed by anvils around every turn. These old cartoons embodied a two-dimensional panorama of "looney," "daffy" sadism and buffoonery, as offensive in its own way to the animal subjects as *Amos 'n' Andy* was to Blacks.

Today's breed of cartoon animal characters are well-rounded, sympathetic, individualized, sophisticated. They are drawn and conceived with a keen sensitivity to their habitats. Bugs Bunny and Mickey Mouse zipped around in planes, trains, and automobiles, not to mention the occasional submarine or hot-air balloon, but contemporary animated animals actually inhabit nature. Though Remy enters into the mainstream human world, his native milieu (sewers, attics, garbage dumps) is established first. The oceans in *Finding Nemo*, the green leafy meadows in *A Bug's Life*, the glaciers in *Happy Feet*, all exhibit a detailed attention to habitat, which counters one of the most dangerous aspects of how our culture traditionally represents animals, alienating them from their contexts. Such detachment erroneously implies that we can "have," and frame, and experience, these animals in ways that are comfortable to us, while their habitats, which we desecrate mercilessly, are expendable, irrelevant.

These movies address a range of ecological challenges. Nick Park's *Chicken Run* (Aardman, 2000) depicts birds in the desperate throes of agribusiness, awaiting the dark moment when they are to become chicken pies. The injustice of factory farming is conveyed from the chickens' point of view, by their sense of a better life outside the compound and their clear, passionate *desire* for such a life. Banding together with determination and intelligence, they learn to fly so they can escape from the greedy cruel humans, and the audience is rooting for the chickens the whole time. *Happy Feet* (Warner Brothers, 2006) portrays people's damage to animals and their habitats, and animals' consequent suffering. The penguins are experiencing famine as a result of overfishing, and our pollution is drifting down all the way to Antarctica. Mumble, the hero, informs people that we need to attend to what the animals have to say, and we need to treat them better. That movie ends, idealistically, with an array of international governments resolving to reform their ecological exploitation.

Bee Movie, a 2007 Dreamworks production, is another movie in this same mold. Its promotional Web site promises that it will "change everything you think you know about bees." Like *Happy Feet*, it addresses people's heedless plundering of the animals' world. Barry B. Benson (voiced by Jerry Seinfeld) represents, like Remy, a creature with aspirations beyond the conventional limitations to which we consign animals, challenging us to appreciate that animals are *more* – more varied, more sensitive, more important – than we have presumed. Barry is "shocked to discover that the humans have been stealing and eating the bees'

honey for centuries," and "ultimately realizes that his true calling in life is to set the world right by suing the human race."[34] As in *Happy Feet*, the animals fight back against people's imperious sense of entitlement. *Bee Movie* joins the ranks of these other movies in advancing the cause of ecological sanity, inspiring viewers to recognize the claims of all the other life forms that were for so long relegated to the background, and who are now colorfully and engagingly coming into their own.

5
Pornographic Animals

Consider animals, animality, and the limits of the human. Whether the tableau of human–animal intercourse is sexual or carnivorous, scientific or semiotic, the "limit" is precisely the place where human interests and pleasures end and animal interests begin. It is the nonhuman animal who is delimited, bounded, and constrained, in the virtually limitless exercise of human experience and pleasure.

The phenomenon of animal pornography suggests many ways to conceptualize "the limits of the human." Some would consider this material at the limit, or beyond the limit, of human perversity and exploitation: of all the things people do to animals this is the limit! The interspecies couplings depicted in animal pornography suggest the limit of our biological relationship to other animals, because while we cannot reproduce sexually with them – that is *beyond* the limit – still it is possible, physically and representationally, to *mimic* such a reproductive act.

The trope of animal pornography is one of presumptive human limitlessness. There is no limit to whom we can fuck. Images of sexually intertwined people and nonhuman animals push the limits of ethics, taste, and imagination. In an era in which we are jaded by cultural hypersexuality, a videoclip of a woman fellating a horse still pushes the limits. A tableau of human–animal sexual engagement has the power to shock, to repel, and for some, to titillate, to an extent that few other mainstream images do. Besides animal pornography, there are myriad other tropes of "human limitlessness" (or more properly, I would say, *fantasies* of limitlessness, because our arrogant sense of infinitude is ultimately unsustainable). Some examples of our limitlessness include fantastic exploratory voyages – Christopher Columbus's to the New World, Neil Armstrong's to the moon, Jacques Cousteau's to the depths of the oceans. In the realm of nature, people industrially

and genetically modify dozens of crops, transcending limits to make fruits and vegetables bigger, juicier, prettier, seasonally independent, and we do the same to animals to make them fatter, more uniform and thus more limitlessly produced and consumed. We extract oil, gas, and coal from places that once would have seemed inaccessible and, again, we fantasize that such resources are limitless, though they are not. Our homes, our technologies, our cars, our populations, our waistlines all become bigger and bigger with no evident restraint: limitless. Of course, those who are informed about ethics and ecology know that there *are* indeed limits, tipping points, points of exhaustion, corrections, that accompany all these infinite fantasies. Since our limitlessness is indeed limited, it behooves us to explore and to deconstruct the predominant sense of human entitlement.

Anthrozoologists study how people look at other animals and explain what we think this means. We explore the repercussions of the ways we see and frame other animals in terms of how we relate to these animals, how we envision them, how we cohabit with them. Elsewhere in this book I analyze people looking at animals in literature, art and photography, in zoos, on television, in animated films, in nature documentaries, and on the Internet, among other venues and media. In this chapter I want to consider how people look at animals pornographically. Other animals, too, experience interspecies sexual attractions. There are accounts of seals mating with penguins, moose or donkeys mating with horses, lions mating with tigers, elephants with rhinoceroses. But human sexual culture uniquely generates the production, spectatorship, and fetishization of this activity.

The most common medium of animal pornography is Internet-packaged versions of mostly Dutch and Scandinavian films produced from the 1970s up to the near-present. More recently, the proliferation of simple cheap recording devices has generated a strain of what we might call personal, amateur animal porn, as opposed to pornographic film studio productions. The studio productions, however roughly made, clearly include at least some involvement from technical crews, while the "amateur" productions generally seem as if they were created by a much smaller operation, possibly even just a single person holding a video camera. In both the earlier studio and the more recent amateur productions, the film and video images depict mostly naked women sexually touching and penetrated by animals, mostly farm animals and pets.

Bestiality and animal pornography were legal in the Netherlands and Denmark for decades. The Danish studio Color Climax was one

of the earliest and largest producers of animal pornography, and the first and best-known human actor in these films was a Danish woman named Bodil Joenson, who appeared in about forty films made in the late 1960s and early 1970s, and who, according to some biographical sources, actually "invented" the modern genre of filmed animal pornography. Friends reported that she enjoyed bestiality, at least early in her career, and used the money she made from these films to support her farm and breeding business.[1] Several Internet sources and a 2006 British Channel 4 documentary called *Dark Side of Porn* report that she suffered physical and mental deterioration later in the 1970s, and is believed to have committed suicide in the 1980s. A compilation of her films known as "Animal Farm" was circulated underground in the 1970s and 1980s.[2] Shinkichi Tajiri's *A Summer Day*, a 1970 documentary about Joenson, had a limited but significant crossover appeal in film festivals and art houses.

In addition to Danish and Dutch productions, there is a Japanese strain of animal pornography, and there are gray areas that foster some production of animal pornography in Sweden and Brazil. Animal pornography was outlawed in the Netherlands in 2010; historically, according to animal rights sources in the Netherlands, as much of 80 percent of the world market in animal pornography emanated from that country.[3]

I want to make four brief stops before I arrive at animal pornography. First, I will discuss a strain that involves animals themselves consuming pornography; second, I will consider interspecies "art" (as opposed to "pornography"); third, I will discuss bestiality and zoophilia; and fourth, I will examine intraspecies human pornography – that is, human-on-human porn. There is a considerable canon of scholarly porn theory/porn studies and, although almost none of it specifically addresses animal pornography, several aspects of it may be fruitfully applied to this topic.

First, I want to note that animals other than humans can be consumers of pornography. Vicki Hearne recounts a story from primatologist Roger Fouts about how Washoe, the first chimp to learn human language (sign language), had a habit "of sitting in a tree in the mornings looking at *Playboy* magazine";[4] Hearne also reports that Lucy, a chimp raised by Jane and Maurice Temerlin as their child, used to masturbate while reading *Playgirl*. In a Thailand zoo, Chuang Chuang, a sexually inactive panda, was put on a regime to increase his likelihood of mating which included watching "porn videos" for fifteen minutes every day – videos of pandas engaged in sex. It did not work, but zookeepers in

China have attempted the same kind of stimulation with their pandas, and report that they think the porn is sometimes effective in inspiring mating.[5]

While such porn-for-animals exists, it is not very profuse, and while it is an interesting tangent here, it is not significant except in its negligible quantity. Other animals do not care much about porn. I do not mean this as a gratuitous comment, but other animals have more important things to think about, more arousing things, in their erotic consciousness. I think that if animals *could* become porn addicts, some animal behaviorist somewhere would have tried to do this, for whatever reason: to "cure" human sexual addiction, or paraphilia, or to prove that animals are capable of human depths of depravity.

Second, I want to note numerous mainstream-cultural examples of human–animal sex which lack the graphic explicitness of animal porn but still broach the same transgressively erotic subject. In Woody Allen's 1972 film *Everything You Always Wanted to Know About Sex (But Were Afraid to Ask),* Gene Wilder plays a doctor whose patient, an Armenian shepherd, comes to him to confess that he is in love with his sheep. Wilder's character is at first stunned and disgusted, but when he meets the sheep he himself falls in love with her. Jim Jarmusch's 1991 *Night on Earth* also features a sheep-love scene. Roberto Benigni plays an eccentric cab driver who picks up a priest in the middle of the night and starts to confess his sins. To the priest's discomfort, Benigni's character goes into great detail about his sexual attraction to a sheep, and apparently as a result of this bizarre confession, the priest has a heart attack in the back of the cab. *Vase de Noces* (1974) – the English title is *Wedding Trough* – is a Belgian art house film directed by Thierry Zéno, which deals openly with bestiality (more graphically than any of these other films) in a story about a farmer's carnal love for his sow. Edward Albee's 2002 play *The Goat, or Who is Sylvia?* features an eminent married, middle-aged, architect whose life crumbles when he falls in love with Sylvia (who is, of course, a goat).[6] *Max mon amour,* a 1986 film by Nagisa Oshima, stars Charlotte Rampling in a surreal comedy of manners about a woman who has an intense affair with a chimpanzee. *King Kong* and *Dracula,* too, are about interspecies sexual attraction, and if one turns to myth, the number of cultural manifestations of human–animal sex grows large, including Leda and the Swan, and Pasiphae and the Cretan bull, among others.

Bestiality is taboo, but like many taboos it can become at least conditionally respectable if it is "licensed" by high culture. People may conceive of animal pornography as isolated in its perversion, but it is not. It

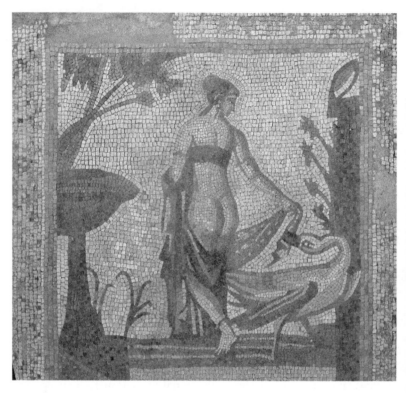

Figure 12 Tile mosaic (replica) depicting Leda and the Swan from the Sanctuary of Aphrodite, Palea Paphos. Courtesy of Kenneth Fairfax

is an extreme end of a continuum that includes numerous more socially, culturally, aesthetically "acceptable" strains of interspecies sexual representations. What makes a text artistic as opposed to pornographic? Probably the most honest definition of pornography is US Justice Potter Stewart's statement from a 1964 Supreme Court case: "I know it when I see it." Profoundly subjective, his statement keenly encapsulates the blurry line between what is culturally tolerable or valuable, and what is salacious filth. It is up to you (especially if you are a Supreme Court justice).

My third intermediate stop is the cultural history of bestiality, which has a substantial scholarly corpus and which is related to, but also different from, animal pornography. Motivations for bestiality, according to Hani Miletski's *Understanding Bestiality and Zoophilia*, include curiosity, sexual attraction, lack of social interaction with people, and availability

of animals. Miletski discovered "a bitter schism" between the communities of bestialists and zoophiles. "There are the more numerous bestialists, who are rather sluttish. They are sado-masochistic, curious, or exhibitionistic, full of ennui, or doing it for the money. They are responsible for the pornography and the sex shows. Zoophiles, however, feel married to their animal lovers. They are romantic and secretive."[7] According to Miletski, zoophiles look down on bestialists.

Going back as far as Stone Age cave drawings that "leave no doubt that our prehistoric ancestors enjoyed frequent and pleasurable sexual relations with animals," Miletski finds a steady transcultural stream of human–animal sexual relationships throughout time. Numerous biblical injunctions against men and women lying with animals show that it has long been a concern, and a taboo. "Whoever lies with an animal shall surely be put to death" (Exodus 22:19). "You shall not have intercourse with any animal to be defiled with it, nor shall any woman stand before an animal to mate with it; it is a perversion" (Leviticus 18:23). Bestiality has been around forever, Miletski's work shows, and so have representations thereof.

Bestiality involves mostly male human beings engaging sexually with animals, for the purpose of experiencing their own sexual pleasure, while animal pornography mainly depicts human women *simulating* pleasure and desire in their sexual engagement with animals for the *actual* sexual pleasure of an absent (remote, unseen) male audience. So, in the first case, we have the male as sexual actor, and in the second, we have the male as voyeuristic consumer. Bestiality involves the actual achievement of human sexual gratification in a literal human–animal interaction, while animal pornography involves an inauthentic, staged sexual engagement between woman and animal. While many scholars and sexologists have studied what we might call "private" bestiality, my focus on the staged, pornographic variant attends to the importance of the sexual activity as public performance and as a text of visual culture. It is an anthropocentric manifestation of how people may contrive and reframe animals in ways that reflect a skewed vision of the ecosystemic relationship of life forms. Animal porn is, thus, related to zoos and circuses – tigers jumping through hoops of fire, bears riding bicycles, elephants balancing themselves on balls, poodles standing in a pyramid on each other's backs – as much as it is to sexual behavior. Both animal pornography and circuses attract audiences by featuring animals doing outrageous things that they would never normally, willfully do.

Finally, before I get to animal pornography, I want to talk about "regular pornography," human pornography. My methodology here is

ecofeminist: I start by examining how heterosexual human pornography constructs the human female, and then transpose these observations to the human pornographic gaze at other animals. Ecofeminism holds that the hegemonic cultural treatment of women and of nonhuman animals often develops along similar, if not identical, pathways, and so understanding and deconstructing patriarchy primes us to understand and deconstruct anthropocentrism.

Human pornography illustrates the straight male sexual fantasy that men can make women have whatever kind of sex with them they want, regardless of women's own desires – indeed, heterosexual male-oriented pornography fundamentally erases women's desires, except to the extent that male desires might require the pretense thereof, but it does not really matter if women are actually sexually fulfilled by the encounter. This one-sided eros justifies and enables the masturbating voyeur who consumes these images. Pornography is mainly about masturbation, about the consumer's solitary pleasure. Porn theorist Rae Langton in *Philosophical Essays on Pornography and Objectification* describes pornography as "sexual solipsism," an insightful phrase that resonates more keenly than the general phrase "objectification," often used to encapsulate the feminist objection to pornography on the grounds of subordination of women. Such objectification is often characterized in other porn theory as "dehumanization,"[8] providing an interesting insight into the trope of animal pornography, in which the dehumanization of the objectified animal actors does not have to be enacted or contrived, as it is *de facto* already the case: the animals are already dehumanized.

Langton characterizes human pornography as a "shaper of desire." The ubiquitous array of pornography that is so accessible on the Internet "changes normative beliefs about the value of women," Langton writes. "And it changes desires, so that [male consumers] are more likely to want sexual experiences they did not want before." Porn "is achieving ever greater social acceptance," according to Langton, as the spirit of the Internet generates a new libertarianism that valorizes freedom of speech, freedom of information, to an extent never before seen, and these freedoms are increasingly regarded as absolutely irrelevant to the actual content of these "free" texts. The Internet as a medium of discourse consummately exemplifies the contemporary sense of human limitlessness. We can have anything, we *demand* to have anything, accessible on our computers with the click of a hyperlink. "With the growth of the Internet, pornography has become almost mainstream. Policies for which there was, and officially is, consensus [such as who should be

in porn and who should not, how it should be seen, and so forth] have gradually been eroded with the new ubiquity of pornography."[9]

Langton's insights about pornography's impact on women apply similarly to animals in animal pornography. While bestiality has existed for millennia, and its representations, too, have existed for as long as that, and in film for at least half a century, it is today more common, more accessible. It is something a Web surfer might accidentally come across, or might easily access on a whim. Previously, it would have been fanatics, devotees, who would have had to work hard, very intently transgressing dominant social mores, to see animal pornography, but today it is very immediately available. While animal pornography is still culturally marginalized in relation to other pornographic discourses, it is much less marginalized than it has ever been before.

Apart from porn, people *desire* animals in many ways. We desire their feathers, their meat, their power, their wildness, their companionship. Following Langton, then, I suggest that animal porn reinforces our desire for animals, our lust for them, in yet one more way. Someone seeing animal porn learns: here's another way in which I can use animals, in which I can want animals. Langton calls human porn a "provider of evidence for belief, meaning that it may directly support belief that women are inferior, or submissive, or enjoy rape."[10] Similarly, I suggest that with regard to animals, animal porn supports the belief that animals are useable elements, resources, in our most intense and selfish (solipsistic) erotic fantasies.

Porn is "an artifact that gets sexually used in place of a human being,"[11] Langton writes – a substitute for a sexual partner; an enabler of solipsism. Is something comparably true of animal pornography? Does the proliferation of porn animals replace real animals, which have disappeared from our proximate contact in the world since the Industrial Revolution? John Berger's "Why Look at Animals?" posits that people have created so many other cultural and visual animals to surround ourselves with simulacra in the wake of our separation from actual animals.

There is, in porn studies, what we might consider a potentially optimistic reading of pornography. Langton writes, "While pornography may be partly a source of lies about women, as feminists argue, it is also, partly, a source of truths, and thus of *knowledge*."[12] Certain films in the 1970s (which we can identify as the "early modern" era of mass pornography) have been credited with helping on some level to expand male understanding of women's sense of sexuality, the nature of the female

orgasm, women's enthusiasm about unconventional sexual practices – beyond the missionary position – and so forth. A male audience learned something about women's polymorphous sexual range and desire. Pornography brought sexuality out of the darkness, out of the closets. People thought about sex, and talked about sex, communally, whereas before, they did not. Mass consumption of pornography perhaps helped facilitate the cultural sexual consciousness as it transcended the historically suppressed condition of erotic desire. Whether it is causal or coincidental, perhaps some of both, pornography began to flourish at exactly the same time as feminism.

Other scholarship in porn studies also finds an unexpected empowerment of women in pornography. For example, Kenneth Kammeyer finds that "Women often have more *agency* in pornography than do men." Women are often in control of sex in pornography, he writes, because "the limitations of male sexuality and the ineffectual male organ are often contrasted with the insatiable sexual potential of women (one orgasm for men, multiple orgasms for women)."[13]

Can we also see empowerment of animals in porn? Maybe the position of the object of lust is, on some level, empowering, embodying a kind of power over the sex-crazed human pursuer. I think it is a strain, but in many pornographic representations involving humans and other animals, there *is* a kind of power that the animals sustain as the objects of such transgressive lust. I think these sex scenes are in many ways crazy, but I do not think the animals in these scenes are crazy, so it must be the people. Is it possible to look at these images and see the animals transcending our embarrassing contrivances?

Laura Kipnis, in *Bound and Gagged: Pornography and the Politics of Fantasy in America*, writes that porn "exposes the culture to itself. Pornography is the royal road to the cultural psyche." She continues: "Within the staged, mythic world of pornography a number of philosophical questions are posed...questions concerning the social compact...questions about what men are (and aren't), what women are (and aren't)," along with questions about "power, desire, and commodification."[14]

Animal pornography, similarly, raises questions about the interspecies social compact, and about what people are and aren't, and what animals are and aren't. As Kipnis argues, it certainly exposes our culture to itself. I think animal porn is, in the main, a reification of our power over animals and our myriad desires to use them in ways that give us pleasure, however inappropriate. But perhaps also, to a degree, in its transgressiveness it is a way of challenging the boundaries between

humans and nonhuman animals, and a way of revealing hidden "lusts," desires, ways of imagining our relationship with them that transcend the "normal," accepted, and mass-commodified discourses, of animal as pet, animal as steak, animal as leather belt. This may speak, consciously or subliminally, to a lurking strain of biophilia, E.O. Wilson's theory of an instinctive bond between human beings and other living creatures, "the connections that human beings subconsciously seek with the rest of life."[15]

So, finally, after my four-step digression, let me describe and analyze the specific visual texts of animal pornography. In my research, I watched ten hours of animal porn, all found on the Internet, all free. It was very easy to find: Google "animal pornography," "bestiality," "horse sex," anything like this, and you get more sites than you can imagine. Indeed, the amount of material seemed to me limitless. Some sites give you, free, full access to clips (usually short, two to three minutes), and others give you a similar type of clip as a teaser to join a pay site; you can watch a couple of minutes of a longer clip, or perhaps ten free clips before you are cut off and prompted to join. These sites have names like animaltubevideo.com, beastfuns.com, animalporntv.com – they are not at all subtle or secretive. I also found, on a free torrent site, a cache of the archives from a pay site, zootube365.com, allowing me to see an entire catalog, several hundred clips, that a paying member would get. These were not significantly different from what I found available for free elsewhere on the Web.

I felt troubled and disgusted, often, while looking at this, but I honestly also felt fulfillment at "discovering" and grappling with a strain of human–animal interaction that means something significant and that is barely discussed in any other scholarship (discovering: like Columbus discovering America – obviously, it was already there). This was my justification for conducting this research, and my motivation to stick with it.

Though I spent only ten hours watching this, I feel confident that I can describe a full picture of the range of animal pornography that is in circulation at present. There was a great deal of repetition of images and tropes, and also a constant array of links to other sites, which provided basically an identical range of material.

The production values are minimal, regardless of whether the film is a studio or amateur product. Camera work is jumpy, lighting is usually inadequate. There is rarely any kind of dialogue, or sound of any kind, other than occasional human sexual grunting, and not even much of

this. There is no narrative structure, no story line, for what was being depicted. I did find a couple of Web sites, "Dirty Farmer" and "Dirty Cowboy," which might suggest a thematic focus, but there was nothing substantial about how the "stories," the sexual interactions, were contextualized.

While it is generally true of human pornography that narratives are minimally developed and negligible in importance, overshadowed by the physical-literal-sexual foreground, still the absolute absence of a narrative hook or frame in animal pornography was striking by contrast with other genres of pornography. This lack (sublimation? erasure?) of a narrative only made me the more curious about why it was not there, and whether it was possible to detect and reconstruct any sort of story about what the visual imagery meant in the minds of the creators and viewers. What sort of account of human–animal relations is being told in these tableaux? What values, and fantasies, explanations or justifications, are embodied in what we see? Perhaps it is shame, or perhaps a sense of ineffability about the enterprise, that stifles any kind of attempt to express in animal pornography a fuller sense of the story at hand. Despite this narratological privation – and, indeed, *inspired* by its elusiveness to pursue it all the more persistently – I attempt below some conjectural readings of what the narrative might say if we could detect it.

It is not just the story that is absent. Indeed, it was nearly impossible to get any sense of context, or background, or geographical identification, from the vast majority of these videos, because they almost always simply depict a tight close-up on two "actors," a human and a nonhuman figure, focused almost completely on their genitals. Sometimes there would be a torso, a face, but rarely a full body shot of the human or the nonhuman animal. I had hoped to learn more from the settings, the venues of these film clips, to get more information about how the genre functions in a larger cultural context, but I simply did not get much of this.

About half the films were set outdoors, some apparently in farms. The rest were indoors, in somebody's house. I had hoped to be able to find out more about the cultural demographics of the *people* involved in these films – even, perhaps, from the hairstyles of the women, some guess as to the period during which these films were made, and the countries of origin, but I found it difficult to make many solid presumptions about this – again, because so little was present in the films. It seems likely to me that a good number of the clips came from the 1970s,

the "golden age" of Dutch and Scandinavian animal pornography, but I cannot state that definitively. Many of the clips seemed to be multigenerational reproductions (that is, a copy of a copy of a copy), strengthening my supposition that these were originally rough films, before digital technology. The women were mostly white; some were East Asian, some Hispanic, and a few were black. A quarter of the films seemed as if they were completely amateur productions, possibly made with a hand-held video camera or even a cell phone. A few of the clips were geographically identifiable by a title or a stamp on the video. I found Dutch, Russian, Australian, and Japanese stamps and titles – though again this is not definitive, as they could have been pirated or otherwise recycled. There were occasional pieces of dialogue, in Japanese, English, Dutch, that identified the actor's provenance, but not enough of these for me to make any definitive conclusions about where the bulk of this material comes from.

Almost all the human actors were women, though there were a few sites featuring "Gay animal porn," that is, men and other animals. As I noted earlier pornographic bestiality differs from non-cinematic bestiality, which largely involves men interacting sexually with animals. It is interesting that pornography depicting men having sex with animals who may be male or female is characterized as "gay" animal porn, regardless of the animal's sex.

There was a bit of pornographic anime (*hentai*) animal pornography, as well as some computer animation, both of which featured relatively more detail, sound, character, and context than the real-life images. These were somewhat more imaginative, and there was one *hentai* film of dinosaur sex that I actually found clever.

A small number of videos depicted animals mating with each other, without any people present. I saw horses, dogs, turtles, seals, zebras, baboons, hamsters. Several of these seemed to be taken from actual nature documentaries. The baboons were clearly filmed in a zoo. There was one video of a donkey fellating himself. And there were a few interspecies depictions, that is, sex between two different species neither of which was human: there was a cat with a rabbit, a dog and a cat, a monkey and a goat. I presume that there were not more examples of purely nonhuman animal sex scenes because the human presence is what is most appealing to the target audience.

In human–animal porn, the animals were mainly dogs (more than 50 percent), followed by horses (about 20 percent – some sources report that the Brazilian films are most likely to feature horses), and beyond

that a range of animals, including donkeys, pigs, sheep, goats. There were just a few cats, and a smattering of camels, tigers, chimps, elephants, fish, and eels. I saw advertisements promising videos of snail sex and a man masturbating a crocodile, but I never found these actual clips. And I did not find any "crush videos": this fetishistic sadomasochistic subgenre featuring women wearing high heels stepping on animals, presumably, appeals to a different audience.

The sexual acts depicted are mainly women fellating and masturbating dogs and horses, and being penetrated vaginally – occasionally also anally – by both dogs and horses. Among the more uncommon scenes, I saw a woman fellating a goat; a woman tongue-kissing a dog while masturbating herself; a nude woman rubbing up against an elephant's trunk; a woman sucking and milking a cow's teats; a cat suckling a woman's nipple. In so-called gay porn, I saw a man copulating with a cow; a dog anally penetrating a man; a man fellating a horse; a man penetrating a sheep. A few especially unusual scenes: a man inserting worms into his urethra, and women inserting eels and fish into their vaginas.

One film featured two nude women standing by a chimp but apparently unable to cajole him into sexual interaction. There was a similar scene involving a nude woman standing near a young tiger on a chain. The film showed simply the juxtaposition of the naked woman with the animal, without any sex; and there was another similar scene involving a camel. I assume these actual sexual pairings were too dangerous, or simply could not be done, or else, they would have been. I think they were included so that the sites could boast as wide a range as possible of the menagerie of animals: camels! tigers! monkeys! In circuses and zoos, too, part of the spectacle's appeal is the vast smorgasbord of animals, suggestively reiterating the all-inclusive animal gathering from the *ur*-story of Noah's Ark.

In about a quarter of the film clips, some of the dogs and horses being sexually stimulated by women had erections and ejaculated. Their participation in the sex sometimes appeared to be enthusiastic, or at least energetic. I put that statement forward *very* tentatively. I am far from certain what the animals think of all this, how they feel about it. Sometimes these scenes showed someone on the side, assisting, or guiding, or forcing, the acts of penetration, but sometimes the scenes seemed to show a woman and a horse or dog coupling "of their own free will" – and I put that phrase in quotation marks. Again, I cannot know the actual circumstances, and I repeat the major caveat that I simply

do not know what is really going on here, from any of the participants' perspectives.

Sometimes it looks as if the sex acts depicted are "faked" (that is, as if the person and animal are not really copulating, but just rubbing up against each other simulating sex from a camera angle that does not capture the supposed penetration), but often, clearly, the camera shows indubitably that there is actual penetrative sex going on in these films. Rarely do the women or the animals – even in the possibly non-coercive sex scenes – look as if they are even pretending to enjoy the perform-ance (as in some human porn, it is possible to do). Often I cannot see the face, the expression of the animal, only his penis, but still, from what I can tell, I think I can safely say that the animal always seems confused by what is going on: disturbed, perhaps traumatically, perhaps not, but still, it seems this is not what the animal would choose to be doing. The same is true for the woman. This is by far my most prevalent feeling watching these films, and I have a hard time getting beyond that.

The sex acts *always* look awkward. They do not look easy, or nat-ural, for either the woman or the animal. Probably, the "unnatural" look is part of the appeal. The two participants do not fit together well. There are many settings in which we are used to seeing, say, people and horses, or people and dogs, or people and cats in close, comfort-able looking intimacy with each other – a person riding a horse, or grooming him; a dog napping on a man's lap; a cat rubbing up against her human companion; a person running with a dog; a girl carrying a rabbit cradled in her arms. The corpus of animal pornography is differ-ent from that. But I do, still, want to make the point that it is not at all taboo to see images such as the ones I have just mentioned – in fact it is extremely common – portraying people in considerable intimacy, and proximity, and sensual interaction, with other animals, in ways that *do* seem comfortable and fitting. And not just in representations, but also in real-world human–animal practices, there are socially approved ways of touching animals intimately that significantly resemble animal por-nography. Consider, for example, animal husbandry, and some of the practices used by workers in that field that involve touching animals to arouse them and facilitate sexual encounters or harvest sperm. Animal pornography is an extreme version of human–animal intimacies, but it is perhaps not wholly unrelated to these others.

Because there was no narrative or context in animal porn, there is nothing that explained its logic, its eros. I guess you get it or you do not. This is in contrast to the "artistically" representational bestiality

described earlier, in the works of Woody Allen, Jim Jarmusch, and Edward Albee, where there *is* an explicit attempt to explain the attraction. Let me try, then, to offer several possible hypotheses, about what an animal porn aficionado might be thinking about these videos: why they are appealing to him and how he processes them; what suppressed narratives may lurk beneath the surface.

Perhaps he finds the woman's body and her sexual activity attractive, enjoying her erotic beauty. This hypothesis omits the significance of the animal. It seems unlikely to me, but possible, that the spectator is oblivious to whether the penetrator is a collie or a pizza delivery man, and his enjoyment resides solely with the naked and sexually active woman. His enjoyment may be either passive or vicarious. That is, he may enjoy watching the woman's sexuality at a detached distance, or he may imagine himself in his fantasy to be sexually engaged with her.

More likely, the viewer is consciously aware of the presence of the animal, and this stokes his arousal. Here are several ensuing hypotheses about this presumption.

Perhaps he is excited by the fact that she is copulating with a dog because it is degrading, and he enjoys her degradation. The erotic pleasure he reaps from her abjection stems from a variety of possible reasons: because he dislikes or fears women, because he feels unattractive to them or mistreated by them and fantasizes, in the scene of abjection, his revenge upon them; because the act of degradation gives him a sense of power, and/or because it is socially proscribed, and thereby feeds his erotic appetite.

Perhaps he is aroused by the fact that she is copulating with a dog because, again, he is sexually insecure and her bestial sexual encounter shows that she has no standards, no discrimination, and would copulate with any living thing... even himself.

Intuitively, I think these last two hypotheses are in some measure fairly prevalent – the viewer enjoys a misogynistic power of enforcing abjection, and his viewing of animal porn, his masturbatory sexual solipsism, indicates that he feels insecure about his own sexual attractiveness which is alleviated by the vicarious thrill of watching a woman who would have sex with any creature, even a dog or a horse. But let me venture a couple more possibilities as well.

Perhaps our hypothetical viewer is aroused by animal pornography because he has watched so many other kinds of pornography, involving midgets, pregnant women, threesomes, foursomes, French maids, and so on, that they have become common to him, boring to him, and

part of the enticement of pornography lies in its novelty: and here is something new!

Perhaps he is specifically turned on by the fact that the woman he sees is copulating with a dog, because he, too, would like to copulate with a dog, or perhaps, even, he has already copulated with a dog. I think it is more likely that the erotic appeal of animal pornography reflects fantasy as opposed to actualization, because there is no indication that the recent widespread growth in Internet animal porn has been accompanied by a similar increase in bestiality. Perhaps the viewer wants to copulate with a dog because he thinks he would enjoy the physical sensation that must be very different from sex with a member of his own species. Perhaps he fantasizes about bestiality because it is highly unusual/transgressive/taboo, which excites him. Perhaps he wants to have sex with a dog because he loves dogs very much, and would like to take this to the next level.

I find these readings somewhat unlikely because they involve the male viewer's identification with the female actor, who is playing a very different role from what he would be doing in an actual interspecies sexual encounter. That is to say, in the film the woman is being penetrated by the dog, while in real life he would be penetrating the dog. So, perhaps more likely, and frankly, most interesting to me as a hypothesis for the viewer's enjoyment of this scene: he is aroused by watching this because he wishes he were that dog copulating with that woman. I think one of the most compelling aspects of pornography, for the viewer, is his vicarious/fantasy identification with the figure in the porn who is a stand-in for him, and who is experiencing sexual pleasure as he too, while masturbating, is experiencing sexual pleasure. While the animals in these videos seem more confused than aroused by the action taking place, I have noted that they do sometimes ejaculate, which might seem, to the viewer, to be evidence of their sexual pleasure. And as to the fact of their confusion, the human viewer, too, might well be confused by this scenario, and that confusion may somehow feeds into his sexual pleasure and solidify his fantasy-association with the nonhuman animal.

In human heterosexual pornography, one popular genre involves men with extremely large penises, colloquially known as "big cock" videos. Why is the straight male viewer attracted by a big cock? Certainly it is possible that he has sublimated gay erotic attractions, but more likely, he enjoys watching a porn actor with a big cock because he wishes he, too, had a big cock. So just as that porn-consumer inscribes himself in

the fantasy of the man with a large penis, it seems here that the animal porn-consumer may be inscribing himself in the position of the dog, the horse, the eel: the animal penetrating the woman, the animal whose sexual fulfillment is being facilitated by the woman.

Let me move toward some conclusions. First of all, I strongly believe that animal porn degrades the animal subject, illustrating just one more way that people conceptualize animals as creatures who exist for us to use as we please. The viewer of such porn is surely aware that the activities portrayed are highly unusual for the animal – and for the person, too, though the person is perhaps choosing, or being paid, to perform these (though possibly the woman is not choosing to do this, but is being coerced or enslaved), while the animal is yoked and set upon. But however unusual the spectacle, still, it is not beyond the realm of possibility. Whatever people can *imagine* animals doing, people can, indeed, make them do: this is our power over them. I believe, further, that animal pornography is animal cruelty. It is not just metaphysically degrading to them, but physically abusive. These animals have not given, cannot give, informed consent. Earlier, I suggested correlations between animal porn and adult human pornography; another correspondence that must be considered is child pornography. In some ways, certainly, I think animal pornography *is* like child pornography, and to the extent that this may be true, it would be consequently impossible to find in it any possible redeeming value whatsoever, and indeed, we should then demand that animals, like children, should be considered a class of subjects who are unable to understand or give consent, and thus deserve to be protected from involvement.

The pornographic conception and depiction of animals is not sui generis, but is a point on a continuum that includes many other depictions of mediated engagements with nonhuman animals: in advertisements, in art, in zoos, in carnivory. These encounters all contain at least some degree of a pornographic conception of the animal – by which I mean, the animal is doing something unnatural, uncomfortable, beyond the limit, in an encounter that may at first glance seem a mutual transspecies engagement but in fact serves merely to glut the human being's solitary, masturbatory pleasure.

It is possible that somewhere in this pornographic bundle of signification lurks a genuine "love for animals." Perhaps some viewers think of animal porn as an expression of intimacy and connection with other species. Perhaps it embodies a "twisted love," a perverse love, that could somehow be untwisted, or normalized, or sanitized. The possibility that

the male voyeur may be inscribing himself in an animal conscious-
ness – imagining himself as the dog copulating with the woman in
the scene he is watching – is fascinating to me. It would be valuable for
people to learn how to put themselves into the mindset of other ani-
mals, and I think such an exercise would advance transspecies empa-
thy and understanding, though I do not believe that this pornographic
vicarious identification is the way to accomplish such empathy. But, at
least, if my hypothesis is correct about this viewer's motivation, we may
have discovered the germ of a desire for transspecies consciousness and
experience that could perhaps be redirected in less exploitative ways.
People do a lot of abusive, sadistic things to animals; and also, follow-
ing Wilson's idea of biophilia, we *do* have an innate and deep connec-
tion to other species. It is a paradox, perhaps the central paradox that
anthrozoologists must confront. People love animals, in some way; not
infrequently, we love them to death.

A central issue in human pornography is the question of whether
porn promotes rape. Some porn theorists argue that it does, by desen-
sitizing men to violence against women, and by convincing men that
women want to be raped. Others say it does not, because people's moral
compass is what it is and is not swayed by contrived images, and some
even suggest that porn may alleviate rape by serving as a "release valve,"
allowing men vicariously, in fantasy, to "enjoy" rape so that they do not
do it in real life. How does this question relate to animals? Does animal
porn enhance/facilitate other kinds of violence against animals, or does
it allow us to let go, cathartically, of our sadism?

Anthrozoology has always been interested in human–animal bound-
aries, and boundary-crossings. We attend to this in our study of chime-
ras, hybrids, monsters, the Sphinx; the bird-women sirens; mermaids;
satyrs; centaurs. We understand that the myth of the Minotaur, replete
with bestiality, is a story that grows out of the worship of bulls. And
indeed many of these boundary-crossings reflect a spiritual or cultural
adulation of the nonhuman animals.

In "The Predicament of Zoopleasures," Monika Bakke describes
many accepted "pleasures" people experience with nonhuman ani-
mals. These pleasures include eating their flesh, using their skin and
furs, using them as a source of entertainment, and "other forms of
total control based on the master-slave relationship." "Erotic bliss" is
another kind of pleasure, heavily proscribed, taboo, and yet it some-
times overlaps with the other acceptable pleasures, Bakke writes. "From
an anthropocentric perspective, animal sex is often viewed with both

fascination and repulsion." Her essay considers what she describes as "human-nonhuman libidinal encounters" from a "postanthropocentric perspective" in which what she calls "zoosexuality" features as a "plenitude open to otherness."[16]

"In zoosexual relationships animals gain the status of a *partner* rather than a victim of human lust." Zoosexuality can be a beautiful thing, Bakke writes, as it "evokes a totally different concept of ourselves, our bodies, and our relations with other animals, including libidinal encounters with them. Zoophilia ... offers an alternative to phallogocentric models of eroticism." She concludes: "Life is based on connections, networking, and exchange on all levels Our identities, like our sexual orientations, are never stable; our bodies are multiplicities."[17]

Porn theory regularly celebrates the role of pornography in "the dismantling of heterosexual normativity"[18] and celebrates an openness to "deviance," which can also be construed as polymorphous sexuality. It is all very postmodern. Bakke's ideas strike me as far-fetched, but nevertheless, I have to admit, it is logically similar to discourse I myself use regularly in my quest to subvert anthropocentrism and patriarchy, and to encourage other posthuman ways of imagining nonhuman animals.

As shocking and disturbing as animal pornography is, there are ways in which we can think of it as being not that different fundamentally from a number of other modes of transspecies interaction. But at the same time, I do not want to cleverly intellectually sanitize this material. In my experience as an anthrozoologist I have studied so many human–animal interactions that reflect human behavior I find oppressive, exploitative, and ethically abominable, and yet through all this I have retained a perhaps unmerited optimism in the enduring human fascination with other animals, and a conviction that enlightened critical attention to transspecies relationships will facilitate and inspire reform. A silver lining of this often-unsettling research foray into animal pornography is my discovery that when I introduce this realm of visual culture to people (who are presumably not already fans of it), it almost always induces them, immediately and of their own volition, to start thinking anthrozoologically. Without any prompts on my part, colleagues and students hear my descriptions of these texts (I do not show the actual images in lectures or in classes) and respond: What does this mean? Why do people do it? These are the questions that initiate the semiotic and ethical analysis of all the framed animals in visual culture.

Recalling that the heyday of human pornography in mass culture coincided with the rise of feminism, we might hope that the recent profusion of animal pornography will be accompanied by a heightened openness to ethical parity between human beings and other animals. The impetus for this revaluation of human–animal interactions could be as simple as a direct reaction, a revulsion, against the seemingly limitless exploitation embodied in the ever-expanding canon of animal pornography. Or, more indirectly, it might be that increasingly thoughtful interspecies relationships come about as the result of a range of visual cultural texts bombarding viewers with such an overwhelming corpus of animal representations as described throughout this book, of which the most shocking are, arguably, these displays of animal pornography. In response to this barrage, perhaps more people will ask the kinds of questions that I am trying to provoke: how have we gotten to this sordidly fetishistic level of cultural interaction with the other animals who live alongside us in the world?

Cultural consumers, viewers of the corrupted and perversely framed animals that surround us at every turn, may finally come to realize that we have had enough, and that we simply refuse to continue consuming what the cultural marketplace supplies for our visual appetites. These eels and dirty cowboys and Brazilian horses and ejaculating dogs have a perversely forceful power to imprint themselves on our visual consciousness and to proliferate exuberantly like a cancer cell run amok. They will become (if they have not already become) omnipresent. Whether or not people are intentionally seeking out these images, they will find us, and they will gush into our visual field, our cultural field. But also, I believe – or maybe it is just a hope – that finally these images will push us over the edge. It will be the proverbial straw that breaks the camel's back, a cliché that is itself ironically (but fittingly) a trope of human violence against animals, but perhaps it will be the last straw and the last dead camel. Perhaps audiences will welcome the eventual release from our dithyrambic orgy of animal-framing with an ethical determination and an imaginative desire to begin thinking of animals in nicer and happier ways, saner ways. We will come to understand that the tableau of a German Shepherd anally penetrating a woman is not the kind of visual cultural expression that represents the better selves people are compelled to discover as we take on the ecological and ethical challenges of the future. In my discussion from Chapter 4 about not seeing some animals in visual culture (woodpeckers in *The Lord God Bird*, and snow leopards in *Silent Roar*), I suggested that their natural

frames, inflected by extinction in the first case and by remote habitat in the second case, made this filmic "invisibility" appropriate. Here, even more keenly, pornographic animals reinforce the ethos of not seeing. Confronted with such animal images, we must finally *look away*. And there may be a larger-than-expected lesson that emerges from this smorgasbord of visual perversity, which is not merely to look away from the degrading images on "beastfuns.com" and others, but also to habituate ourselves to look away from a range of other framed animals that have always seduced viewers to *look at*. For example, zoos.

6
Zoo Animals

Zoos present themselves as venues for visual cultural consumption par excellence. Visual: look at everything and stare for as long as you wish – the animals are not going anywhere. Culture: the animals are on display in the hearts of our cities, in institutions promoted as prominent elements of the cultural/tourist infrastructure, heavily advertised and marketed and commodified, replete with gift shops and cafés (which always feature carnivorous menus; at aquariums, there tends to be more seafood).

Zoos epitomize the failures of seeing animals in visual culture. What audiences *see* at the zoo, if we look carefully and thoughtfully, is that we cannot see. Britta Jaschinski's *Zoo* makes this point keenly, with its blurry, dark images of caged animals, chopped and cropped out of her photographic frame to signify their cultural dismemberment.

The zoo experience is voyeuristic, imperialistic, inauthentic, and steeped in the ethos of consumer culture, which is antithetical to nature and ecology, and hence a danger to animals. The animals do not belong there. They cannot possibly be happy there, which negates the possibility that a zoo visit can be an educational experience (the *raison d'être* advanced today by zookeepers to justify the existence of zoos). Zoos contain sad animals, constrained animals, displaced animals, but zoo spectators are induced to sublimate this, and pretend they are looking at real animals.

The experience is set up for the ease and convenience of people: it is like a mall, as visitors stroll from cage to cage, window-shopping. Zoo-goers are in the position of imperial overlords regarding the subalterns. This is an undesirable perspective for learning about animals, for reasons that should be obvious. In zoos, people are at liberty

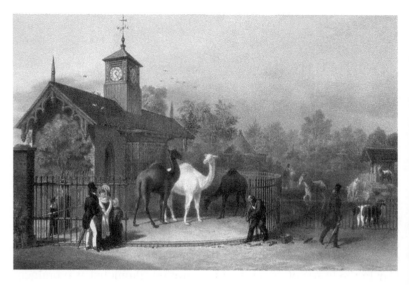

Figure 13 "A View of the Zoological Gardens in Regent's Park, London, 1835: the camel house." Collection of the Museum of London. Wikimedia Commons

outside the cages, and animals are captive inside, so all the spatial and institutional cues suggest that we are in control of them.

In the zoo, every animal's context is absent – her habitat, range, climate, geography, geology; her regional altitude, her interactivity with other species and plants and landscapes. All these elements comprise a huge part of who animals are, and what their lives are like. Lacking these, we cannot learn about nor empathize with animals.

Zoos have self-interests, institutional and commercial hegemonies, in promoting a cultural sensibility that is not inherently ecological. To survive financially, they must feature crowd-pleasing programs and produce blockbuster shows. The zoo's perspective on animals is culturally biased – they spotlight cute animals, fuzzy animals, "charismatic megafauna." These biases shape their collections and displays, and also their "research agendas." Panda bears are not the most important species in nature, but they certainly are in zoos.

Zoos are sites of captivity, commerce, and pain. In the great nineteenth-century European capitals, zoos were founded with the mission to display living imperial booty – mostly nonhuman, but sometimes people appeared in the cages as well (a certain type of people: subaltern, ethnic others). The intent was to persuade the masses that Europeans benefited somehow from the imperial enterprise – that is, "the white

man's burden," the task of conquering and pillaging the world, achieving domination and ownership, of imposing commercial, cultural, political, and ideological control over all the world's different regions and habitats and cultures. The proletariat's imperial payoff was simply being able to see all these geographically diverse and exotic creatures and take pride in the political/military/commercial prowess that facilitated their country's collection of such a splendid corpus of animals.

Postcolonial scholarship testifies to the cultural agenda that accompanies the imperial agenda. Edward Said's *Culture and Imperialism* shows "the involvement of culture with expanding empires, the connection between the pursuit of national imperial aims and the general national culture."[1] Yi-Fu Tuan writes, in *Dominance and Affection: the Making of Pets*, about how animal collection is a model of imperialism: "Potentates demonstrate their power by appearing to sustain a cosmos. One element of that cosmos is a menagerie. The keeping of menageries is a tool of high civilization, combining the desire for order with the desire to accommodate the heterogeneous and the exotic."[2] Harriet Ritvo describes how the early nineteenth-century competition among European imperial cultures to develop larger and more complex zoos precisely mirrored the global imperial competitions that were playing out at the same time. Throughout the nineteenth century in Europe, and beginning in the early twentieth century in America, the agenda of zoos was to display and justify the fruits of expansionism. Bob Mullan and Garry Marvin, in *Zoo Culture*, describe how the ownership of rare and exotic animals represents a display of prestige for the rich, powerful societies that create these zoos.

A zoo animal from China, or India, or Africa on display in London or Paris semiotically describes a power relationship between the spectator and the culture from which the animal was taken. In American and European zoos today, this relationship is still, as in the imperial era, construed as a relationship between a more *advanced* culture and a more *primitive* culture. It is, of course, the advanced culture that removes (and controls and displays) the interesting specimens from the more primitive culture.

Animals are part of the exchange of imperialism, and of globalism. Along with all the other raw and technological commodities that are coursing through the globalist network, animals, too, are drawn in, and thus commodified. In 1999 two new panda bears were brought to my local zoo, in Atlanta. They were "rescued," as local media implicitly suggested, from China, where they were not doing a very good job of preserving the pandas' habitats, their bamboo forests. In exchange for

the rights to display these bears, Zoo Atlanta promised $10 million over ten years for research funds to help the Chinese improve their forestry practices. This money was to come from admissions fees guaranteed by the pandas' highly prominent market appeal. China had the "natural resources," America (at least at that time, if not now) had the money, and we traded money for bears, while also ensuring that our investment would lead to the possibilities of more bears from mating, and of course the zoo would reap a percentage of the profit from the offspring. When the bears were brought to Atlanta, much fuss was made of their trip here on a specially chartered UPS plane – United Parcel Service, a key player in the infrastructure of global trade, is headquartered in Atlanta. The company repainted a plane with a picture of a panda on the side, calling it "The Panda Express" and celebrating its contribution to Atlanta's "panda-monium!" In globalism, as in imperialism, the zoo animal figures as a token of value, exchange, and desire in the overarching praxes of the commercial enterprise.

The zoo scenario encourages us to think of ourselves as emperors of the world. We have gone everywhere, and we have confiscated and kidnapped specimens to celebrate our far-reaching power. Zoos have not fundamentally changed since their origins. Still, today, they are complicit in the hegemonies of Western industrial cultural dominance. The forces that promulgate and support zoos tell a story about people's relationship to other species, and this story is: We are in charge. We are in control. We are doing a good job, a responsible job, serving as the stewards of the natural world. And, in turn, our sound stewardship of nature testifies to our general merit as economic and political leaders. As in its infancy two centuries ago, the zoo today stands as a testament to the reach of the culture that sustains it. Just as the collection of animals amassed in Noah's Ark signified the favor that God had bestowed on his chosen people, so too the institution of the zoo asserts that its society reigns as a righteous force, and the creatures from all over the earth are gathered together under the good citizens' gaze in London, or Sydney, or San Diego, as a token of their dominance.

See how well we are caring for nature, how benevolent we are toward other animals. We are in control of our ark, steering it safely through the floods. This sense of dominance is the most prominent thing people see at the zoo. Instead of powerful, fast, and proud, the animals we see in their enclosures are slow, powerless, domesticated, unable to manifest the life-force that they naturally would in their native environments. Their pride and strength have been abrogated. The compelling attraction here comes from sublimated *schadenfreude*. In taking away

the animals' power and freedom and beauty, we have somehow taken it on for ourselves. They do not have it anymore in their cages, but it must have gone somewhere: zoo spectators themselves have imaginatively or semiotically usurped the animals' force. It is not a nice sentiment, and certainly not the kind of education cultures should be promoting. The animals would be safer and happier if they could escape our "ark" and all the other anthropocentric constructs and contexts people impose upon them.

Zoos go in and out of fashion. In recent years, as ecological consciousness has risen to the forefront with the threats of global warming, accelerating rates of extinction, and habitat destruction, the tide has turned at least a bit against zoos. The idea of animals in cages has always rankled to some extent, and those objections are becoming more pronounced. Certain species, like elephants, have become recognized as especially unsuitable for zoo confinement, and movements are afoot in many cities to release them. Newsworthy events like the attack at the San Francisco Zoo in 2007 in which a Siberian tiger, taunted by spectators, escaped from her cage and killed a visitor, and the chimp at Sweden's Furuvik Zoo, in 2009, who craftily planned stone-throwing attacks on spectators, make people more aware of the zoo's dangerous, volatile conditions – dangerous for people as well as for the animals on display. News stories about zoo animals suffering in places afflicted by war and by economic hardships remind us that zoos regularly fail to carry out their professed commitment to the protective stewardship of animals.

In Atlanta, a new aquarium opened a few years ago, billed as the world's largest, presenting itself as a major tourist attraction and an institution for the city to take pride in. Then the animals started dying. The aquarium keeps replacing the dead whale sharks and beluga whales, but audiences are becoming aware of the toll that captivity takes on these deep-sea creatures who do not belong in Atlanta, and do not belong in captivity.

Recall the fate of Knut, in the Berlin Zoo. An incredibly cute baby polar bear garnered international acclaim in 2006 when the zoo nurtured him after his mother rejected him. The sentimental narrative attracted international attention. But within a few years he became despondent and maladjusted. His once bright white fur became dull, and his star appeal, too, dulled. He once earned the zoo millions of euros a year from sales of cuddly Knut toys and T-shirts, but when he became less appealing to the crowds the zoo considered "surplusing" him as it was unable to raise the funds to build him a larger enclosure.

His natural Arctic habitat offered him a range of around one million times more space than his current zoo cage provides (which is, pointedly not a piece of education that the zoo provides). In 2011 he died in his enclosure by drowning, after he collapsed into the pool. The bear suffered from encephalitis, an inflammation of the brain, which caused him to collapse before he drowned, a necropsy indicated. Knut would have likely died from brain swelling if he had not drowned, zoo officials said.[3] Zoo officials planned to stuff Knut (like Dolly and Balto from Chapter 2) and display his corpse in the Berlin Museum of Natural History, though protests from Berliners who considered this disrespectful have complicated and delayed this plan.

People are becoming more cynical about whether zoos are taking good care of animals. Animal rights groups, like the Born Free Foundation and the Captive Animals' Protection Society, regularly document abuses and deaths of zoo animals, and they have had success at getting these incidents reported in the media and stirring up activism in opposition to the oppressive practices of zoos. When social currents generate such assaults on the institutions of zoos, the primary defense offered in response is that they are important venues of education, places that uniquely offer people a chance to learn about, and connect with, other species, in ways that will (implicitly) make people better ecological citizens.

But zoos are sites of blatant miseducation, teaching exactly the wrong things about animals. Zoos suggest animals are "ours" in some way, and that they may be experienced in an artificial urban compound at our convenience. Animals' habitats (and natural behaviors in those habitats) are completely absent in the zoo setting, suggesting that they do not matter – that animals can be experienced apart from their habitats. Ecologically, this is a retrograde message. The implication is that we need not worry about destroying the wild, because animals may be salvaged from troubled habitats and viewed in isolation. The visual cultural experience is meant (by the institutional power structure of zoos and civic cultural organizations at large) to reassure audiences that *seeing* these animals suggests that all is well: seeing is believing. But what we are seeing is a sham, a deception.

Here is the central pedagogical assumption that zoos make. People, especially children, must see animals – lots of animals, from regions representing the four corners of the earth. Obviously the earth does not have "corners," being spherical, but this phrase reflects our intellectual sense of place on this planet. The image of corners reinforces our cartographical fetishes, our ways of showing understanding and ownership

of the planet by inscribing it on a piece of paper, a rectangle, a frame. Corners, too, help convey a desired sense of marginalization that is fundamental to imperialism: if there is a "center" of the world, which is how an imperial capital envisions itself, then there must be four corners far away from this center.

The point of seeing lots of animals, which zoos facilitate, is to "appreciate" them: to know them, to understand them, to feel empathy for them, and to be motivated to engage in environmental activism of some kind on their behalf. I refute this on four grounds.

First, the animal we see in the zoo is not the "real" animal. The real animal lives in her place, in her habitat, in her environment, among and alongside many other animals of her own species, as well as many animals of other species, predators and prey, friends and strangers. She lives there because her life cycle is predicated upon a certain seasonal climate, a certain temperature, a certain environment of certain plants, trees, water, dirt, stones, topography, and so forth. It is fundamentally impossible for zoos to reproduce any significant amount of this animal's habitat. For a long time, zoo animals were simply put in cages. Then, as people expressed feelings of guilt about seeing animals in prison, zoos began to prettify the enclosures, largely to alleviate the spectator's discomfort – not the prisoner's. In a cage or in a "cageless enclosure," the animal on display in a constrained, artificial compound lacks so very many aspects of the environment in which he or she naturally lives – the space, the social groups, and so forth – that we are simply not seeing the real animal. We are not seeing a creature who acts or feeds or sleeps or eats or mates or nurtures or fights in the way a real animal would. Depressive, anxious, and fearful behavior is rampant among captive animals on display. The animals exhibit learned helplessness, self-injury, stereotypic repetitions. Zoo spectators are seeing not a monkey or a giraffe, but a *caged* monkey or a *caged* giraffe, which are not remotely the same things as the actual animals. Zoos are not a pedagogically sound venue for education about animals.

Second, the zoo scenario encourages us to think of ourselves as emperors of the world. We have gone everywhere, and we have confiscated and kidnapped specimens to celebrate our far-reaching power. Every ecologist knows that people today need to simplify, scale back, and recognize our proper and humbler place in the ecosystem, rather than flouting our imperial grandeur as we have been doing for centuries.

Third: the educational value of seeing animals in zoos is profoundly compromised by how easy it is to see them – to see such a wide array of animals, all in one quick short visit. In a zoo animals are too available

too easily, so audiences do not appreciate them. In *Zoo Culture*, Garry Marvin and Bob Mullan cite a survey showing that people spend on average forty four seconds at each cage. How much education can be going on in that time? If people had to work hard to get to an animal, and if people saw exotic animals perhaps only once or twice in their lives, they would bring more attention, engagement, and wonderment to these experiences. The fact that a cornucopia of zoo animals is so conveniently available to spectators suggests that it is *easy* to see the world of other animals, easy to access a hundred different species from a hundred different biotas, easy to digest all that the animal world has to offer, or at least its greatest hits, in a two-hour excursion. In fact, I believe, it is extraordinarily hard to see and understand these animals, because they are so complicated and because their lives are so different from ours, and from each other's. And as these animals and their habitats become more endangered, it is becoming harder to know them and to connect with them, but zoos are trying to make it seem even easier, with the goal of denying the difficulties we pose to other animals.

And finally, fourth, consider the animals' displacement from their contexts. The message is, explicitly, that habitats do not matter. Why worry about habitat destruction when zoos can remove and "preserve" whatever is interesting (that is, an isolated animal) about a given environment? When zoos tell spectators that they are rescuing animals from endangered habitats and caring for them, what is actually going on is that the animals that would have been inaccessible had they stayed in their habitats are now made accessible to viewers – so there is a perverse spectatorial benefit that people accrue when animals are separated from their worlds, accompanied by a disincentive to develop concern for endangered habitats.

Instead of bringing people and animals together in zoos, a better education would teach the lesson that these animals live far from us, are threatened by us, do not want to meet us eye to eye as they are held captive inside a cage. That, precisely, is what makes other animals so interesting, so important, so necessary to learn about: they live in a different place, not in our cities. We are destroying their environments to satisfy the unsustainable consumption demands of our world, and we need to stop desecrating their habitats, and make it possible that they can live there. We are not entitled to experience all these animals. We cannot see everything. Our cultural imagination has been stinted because zoos teach our children that they can have everything easily presented, right in front of their faces. Zoos make spectators dull,

especially the children, dull to the real fascination of these creatures, and they miseducate viewers about the lives of other animals.

Zoos attempt to shield themselves from the literal and unpalatable discourse of zoo-going, which involves neurotic animals cramped in smelly cages; quick and blasé gawking at the inmates; junk food, and other general junk at the gift shop. They try to invoke their connections with the discourses of science, ecology, and ethics in order to sublimate the seedy discourse of zoo spectatorship, but these connections to the nobler discourses are easily debunked.

The zoo presents itself today as a venue where scientific learning may take place by spectators who are at least in part scientifically attuned, as guided by the scientists who have arranged this institution, replete with scientific signage and scientifically oriented pedagogy. We are also told that an even greater, deeper level of science is enabled by our patronage, as most zoos sponsor scientific research, usually linked to an exhibition or a focus of interest at that particular zoo. Zoo audiences feel that they are getting a small taste of the science that is being conducted in greater detail out in the field.

But zoos are not very forthcoming about what percent of their operating budgets goes toward such actual science in conservation and ecology. I have asked. Most zoos, especially in our recent economic downturn, are under great financial strains merely to feed their captives and run their cafés, and their scientific expenditures have been similarly reduced. It takes a great deal of money to run a zoo, and the science is not necessarily an important part of the enterprise in terms of attracting, entertaining, and satisfying audiences. It is important for zoos to *say* they are doing science, so that the audiences will feel as if by visiting the zoo they are supporting, or even vicariously engaging in, such science, but it is unlikely that the visitor will actually keep track of the research results or read the scientific papers that emanate from zoo science. The actual scope of this science is expendable. Zoos are not accountable to their visitors for the level of scientific output, but it is nevertheless in their interest to pretend that they are doing science and to sustain at least a token measure of scientific activity.

Historically, the zoo has presented itself as a scientific archive, a place where specimens are collected, preserved, cataloged. As such, it invites comparison to the discourses of the great scientific animal-archival enterprises of the past. Scientific compendia of animals bestow a sense – a false sense – of ownership, control, mastery over nature. It is something people have been doing for thousands of years, and still

today, on the Internet, we are doing it voraciously. In 2008 E.O. Wilson launched a Web site called the Encyclopedia of Life, in which he aspired to allocate a Web page to each of the 1.8 million known species of life forms on earth.[4]

Zoos have the palliative effect of making the public less concerned about threats to animals – less worried about their diminution in nature – because they preserve (token) animals in this archival capacity. We have them cataloged, in detailed scientific nomenclature, so it matters less if they are endangered in some world out there that we rarely experience anyway.

Encyclopedic scientific animal archives compete with the real-life animals. We have a habit of framing the natural world in ways that suit our purposes and facilitate our interaction with other forms of life, our use of them. We want everything to be available and accessible to us, and zoos exemplify this craving for a vast helping of nature served up quick and easy. Perhaps nature would be more secure if it were harder for us to get at it, harder to understand, to quantify, to arrange.

Looking back at people's relationship to nature over the past centuries, we see on the one hand an accelerated effort to learn about and "arrange" and archive plants and animals, and on the other hand, we see an exponentially increasing exploitation of nature – unsustainable harvesting, habitat destruction, deforestation, greenhouse gas emissions, industrialized agribusiness. These two phenomena are related. Either our sophisticated encyclopedias and taxonomies directly abet the exploitation, or they insufficiently persuade us of the importance of ecology on its own terms. Either way, the discourse is dangerous.

The great age of encyclopedias, the Enlightenment and Victorian periods, produced works replete with information about exotic "others," yet regarded them with detached superiority. Writers and readers did not enter into the perspectives of the subjects, but as philosopher Alasdair MacIntyre argues, they "insisted upon seeing and judging everything from their own point of view."[5]

An archive presumes that its scientific ideologies and epistemologies – its ways of valuing, processing, and diffusing knowledge – fittingly overlays its content. Aristotle's *History of Animals* colors its subjects in the hierarchical tropes of Aristotelian logic, arranging nature as a ladder, a *scala naturae,* the seed of the "Great Chain of Being." Human beings (especially men) are construed as the ultimate form of life, and the presumption of human perfection renders all other creatures inferior.

Linnaeus's eighteenth-century *Systema Naturae* captured all of the natural world within one schema, transforming the amorphous "wild"

into structures that were named and organized – thus somehow, owned – by people. Harriet Ritvo writes in *The Platypus and the Mermaid, and Other Fictions of the Classifying Imagination*, that Linnaean classification "separated people from the other animals." Taxonomists following in this tradition "easily conflated the metaphorical dominion of knowledge with more practical or literal modes of appropriation. Naturalists in the mother country automatically claimed the rights to classify the plants and animals of its growing colonial territories…. [S]ystematization was a means of consolidating the intellectual dominion of science over nature."[6]

Linnaeus's Latinate names and his Enlightenment hierarchy reflect a particular set of values. Imposing classifications and epistemological portals bespeaks control, establishing the vocabulary that privileges some types of interaction with the subject and discourages others. Structuring the natural world meshes with the structure of imperial power.

Even Charles Darwin's *Origin of Species,* for all its brilliant science, cannot fully escape the paternalism, racism, and sexism of its age. Darwin's discourse of rationalism and empiricism abets the Victorian narrative of progress. As his metaphors invoke capitalism, competition, polity, and market niches, his enterprise dovetails with the ecologically disastrous ideology of imperial expansion. "The classification of animals," Ritvo writes, "is apt to tell us as much about the classifiers as the classified."[7]

The most popular scientific compendia resonate with the stylistic eloquence of their creators. Jean-Henri Fabre's entomological writing is so vividly poetic that Victor Hugo called him "the Homer of the insects." The creatures in John James Audubon's 1838 *Birds of America* resonate with the rich ethos of American Romanticism – colorful, powerful, dramatic, brash – while those in Buffon's eighteenth-century best seller *Histoire Naturelle* embody the piquant grand generalities of the French Enlightenment.

Yet those efforts do not reflect different natures. Their subject is the same – but transformed, transposed, through different scientific lenses, different cultural lenses, different frames. We must recognize how much our own perspective colors our accounts of nature, and move beyond it to understand nature as it really is.

I am leery of the scientific value of zoos, and of the self-serving authority of scientific discourse as it emanates from zoos. "Good science" about animals and ecology cannot come from conditions of captivity and decontextualization. Zoos cloak themselves in the mantle of scientific authority, but they are in fact beholden to the realities of the

economic marketplace, which draw upon a discourse that is in many important ways at odds with science. When zoos engage in scientific exploration, it tends frequently to involve what zoo managers describe as "charismatic megafauna": lions, panda bears, all prime zoo attractions. Economic discourse, thus, rather than ecological discourse, motivates the agenda of zoo science.

In the zoo, all the animals' ecological contexts are absent. Ecological discourse defines a huge part of who animals are, and what their lives are like and, absent this, we cannot learn about animals. Ecology is predicated upon the necessity of understanding the largest possible context for whatever we discuss. The butterfly effect, as described by mathematician and chaos theorist Edward Lorenz, encapsulates a fitting conception of ecological interconnection and complexity. A butterfly's wings might create tiny changes in the atmosphere that may ultimately alter the path of a tornado. A small change at one place in a complex system can have large effects elsewhere. Our contemporary ecological ignorance, if that is not too drastic a charge, comes from our refusal to acknowledge the long-range, long-term repercussions of our ecological behavior. While contemporary citizens are aware, theoretically, of ecological imperatives and the need for conservation, sustainability and reduction of our carbon footprints, we are seduced by large homes and cars, consumeristic excess, and the construction of civic infrastructures (roads, housing developments, shopping malls) in places and at scales that compete with nature, and that destroy nature.

With regard to animals, these activities take many forms, but we may focus simply on habitat destruction and environmental degradation. We build, we mine, we harvest at ever-increasing levels, to sustain the mantra of economic growth in ways that impinge, acre by acre, upon habitats where animals live. Once we have encroached, once we have taken or polluted animals' habitats, the animals can no longer live there. They flee, they diminish, they die. This is our current troubling ecological dynamic.

The ecological danger of zoos is that they allow us, indeed, encourage us, to sublimate the reality of the dangers that animals face in the wild, in their habitats. Zoos do this by minimizing our sense of context, our sense of habitat – by encouraging the restriction, rather than the expansion, of our ecological consciousness. If we were properly ecologically attuned, we would see an animal, say, a panther, and we would then expand our vision, our consciousness, to see that panther as fundamentally comprised of her environment, the space in which she naturally ranged. A river might run through her range, so we must

then expand our ecological attunement to include the riparian ecology. Where does the river originate? What runoffs might be threatening the river's health? What human communities upstream control the river's flow? What sort of land use is occurring in its watershed?

We must attend to the panther's cohabitants. What other animals live alongside her in her world? What migratory animals pass through? What plants contribute to her ecological well-being, and what sorts of conditions affect their prosperity? What climactic conditions support her ecosystem, and what threats, from climate change, for example, threaten climactic patterns? What are her population limits? What is her place in this ecosystem – what does she take from it, what does she give back, and how would it function without her? These kinds of deliberations, to my mind, represent just a small sampling of the crucial ecological discourse that attaches to every animal.

But in a zoo, this discourse is abrogated, condensed and conscribed to fit into the small and keenly delimited box or cage – the frame – in which all animals are constrained. We are told by the signage that this cage contains a panther, but I would argue that it does not. It contains a small and profoundly compromised token of a panther, but lacks so much of the animal's ecosystemic identity, her ecological meaning. We are looking at a panther through massively limiting ecological blinders. And, worse, we are told, explicitly or implicitly, that the way we are looking at this caged, diminished panther is a good thing. We are persuaded that our attendance here in the zoo is ecologically enlightening, that we are "connecting" with other animals, that we are somehow contributing to their survival and well-being through some fantasy of ecological research and reparation that zoos constantly pretend to be undertaking for every captive animal they display. Viewers see an animal ripped out of its context, ripped out of its ecology, and are cajoled to believe that this is ecologically educational. And the reason for this, in my grand conspiracy theory, is that this allows us, even encourages us, to sublimate and deny the real ecological discourse – a discourse of vast range and interconnectivity, as exemplified in the impact of a butterfly's wings on a tornado in another hemisphere – because it is psychologically painful for us to confront the real ecological impact of our unsustainable overconsumption. We are bad ecological citizens, and our consequent rationalization of this condition is to rewrite ecological discourse, to turn it on its head, to redefine ecology in a way that strips it of its vitality and exculpates us from condemnation according to its praxes. This diminution of ecological consciousness parallels the phenomenon of "Newspeak" in George Orwell's *1984*, the whittling down

of the language to a profoundly small number of words, thus making it impossible to criticize the dictator, Big Brother, and his totalitarian hegemonies.

Zoos enact a comparable whittling down of discourse. Zoo-goers are shown an animal removed from, and stripped of, his ecological context, and told that he is nevertheless the same animal. Perhaps even he is a *better* animal than another in a distant, inaccessible ecological context, because this one is in front of our eyes. We like things that are immediately visible, immediately accessible, immediately consumable in their convenient frames. Those commodities that are difficult to experience, difficult to possess, taunt us with their inaccessibility to our reach and our unrequited appetite for them. An ecologically accurate animal is, by definition, beyond our grasp – panthers do not live in Paris or Atlanta – thus are less valuable in our economy. It is, precisely, the removal of an animal's ecological authenticity, his ecological value, that coincides with the creation of his economic value. This economic value may be expressed, for example, simply as the money that a cute new bear or giraffe brings into the zoo, or, more broadly, more complexly, as the justification and self-celebration that a zooful of animals, a modern day Noah's Ark, confers on the society that displays these animals. The supposed care and devotion that we lavish on zoo animals implies that we are ecologically sensitive. But it involves a wholesale rewriting of ecological discourse to sustain the fantasy that a captive and decontextualized animal in a cage has any coherent relationship to valid ecological discourse.

Many people have told me they had their first glint of ecological consciousness while looking at a lion in the zoo. To this, I respond: your consciousness was highly inflected by the dynamics of power. You were standing in freedom, in your hometown, outside the cage, and the captive animal stuck inside had been taken from *his* hometown. Your ecological consciousness was wrong.

Cities should stop building zoos, and people should stop going to zoos. We should examine zoos, and zoo-going, as examples of human sublimation of real ecological threats, and denial about our danger to other species. We should conceptualize zoo-going as actively dangerous for children. The zoos' ecological messages are false, and it is therefore unethical for zoos to abet the dissemination of this disinformation. It is unethical for zoos to capture animals, or breed animals, and force them to live in uncomfortable and inhospitable artificial compounds.

Like so many other visual cultural venues, the zoo serves *our* purposes, our desire for entertaining spectacles, promoting our sense of

ourselves as masters of all we survey; but whatever values we reap from zoos are at the expense of the animals caged therein. Zoos say that they work to make these animals comfortable; I do not think they do. Zoos say they are preserving endangered animals and, again, I dispute this. Captive breeding programs are flawed because it is virtually impossible to sustain a broad enough gene pool in the long term, so zoos are simply breeding captive animals with inmates from other zoos, which will provide a source of animal displays for zoos for a few more generations but not indefinitely. An ethical imperative of preservation would be the ultimate release of the animals and their reintroduction into their original natural habitat. This is not happening, and it cannot happen, because endangered habitats are becoming increasingly compromised and toxic. It is much more ambitious, and much more expensive, to conserve or repair a damaged habitat than it is to breed a few token animals for display. Zoos disguise the real dimensions of the ecological crisis that our habits of overconsumption have brought about. It may be psychologically soothing to mask the evidence of habitat destruction and extinction that has been escalating exponentially for the past several generations, but it is not ethical to do so. We need to find ways to educate people about animals, and about ecology – ways that tell the truth.

7
Weird Animals (or, Why Did the Chicken Cross the Road?)

Americans do weird things with animals. Others do as well, but as in most other mass-market cultural enterprises, Americans lead the way with our commercially powerful resource-intensive anthrozoological perversities. These perversities proliferate amid America's imperialistic orientation of entitlement toward our ecosystem ("It is all ours, we bought Alaska, so drill away"), an orientation that sanctions animal fetishism, speciesism, and short-sighted greed for material goods and experiential novelty that we reap at the expense of nonhuman animals.

Probably, our imperious stance toward the natural world grows out of the same sensibility embodied in the political ideology of Manifest Destiny. Nineteenth-century Americans invoked Manifest Destiny to justify westward expansionism toward the Pacific Ocean. In the twentieth century a comparable ethos of self-important entitlement underlay America's claim to the role of superpower. And now, having achieved a virtually unilateral geopolitical dominance, the next realm ripe for the onslaught of Manifest Destiny is nature. More trees must be cut down, more habitats bulldozed, more wetlands dried out, more wilderness plundered, more coal mined and burned – all in the name of American progress.

We Americans have a dysfunctional, and sometimes paranoid, compulsion to "disarm" the threat we see emanating from "nature-as-other." Our cultural exploitation of animals often facilitates – directly or indirectly, consciously or subconsciously – this agenda of disempowering animals. We seem to embrace Freud's expression that a civilized society is one in which "wild and dangerous animals have been exterminated" (30). People's weird constructions of animals are a way of figuratively exterminating them: defusing their wildness and danger, transforming these properties into harmless, clownish impotence.

When we encounter other animals, we often selfishly abuse and manipulate them, and on a grand scale. Mostly, we simply do not understand them, and we are certainly poorer for this. Our cultural interactions and visual representations are ecologically significant. The way we treat animals in culture affects how we treat animals in nature. Our imagistic exploitation and manipulation of animals foreshadows our more literal incursions into their world and paves the way for these incursions. What might the world look like if we could transcend demeaning *idées reçues* about other animals' *abjection*, their lack of control over their own representation, and commence upon the challenge of seeing them in a way that would enable us, in the future, to generate representations that are more ethically and ecologically reasonable? "What is at stake ultimately," as Erica Fudge writes, "is our own ability to think beyond ourselves" (22).

Americans are not unique in our proclivity for using animals weirdly. A Brazilian "artist," Eduardo Kac, created what he calls a GFP Bunny: GFP stands for Green Fluorescent Protein, which is normally produced by genes in the DNA of jellyfish. This rabbit glows in the dark. Kac calls it transgenic art, billing this project as the first artwork to include a genetically altered mammal.[1] Nathalia Edenmont is a Ukranian "artist" who kills animals to make art. She constructs displays of the taxidermized heads of mice, rabbits, doves and cats – for example, a sculpted hand features the head of a dead mouse on the tip of each finger. Her gallery defends her by saying, "One can, of course, choose to think that it is always wrong to kill animals in the name of art ... [but] many other beautiful things hide some sort of suffering.... Many of us eat meat, wear leather, or use makeup that has been tested on animals.... But when a picture shows a dead rabbit, all hell breaks loose.... She is not the first to use dead animals in works of art."[2] Indeed she is not: English "sculptor" Damien Hirst, too, does weird things with dead animals: *This Little Piggy Went to Market, This Little Piggy Stayed at Home* (a pig cut in half); *The Physical Impossibility of Death in the Mind of Someone Living* (a shark floating in formaldehyde); and *A Thousand Years* (a rotting cow head with live flies). One could enter into a long and heated debate about how such tableaux relate to the tradition of art: what this work means, and whether, as Hirst has suggested, we may actually read into his oeuvre some sort of redemptive, eye-opening exposé about the human–animal relationship.[3] But I prefer not to have that discussion, and simply to dismiss him as brutal in the particular mode of high humanism. That is, the conceit that we can do what we want with animals, because ... we can do what we want

with animals. Anyone can do anything. This is my pithy formulation of the humanist ideology.

But even amid this international carnival of anthrozoological weirdness, I would argue (on behalf of my countrymen and women) that Americans do the weirdest things with animals, and with such extensive global ramifications, that we would do well to investigate, and ideally to reform, some of our cultural habits and behavior. My premise is that it is morally, intellectually, and ecologically preferable not to do weird things with animals. By "weird," I mean *contra natura*; silly, irrational, counterproductive or retrograde, in terms of envisioning a relationship that people *could* have with animals that would be more fulfilling and better suited to our role as one species among many in a complex and vast ecosystem. As someone who tries to be ecologically informed and intelligent – aware of the complex interrelations that exist between me and other animals, and plants, and the environment; intent upon behaving in a way that respects their rights and the integrity of all these elements, and minimally impinges upon their prosperity – it makes me cringe with embarrassment for my fellow human creatures in the presence of the pervasive cultural weirdness that manifests itself so frequently. Characterizing this sensibility as "weird" is an admittedly simplistic, perhaps even juvenile way of trying to shame the weirdoes into recognizing their annoyingly bad form. On the schoolyard the taunt is hurled with the intent of challenging, even bullying, the deviant subject to adhere to social norms. In this chapter the taunt is meant to challenge the ecologically deviant actors among us – the anthropocentrists – to stop behaving in a way that mocks the "normal" symbiotic dynamic of our ecosystem.

To give a self-serving example of how people might benefit from a more enlightened relationship with other animals: during the 2004 Asian tsunamis, many animals escaped. They seem to have had some sort of "sixth sense" (though this metaphysical construction might simply describe other animals' keen sensitivity to the elements and to the planet's rumblings). It was widely reported that no animal corpses were found among the tens of thousands of human corpses; the animals apparently fled to higher ground before the waves hit.[4] Eyewitnesses reported that elephants screamed and ran for higher ground, dogs refused to go outdoors, and flamingoes abandoned their low-lying breeding areas. Despite our earthquake and tsunami alert technology (which, like the Maginot Line, was facing the wrong way[5]), despite all the satellites and sensors and computer models, we as a species failed to

save ourselves while the animals survived. Maybe someday the animals will tell us how they did it.

We do in fact talk to animals today. Animal behaviorists, modern day Dr. Doolittles, teach animals human signs, words, and grammars. The apotheosis of this enterprise, as it now stands, is that we teach orangutans how to communicate in sign language, such expressions as "I would like to buy an ice cream cone"; and when the animal gives over the correct change (he is paid in coins for performing upkeep tasks in his compound), he gets his ice cream.[6] Learning to talk with animals is a great idea, but we should not be talking about ice cream. Maybe somebody thought it would be a clever market expansion to train another species to consume our goods in a commercial economy, but I think we need to be talking more along the lines of: How can we escape from the tsunamis? And what do you think about what we are doing to the forests? Do you have any better ideas?

I want to interrogate humanism in terms of how we have integrated animals into our cultural worldview. I am interested in what part animals play in this bundle of culture in the age of humanism, and what comes next. What part will animals play in a posthuman consciousness? Let me cut to the chase and acknowledge that my answer, indeed the final three words of this book, will be, "I don't know." But I would nevertheless like to ask these questions and, by critically examining the state of animals amid the last days of humanism, try to inspire others to grapple with some of the problems I am unable to resolve myself. It appears that the collapse of humanist ideology is imminent in a dithyramb of toxic junk food and toxically bad culture (reality tv) and insane globalist fantasies (Iraq, "mission accomplished") and economic upheaval and ecological suicide by SUV. We might think about where people will stand when the dust has cleared, and we would be wise, in this assessment, to look carefully at animals: to look at people and animals; to look at people *as* animals.[7] Nonhuman animals have not been corrupted in the humanistic fiasco as we human animals have been, so their virtues, their survival instincts, their ways of being, may be better suited as models to lead us more sustainably into the future.

* * *

The specific phenomenon that inspired this chapter is a series of photographs of old women wearing blouses made out of dead chickens. Reading a story about this in the newspaper one morning, I said out

loud to myself, "Americans do weird things with animals." The photographer is a Brooklyn artist named Pinar Yolacan, and her 2004 series is entitled "Perishables."[8] Yolacan sewed these blouses herself, out of raw tripe and chicken skin and other assorted pieces of the birds. I presume that my reader will indulge my premise that this is weird. Let me speculate as to what might be going on in these photographs: what the "artist" might think she means.

Indeed, people *do* wear dead animals in socially and fashionably acceptable ways: leather, fur, down, so why not chicken? These blouses are obviously meant to disgust us on some level – but why? Certainly the ways in which people use animals are arbitrarily culturally conditioned, and Yolacan might have thought it would be interesting to make us reflect on why people regard certain exploitative uses as beautiful and valuable while we respond viscerally to others as disgusting.

Perhaps we are meant to wonder what it would feel like, and smell like, to be these women wearing these chickens. Maybe Yolacan is inviting us to think about our sensory relationship to animals. Again, it can be delicate, beautiful – the smell of charred flesh wafting

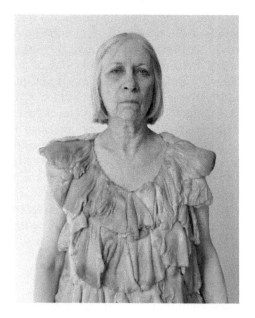

Figure 14 Pinar Yolacan, Untitled, from "Perishables" series 32 × 40 inches, C-Print, 2004. Courtesy of the artist

through a restaurant, if that is your fancy; perfumes from secretions that are harvested from animals (musk from deer, ambergris from sperm whales, castor from beavers, civet from the civet cat) – or it can be putrid. Presumably these pictures mean to evoke the putrid end of the scale and, yet, the women who are the human subjects of these photographs actually *do* look somewhat dignified and seem as if they fit at least somewhat in these skins, and there is even a certain beauty about the forms, the clothes, which are not unlike some styles of haute couture. So we come back to the question of how we relate to animals, how we use them, how they appear in our culture: What do we *do* with them? What boundaries or guidelines (if any) are there that mediate what we do with animals? What ethical guidelines? What aesthetic guidelines? What fashion guidelines? What ecological guidelines?

I think the answer is, few to none. Yolacan's photos pretty clearly cross the line, but that line is already far afield. There are few guidelines, few rules about what we cannot do with animals, and this is weird – or, this facilitates and legitimates weirdness. Any extant guidelines are cultural conventions, and artists like Yolacan show these to be malleable, dispensable in the cause of art (as they are dispensable also in the causes of commerce or human convenience). Yolacan's photography is weird, I think, in a self-conscious, showy way. Other weird things that people do with chickens – on factory farms, for example, as Peter Singer describes in *Animal Liberation* – are more covert, things we would not want to look at or think about while nibbling on drumsticks. But they are fundamentally of a kind with this public artistic weirdness, situating a nexus of all the weird things we do with animals. They all supplement each other, and they all contribute to the anthropocentric hegemony that keeps animals subaltern.

I wonder, as I look through Yolacan's lens at a woman and a chicken, a woman in a chicken: Where's the chicken? Yes, it is there, but there is no *there* there. The only chickenness in these images is negative: the absence of a chicken, the mockery of a chicken, the destruction of a chicken, the perverse human transformation of a chicken. (Carol Adams's formulation of the "absent referent" – by which animals "in name and body are made absent *as animals*"[9] – is germane here.) I am not suggesting that it is the burden of every artwork to interrogate the chickenness of the chicken, but I am ecologically offended by the pervasive failure of human culture, and Yolacan's work conveniently exemplifies this aporia, to acknowledge with any serious engagement the

integrity, the consciousness, the real presence, of other animals in our world.

"Perishables" calls to mind another weird, famous juxtaposition of animals with human fashion: a photograph called "Dovima with Elephants," from 1955, by Richard Avedon – one of the best-known fashion photographs ever published.[10] Dorothy Virginia Margaret (Do Vi Ma) Juba was a high-powered supermodel in the 1950s. In the photograph, Dovima stands in the middle of the frame, striking a pose of lavish elegance. Her left foot points forward in a lithe step, her right obscured by the large trailing creamy sash wrapped around a tight, sleek black pantsuit by Dior. Her arms are spread as if she were in a ballet about to take flight. Behind her are four elephants (one of whose body appears intact; the other three are only partly in the frame); she places her right hand on one elephant's trunk, and appears to touch another elephant's ear just lightly with her left hand. The elephants are not static: three of them have legs lifted, giving a sense of movement and energy. Behind the elephants, the backdrop is a plain photographer's screen. The group stands on a wooden platform covered with a layer of straw and, less immediately visible, chains that are attached to the legs of at least three elephants. The trope here is beauty and the beast. Avedon represents the elephants' chained raw power, subservient to the delicate princess, and so animality becomes transformed into a fashion accessory.

The tension in this encounter that empowers Avedon's image involves a contrast, a contest: between the beauty of nature and the beauty of human cultural artifice. Who is more powerful in this shot? Who is more beautiful? (These two questions are really the same question in the discourse of fashion photography.) That is what Avedon is asking. What I am asking is, why are we even playing these games? Why are we so wrapped up in the discourses and fetishes of interspecies power relationships, which displace the discourse of ecological relationships? In humanism, we play out these discourses of power by cloaking them in our uniquely human tropes of aesthetics – fashion, art, and so forth; and this, I suggest, is our fundamental hubristic flaw. The discourse of ecology embodies its own power dynamics, but it does not play games like this. Power is a real force in nature, and ecology integrates the realities of power struggles, but that kind of power has a much greater logic and function than this kind of power. *This* power that Avedon and Dovima manifest here – power over the elephants, power over nature – is just...weird.

Fashion writer Annalisa Barbieri writes that this photograph

> to me typifies what fashion photography should be about.... There
> are people that criticise fashion photography and say that it is not
> depicting reality, but I think it should always be inspirational and
> aspirational. I love the scale of this picture. I love the fact that she
> looks almost as tall as the elephants and the way the sash is done
> lends a very long line to her.... Having also worked with animals
> in fashion photography I know that there must have been a crew
> of several dozen to actually control them and I wonder how many
> takes they must have used to get this picture right. I just love the
> sheer scale of it and I think if more people did more things like this,
> instead of the reality that is creeping into fashion photography, we'd
> have far more beautiful images to look at.

Barbieri looks at the picture and infers control: dozens of people control-
ling the animals, though beyond the frame of the photograph – it *looks*
as if it is just Dovima, and Avedon, and Dior controlling the elephants.
But the controlling human presence is, as Barbieri demonstrates, pro-
foundly implicit in this image.

Consider the composition. Dovima is, of course, in the middle, and
her corporeal presence is unmolested. But three of the four elephants'
bodies are cut off: is this an anticipation of Damien Hirst? Perhaps that
is an unlikely overreading, but perhaps not – we cut animals in half, cut
their parts off, separate them, disfigure them, at will. What Hirst does
with his animals is the logical culmination of the ethos underlying the
framing, the cropping, the composition, of the animal images seen in
Avedon's work.

Dovima's hand rests on an elephant's trunk, which is raised and
seems to be in motion: as if the animal is responding with a semiotic
erection. Another elephant's trunk is cropped out, and Dovima's sash
suggestively replaces this trunk. Dovima and Dior convey a sense of
emasculation as the lithe woman phallically overpowers the great big
animal. Through the marvels and powers of culture, of fashion, her
dick trumps "his." (Actually, the elephants are probably female, like
most circus elephants, as bull elephants are too difficult to control, but
the semiotics of animal representation often ignore literal biological
realities.) Dovima has the flashiest phallic-icon in this picture.

Elephants are "cool" because they have trunks – that is their sell-
ing point in visual cultural iconography. A reductive commodification

condenses the animal into a synecdoche, one part representing the whole, that becomes the distinctive selling point. A giraffe is a neck; a peacock is a feather; a zebra is a stripe. Dovima outdoes the elephants at their own game, as her sash displaces/replaces the animal's trunk. Her pose, her presence, is inspired by them, and I suggest that something is simultaneously taken from them, and they thus become much less necessary in this tableau. They are a backdrop, a reference point, but no longer subjectively significant in any sense. Their chains are almost incidental to their figurative captivity in this photo (they are chained in so many other ways), but nevertheless confirm their literal imprisonment, and our power and desire to chain them. The power we presume by keeping them captive allows this weird woman with a weird name to stand right up close to them for a clever photo, despite the danger that there *should* be in this tableau. Confirming Freud, the dangerous animals have indeed been exterminated, and what we see framed here are the pale simulacra, the ghosts, of their once-dangerous spirits.

Half a century later, with a postmodern sideways glance at Avedon's weird elephants, the fashion magazine *W* offered a spread featuring elephants dressed by top designers.[11] Karl Lagerfeld used ninety yards of tweed to make a pair of Chanel suits, an ensemble including matching hats and earrings. Manolo Blahnik designed lace-up shoes. Helmut Lang designed a black satin-striped cotton jersey tank top and a beaded bra. A *New York Times* article about this spectacle quotes the photographer, Bruce Weber, saying: "The wonderful thing about elephants is they love to work, so it wasn't like we were forcing them to wear clothes" (Horyn). Weber reiterates the myth of the contented slave, a cultural lynchpin of slavery from earlier American history. I would respond to Weber: it is not like you *were not* forcing them to wear clothes – it is not like they asked for them.

The *Times* article included an image of Lang's design sketch for one of the "models," named Tai. The sketch depicts an elephant overlaid with lines – measuring lines, for taking the dimensions of the cloth – but these lines also suggest chains, not unlike the chains in Avedon's photograph. Indeed, Lang's lines *are* chains, and the measuring lines at the borders of the sketch form a kind of symbolic cage. Every frame becomes a cage, for animals in visual culture. Lang's sketch is, seen another way, an elephant chopped up into pieces, which is what people are prone to do with animals. We chop them, we crop them, into the pieces that comprise Yolacan's blouses and accessories, or the measured pieces, precisely quantified on Lang's sketch, 156 inches, 186 inches,

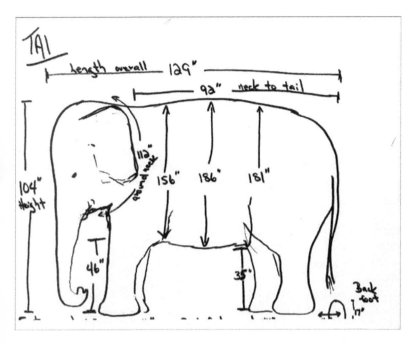

Figure 15 Sketch for a fashionable elephant. Drawing by tailor from Helmut Lang, made-to-measure studio, 2004

181 inches, that we use to assault these elephants in *W*, to hide their animality – to cloak them; to mock them; to reduce them to human fashion. We force them to model our postlapsarian shame of our natural bodies. We make them wear the ridiculously uncomfortable shoes that we wear, because we are slaves to fashion and misery loves company. Clothes make the man, they say. Now clothes make the animal too: or make the animal a (parody of a) man. How weird to think these elephants would want to be like us. So these designers hope that some day every elephant will have a designer outfit? (To wear on their outings to buy ice cream cones, perhaps?)

In *The Sexual Politics of Meat*, Carol Adams explains how dismembering animals is a step toward objectifying them. "The institution of butchering is unique to human beings," she writes. Butchering involves fragmenting a large, impressive creature into small, unthreatening, standardized pieces that are unrecognizable as the original animal. Adams calls butchering a way of rendering animals being-less. In a slaughterhouse, "an animal proceeds down a 'disassembly line,' losing

body parts at every stop. This fragmentation not only dismembers the animal, it changes the way in which we conceptualize animals." After butchering, the name of the animal changes (from cow to beef, from pig to pork, ham, and bacon), and "only then can consumption occur."[12] The same is true for cultural butchering and consumption, which is what Yolacan, Avedon, Lang, and the other fashion designers are all doing with these animals. Another example of the cultural fragmentation of animals is the disassembly (flensing) of the whales in Melville's *Moby-Dick*. How the whalers cut up and use every last morsel of the whale has been conventionally regarded as an example of human ingenuity and resourcefulness, a puritanically obsessive efficiency; I read this, on the other hand, as a monomaniacal destruction of the whales' integrity. Sadly, these readings are not mutually contradictory: human ingenuity and violence against animals are complementary facets of the same sensibility. This is all weird.

The "designer animals" framed by Avedon, Yolacan, Lang and others are all very carefully posed in their tableaux. At the other extreme from the designers' meticulous arrangement, the Internet overflows with another kind of animal images: these are common, spontaneous, "amateur" pictures of animals on Web sites like cuteoverload.com, icanhascheezburger.com, petpics.com. A trope that typifies what happens in these frames can be found by doing a Google Image search for "cat in box," which reports over 52 million results.

Two of them, from petpics.com, speak to our fantasies of framing animals in tropes of human cultural commodification, figuratively (and here, literally) putting animals in boxes. One kitten looks out at us from a used *Pop-Tarts* box, and another spills out of an empty *Tampax* package. I wonder about the staging of these photos: Were they as complicated and as laboriously organized as the photograph of Dovima's elephants? Or were they spontaneous, kitten-originated experiences? "Hank, Fluffy just crawled into a box – grab your camera so that we can put this on petpics!" These pictures have no need of the extensive power-wielding crews that Barbieri imagines beyond Avedon's frame, and yet, in terms of the cultural subordination of animals, I suggest an equivalence. These seemingly innocuous, casual pictures of cats in boxes embody as much weird force as Avedon's classic image.

I wonder if the specific commodities referenced here are significant. Pop-Tarts are yummy, processed, convenient junk food. Tampax are a product designed to make the messy course of nature more manageable.

Both these products represent quick, easy, commodified responses to the biological imperatives of hunger and menstruation. Both come in individually wrapped units, in lots of different flavors. In these images, the boxes are "recycled" in a way that suggests that our animals, especially when they are at the peak of their cuteness – and are therefore most valuable, in the currency of American cultural aesthetics – mesh well with the discourse of American consumerism. (Imagine if you really could buy cute kittens in assorted flavors and styles, as you do with Pop-Tarts and Tampons.)

In fact, I believe it is *not* the case that the tropes of American material consumption facilitate the well-being of animals. The discourse of consumerism is dangerous to animals, and counterproductive in terms of advancing our ecological understanding of anthrozoological relations. The pet owners who put these kittens in the used boxes, or capture their images when they ramble into the boxes of their own accord, suggest that these animals, like all animals, are somehow to be consumed .

* * * *

Siegfried & Roy do weird things with animals; they are animal "trainers," showmen, illusionists, who ran a show on the Las Vegas strip for thirty years featuring a kitschy mélange of flamboyance, magic, and animals. The keynote animals in their act are royal white tigers. According to their Web site (Siegfriedandroy.com), there were only 200 of them extant in the world in 1998, mostly in captivity, and "fifty eight of them are Siegfried & Roy's White Tigers of Nevada." White tigers are very rare – they are, in a sense, weird freaks. It is counterprotective for a tiger to be white, both in the jungle and in a culture that fetishizes the fashion of exotic whites. They have been widely poached for their pelts and body parts, which command tremendous prices on the black market. (The black market for white tigers: there are some interesting semiotics lurking in there.) The result of inbreeding, these tigers are quite rare in the wild, likely to be born in zoos and captive breeding programs. White tigers of Nevada: weird! The nomenclature bespeaks proprietary control (all of Nevada owns them), a perverse geographical reconfiguration. They are *not* "of Nevada" ... except that they are now. Siegfried & Roy have made them "of Nevada" and, given their name, where else but on the Las Vegas strip would White Tigers of Nevada belong?

In October 2003 a White Tiger of Nevada named Montecore lunged at Roy Horn during the show and dragged him offstage. The tiger closed his jaws on Roy's neck; his heart stopped for a minute and he was resuscitated. Bleeding from a cut artery restricted the oxygen flow to his brain, leading to a near-fatal stroke. Doctors had to remove part of his skull and sew it into his abdomen to relieve swelling on the brain until it could be replaced weeks later. The entertainer was left partially paralyzed and lost control of his speech. During the attack, most of the audience thought that this was all part of the show – part of the illusion.

The tiger was not killed, as would normally happen when an animal mauls a person. Roy himself commanded that the animal's life be spared, in a display of his magnanimous love for the tigers despite Montecore's beastly behavior. My reading of this story, at first, was, simply and unkindly, as Dante would say, *contrapasso*: what goes around comes around. It seemed self-evident that this is what happens when people play with fire, a sign that we should not be doing this sort of thing.

But as a parable in my cavalcade of anthrozoological weirdness, I think Montecore's attack – might I say, "Montecore's revenge?" – begs more detailed scrutiny. Indeed, in the popular reaction to this incident, the moralism that seemed so obvious to me (i.e., Roy had it coming) was not at all widespread. Roy himself said that he thought the tiger might have been protecting him (from what?) – trying to drag him to safety. A mauling, or at least the possibility of a mauling, is in the subtext of every such carnival show. That is what people pay hundreds of dollars per ticket to see: a non-mauling, on most nights, though they know, deep down, that there *might* be, or even *should* be, a mauling. So the audience finally got what they expected, what they knew and perhaps on some level even hoped would happen some day, but at the same time, as I noted, the audience responded as if this were simply part of the show. This illustrates our conflicted behavior as a cultural audience, our head-in-the-sand, willful self-deception with regard to animals and what we do with them. We are flirting with danger, thrilled by the spectacle of human mastery (Siegfried & Roy's slogan is "Masters of the Impossible"); and then, when the animal attack comes, the audience does *not* revise their paradigms accordingly, does not acknowledge that one might reasonably have expected an animal revolt to happen. Animal shows, circuses, and carnivals, other than this one, were not cancelled or outlawed after Montecore's attack.

In the media, Roy staged a comeback. Maria Shriver interviewed him on a television news magazine show that offered, in the words of its

promo, "an intimate look into his harrowing experience[,] ... chronicling Roy's journey, including never-before-seen footage and new details about his against-all-odds recovery."[13] Roy's narrative is, loosely, in the mode of the great white hunter tales of African adventure. The wily, persevering hero is threatened but not overcome by the wild animals' brute force. Frank Buck was the most prominent adventurer in this genre, in the 1930s. But today, the narrative setting has shifted to Las Vegas instead of the "dark continent," into a flashy indoor arena instead of the jungle, and the tigers are white instead of the usual camouflage variegation. It is all very precious and tame instead of wild and woodsy, and instead of the macho, khaki-attired he-man, Frank Buck, the heroes are a sequinned gay couple. Their Web site features the tigers in their resituated "habitat." An image of a tiger traipsing through their living room has a caption reading: "Here you can see one of our magnificent Royal White Tigers making himself at home in our Jungle Palace. Although the tigers generally prefer to roam in the lush greenery, occasionally they like to silently pad from room to room, paying us a personal visit." The Jungle Palace is Siegfried & Roy's residence, which features, as another Web page explains, "a hand-painted Sistine Chapel Dome It enhances the baroque splendor of one of our favorite areas – a cappuccino bar with antiques and collectibles from around the world." In this fantasia-habitat, antiques, miscontextualized artistic reproductions, cappuccino, and tigers all feature as constituent elements of its global queerness.

This is the setting for the contemporary version of the conflict between man and nature. Having driven the real animals in the real jungle to the brink of extinction, we breed them and hoard them in Nevada and then play out our perverse contests with them in these extravagantly tacky culturally mongrelized Las Vegas sets. The icon of Las Vegas is its pastiche of skyline, bricolage gone berserk, with the Brooklyn Bridge replica next to the Eiffel Tower replica, next to the Empire State Building replica: all of which serves to reinforce the kind of geographical and cultural dislocational bastardizing that results in White Tigers of Nevada.

Unlike the Frank Buck versions of this story, neither man nor beast died in Las Vegas. But I think this was the last installment in this genre; I do not think it can happen this way again. Let us call this contest a draw, but next time, I predict, the animal will win. I do not know where exactly the battle will play out, or which people and animals will be involved, or how the animal's triumph will be figured, but I think that, on the brink of the posthuman age, there is a narrative compulsion for

the outcome that I have predicted. Putting gay men at the center of this kind of story is a sign that it is nearly exhausted: the heteronarrative versions that mainstream culture prefers to the queerings have been used up.

* * * *

Turning from real animals to animated animals: *Finding Nemo*, Disney's 2003 film, typifies the kind of American children's cartoons discussed in Chapter 4 that are lately becoming considerably more intelligent, more thoughtful, more sensitive to ecological and anthrozoological issues. The film is a big improvement on the days when the cartoon canon was comprised of alliterative animals (Road Runner, Porky Pig, Donald Duck, Woody Woodpecker, Mickey Mouse) who had no discernable relevance to the creatures they purported to represent. *Antz* (1998), an animated Dreamworks movie starring Woody Allen as the voice of a neurotic but lovable ant, is another thoughtful encounter with animals. In these films, animals are dignified with agency and complex characters. Their narratives are elaborated in a way that at least considers some degree of parity between human consciousness and animal consciousness; human emotion and animal emotion.

But while I laud these films, I am sometimes disturbed by audiences' responses to them. Here's the rub: after *Antz*, sales of ant farms (Foucauldian voyeurism run amok) went through the roof. Ants do not belong in ant farms any more than white tigers belong in Las Vegas or kittens belong in Tampax boxes or chickens belong on the torsos of old women. After *Finding Nemo*, sales of clownfish skyrocketed.[14] The dynamics of consumption show consumers to be *completely* oblivious to the message of the films. Let me spell this out, at the risk of belaboring the obvious: *Finding Nemo* – starring, in the title role, a clownfish – is a movie whose clear, unmistakable point is that fish do not like being in aquariums and will go to enormous lengths to avoid this fate. It is a movie that anthropomorphizes (perhaps inaccurately but nevertheless movingly) the family connections in animals and the extent to which animals value liberty, equality, and fraternity as we do, showing that they have comparable aspirations for integrity, self-control, pleasurable existence.

Audiences seemed to understand what *Finding Nemo* was dramatizing, and they seemed to enjoy seeing this but then apparently integrated that message into their cultural consciousness by going out and buying

clownfish. What were they thinking? What is it like for a family that owns a clownfish? Do the kids look at the fish and think of Nemo and his family? Does "their" fish remind them of the movie? Are they able to see the fish, think of the movie pleasurably, and yet not comprehend that their actions betray its narrative?

How does this cognitive-ethical process work? What allows people to indulge in such blatant hypocrisy? Is it that the Disney fish is a Hollywood fish, and the ones we buy are somehow less deserving of our benevolence? Maybe real fish even deserve to be imprisoned, because they are not movie stars? Does the cultural attention to one token, isolated animal somehow justify, or even demand, the oppression of thousands of others? Something along these lines explains what happens in zoos – audiences fetishize a small, manageable, distinct canon of animals, and then rationalize that they have given their ecological quota of loving attention to animals, so all the others become expendable. Perhaps people fetishize these animals because they are such weird freaks: a panda bear in Atlanta! A giraffe in London! Displaced, caged, chained…. Maybe we do actually perceive the difference between zoo specimens and real wild animals, and we "protect" the zoo animals while we devastate the populations of wild animals precisely because they are wild animals. We feel guilty that we are destroying their habitats, so if we eliminate them all they cease to be a problem. Maybe we oppress animals simply because we still believe in the Great Chain of Being and see it as our duty to keep the inferior species inferior. Maybe we are jealous of their wildness, their transcendence of the trials of modern industrial life. Maybe we want to drag them down to our level.

Any or all of these reasons might explain why people pretend to celebrate the figure of one animal, like Nemo, and then massacre, capture, destroy, imprison, all the others. Weirdly, we show our admiration for these ants and fish by bringing them into our lives as subalterns. We pay lip service to respectful and environmentally conscious considerations of animals in movies like *Finding Nemo*, but then we buy more clownfish.

Cassius Coolidge's famous image of dogs playing poker, *A Friend in Need* (ca. 1870 and still going strong over a century later), typifies the retrograde consciousness that a more enlightened cultural public will, perhaps, someday transcend in their desire to understand better the integrity, authenticity, and sentience of other animals. Americans do weird things with animals.

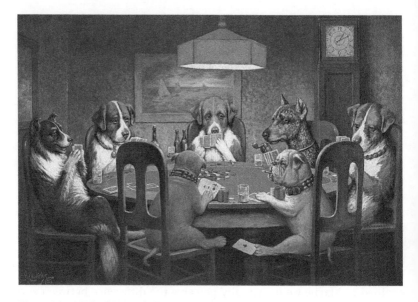

Figure 16 A Friend in Need, Cassius Coolidge, ca. 1870

Coolidge's kitschy image has been reproduced endlessly, in cigar ads, on calendars, on throw rugs, and in velvet. Dogs cannot sit on chairs in the way that Coolidge depicts. They would not want to. But Coolidge has made them. Dogs cannot play poker. They would not want to. But Coolidge has made them. The punch line of this painting, and the aesthetically ethical harm of it, is the disjunction between what is depicted and our knowledge of the *reality* that dogs cannot sit on chairs, smoke cigars, and play poker. Dumb dogs. But we have made them do so. Clever us. At the risk of sounding like a priggish killjoy – I know this is just supposed to be a fun painting – the more I think about it, the more I see a kind of violence here that is not so dissimilar from Yolacan's chicken-blouses or Hirst's rotting corpses. What Coolidge does with his dogs here strikes me as tremendously presumptuous. Like the behaviorists who teach orangutans to buy ice cream and the couturiers who drape elephants in jewelry and tweed pantsuits, Coolidge reifies the fantasy that ours is the best of all possible worlds and other species could do no better than to emulate humans, however ridiculous they might seem in so doing, and however foreign our humanity may be to their animality. I would be less offended by Coolidge if he, or other artists, also created art that involved human animals in the guise and context of

nonhuman animals (and did so without intending to cast aspersion on the "swinish" "beastly" humans so represented): if there were a reciprocity that bespoke a sincere desire to broach the species barrier and see how the other half lives. But that would not sell many cigars.

<p style="text-align:center">* * * *</p>

Why did the chicken cross the road? This question has challenged Americans for generations. It is, arguably, the single question that we most often ask about animals. I believe we should be asking a lot of questions, a lot of different questions, about animals.... And because we spend so much time asking this question over and over, we get distracted from the more important questions we should be asking – questions like how might we avoid a tsunami, and what is it like to be a bat?

The humor plays out as follows: Why did the chicken cross the road? To get to the other side. The answer is funny because it is not funny. It is obvious. Why does anyone cross the road? To get to the other side. But the joke lies in the presumptive disjunction between chicken and road. That is to say, the riddle is, indeed, initially framed as an anthrozoological problem: with the underlying tensions about the danger that there might be in a chicken's crossing the road, and even, as Thomas Nagel might wonder,[15] what it is like to be a chicken crossing a road, what the chicken thinks of the road, why the chicken might want to cross the road, what goes on inside the mind of a chicken. But, then, the riddle's answer is a cold dousing refutation of the anthrozoological teaser. To get to the other side: duh. Why does anyone cross the road? To get to the other side.

So a chicken is just like anyone else (in the same way that Coolidge suggested a dog is just like anyone else). The riddle suggests that a road to an animal is like a road to a person – which, of course, is not the case. Ask any deer, or armadillo, or possum, or whatever species proliferates in your local brand of roadkill. Yes, people get killed on roads too, but that is an accepted risk that we understand when we use roads. We benefit from the roads as well as, occasionally, suffering from them. And we might have houses on one side of the road and stores on the other side so, again, we benefit by crossing the road. But animals encounter only the risk and none of the benefits. If a chicken is actually on the road, she is on a large truck on its way to the abattoir, and in a metal container with airholes that emits feathers and smells and always reminds me of the trains on the way to the concentration camps. My point is

simply that a road to a chicken is a very different thing from a road to a person. The riddle that draws its humor from the repudiation of this premise is just another example of the weird, blinkered, self-obsessed, anthropocentric perspective that Americans have on animals.

There are a hundred variations on this riddle, as Americans have asked this same question over and over through the years. Here are a few that you can find by Googling "Why did the chicken cross the road?" suggesting how famous figures from history might have answered the riddle:

Joseph Conrad: Mistah Chicken, he dead.
Salvador Dali: The fish.
Bob Dylan: How many roads must one chicken cross?
Walt Whitman: To cluck the song of itself.
Mark Twain: The news of its crossing has been greatly exaggerated.

Gary Larson's *The Far Side* presents a cartoon version that embodies an existential challenge to the not-very-funny-the-longer-you-think-about-it riddle. A chicken stares cross a two-lane desert highway at a large road sign that reads: "THE OTHER SIDE," and beneath, "Why do you need a reason?" (79) The chicken in this cartoon, we should note, is not crossing the road. Maybe she is about to, or maybe she is stuck in an existential stupor brought on by Larson's deconstruction of the hackneyed joke. Larson inspires my own contribution to this trope, my posthumanist rejection of the fantasy of human omniscience with regard to animals.

Why did the chicken cross the road? I don't know.

Notes

Introduction: Framed Animals

1. The phrase comes from William Cowper's 1782 poem "The Solitude of Alexander Selkirk," which opens in a paean to anthropocentric hubris:

 > I am monarch of all I survey,
 > My right there is none to dispute,
 > From the center all round to the sea
 > I am lord of the fowl and the brute.

2. p. 180. Moore published two versions of this poem; I use the shorter version here.

2 Famous Animals

1. My formulation, not Lomborg's, lifted from W.H. Auden's 1938 poem "Musée de Beaux Arts."
2. p. 89.
3. This is an old joke, probably dating back to the turn of the twentieth century.
4. Quoted in Jason Hribal. *Fear of the Animal Planet: The Hidden History of Animal Resistance*. Petrolia, CA: CounterPunch, 2010.
5. *Rin Tin Tin: The Life and the Legend*. New York: Simon and Schuster, 2011.
6. http://www.fsinet.or.jp/~sokaisha/rabbit/rabbit.htm Accessed 8 August 2011.
7. pp. 239–40.
8. http://www.infinitecat.com/ Accessed 8 August 2011.
9. Animal Planet's homepage is http://animal.discovery.com/ Accessed 8 August 2011.
10. http://www.militaryphotos.net/forums/archive/index.php/t-64501.html Accessed 8 August 2011.
11. http://www.click2houston.com/news/5288960/detail.html Accessed 8 August 2011.
12. http://www.msnbc.msn.com/id/10280606/ns/health-pet_health/t/stowa-way-cat-flies-business-class-back-home/#.Tj6xM2ahBl0 Accessed 8 August 2011.
13. W. Broad. "It's Sensitive. Really. The Storied Narwhal Begins to Yield the Secrets of Its Tusk." *New York Times*, 13 December 2005, D1, D4.
14. *The Others: How Animals Made Us Human*. Washington, DC: Island Press, 1996.
15. p. 237.

16. p. 240.
17. p. 139.
18. Hribal, pp. 29–30.
19. "Chris Rock: Never Scared." HBO, April 2004.

3 Photographic Animals

1. In Brookman et al., p. 281.
2. pp. 21, 26.
3. pp. 30–31.
4. Brookman et al., pp. 80–81.
5. Brookman, p. 84.
6. Ralph Waldo Emerson. "The Young American," 1844, published in *Nature: Addresses and Lectures* (1849).
7. Brookman, pp. 83–84.
8. p. 73.
9. Quoted in Brookman, p. 89.
10. p. 22. Holmes quoted from "The Stereoscope and the Stereograph." *Atlantic Monthly*, June 1859.
11. p. 13.
12. E-text http://www.marxists.org/reference/subject/philosophy/works/ge/benjamin.htm Accessed 8 August 2011. Section X.

4 Film Animals

1. http://www.americanhumane.org/protecting-animals/programs/no-animals-were-harmed/ Accessed 8 August 2011.
2. http://www.americanhumane.org/about-us/who-we-are/faqs/no-animals-were-harmed.html Accessed August 8 2011.
3. http://www.americanhumane.org/faqs.html Accessed 8 August 2011.
4. http://www.americanhumane.org/faqs.html Accessed 8 August 2011.
5. http://www.imdb.com/title/tt0136536/ Accessed 8 August 2011.
6. Biles, pp. 116–17.
7. p. 11.
8. p. 17.
9. Mulvey (quoting Budd Boetticher), p. 11.
10. pp. 42–3.
11. p. 3.
12. Cynthia Chris. *Watching Wildlife*. Minneapolis: University of Minnesota Press, 2006, xi.
13. p. xii.
14. p. 3.
15. Mitman, p. xiv.
16. p. 4.
17. Mitman, pp. 135–6.
18. Mitman, p. 132.
19. p. 181.

20. http://old.boxwish.com/profiles/blogs/avatar-wins-peta-award-for-promoting-natureAccessed 8 August 2011.
21. http://www.americanhumane.org/animals/animal-welfare-news/think-no-animals-were-harmed-in-the-making-of-avatar-you-re-right-think-no-animals-were-used-in-the-making-of-avatar-you-re-wrong.html Accessed 8 August 2011.
22. Posted by Sebastian Verdikt, 22 January 2010. http://blog.peta.org/archives/2010/01/james_cameron_avatar.php Accessed 8 August 2011.
23. Stephanie Ernst. "Domination and Rape in *Avatar*: This Is 'Respect' for Animals?" On "Animal Rights and AntiOppression" Website, http://challengeoppression.com/2010/02/16/domination-and-rape-in-avatar-this-is-respect-for-animals/ Accessed 8 August 2011.
24. http://challengeoppression.com/2010/02/16/domination-and-rape-in-avatar-this-is-respect-for-animals/ Accessed 8 August 2011.
25. p. 28.
26. Richard Conniff. "The Consolation of Animals." http://happydays.blogs.nytimes.com/2009/05/27/the-consolation-of-animals/ Accessed 5 October 2009.
27. p. 187.
28. p. 165.
29. Baker, inside cover.
30. p. 9.
31. p. 17.
32. http://zoomorph.org/ Accessed 22 November 2011.
33. http://www.psychologytoday.com/blog/animal-emotions/201111/animals-in-art-nonhumans-benefit-responsible-representation Accessed 22 November 2011.
34. http://bluray.highdefdigest.com/4128/beemovie_combo.html Accessed 8 August 2011.

5 Pornographic Animals

1. http://alldogs.xtremebeast.com/bodil/bio.html Accessed 8 August 2011.
2. http://www.imdb.com/title/tt1009432/ Accessed 8 August 2011.
3. http://www.rnw.nl/english/article/netherlands-bans-sex-animals Accessed 8 August 2011.
4. p. 35.
5. http://www.associatedcontent.com/article/193552/panda_porn_fails_to_heighten_captive.html Accessed 8 August 2011.
6. Albee's subtitle for the play is "(Notes toward a definition of tragedy)," and the Greek etymology of the word "tragedy" is "goat song": *tragoidia* is a compound of *tragos*, "goat," and *aeidein*, "to sing." The origin of the coinage is obscure. Some hypothesize that a play with an undesirable resolution could be figuratively considered a "goat song"; some believe that tragic actors dressed in goatskins to represent satyr, goat-like woodland deities; some suggest that a goat might have been awarded as a prize for the best

performance, and some believe that a goat sacrifice might have been part
of the performance.

7. Gold, p. 32.
8. Langton, p. 10.
9. pp. 15–22.
10. p. 16.
11. p. 17.
12. p. 16.
13. p. 104.
14. p. viii.
15. p. 350.
16. pp. 222–23.
17. pp. 224–28, 240.
18. Sigel, p. 23.

6 Zoo Animals

1. p. 13.
2. pp. 75–76.
3. http://news.discovery.com/animals/polar-bear-knut-drowning-110401.
html Accessed 8 August 2011.
4. http://www.eol.org/ Accessed 8 August 2011.
5. p. 185.
6. *Platypus*, pp. 15–19.
7. *Platypus*, p. xii.

7 Weird Animals (or, Why Did the Chicken Cross the Road?)

1. http://www.ekac.org/gfpbunny.html#gfpbunnyanchor Accessed 8 August
2011.
2. http://www.care2.com/c2c/groups/disc.html?gpp=1387&pst=42800
Accessed 8 August 2011.
3. On this topic see Steve Baker's essay, "'You Kill Things to Look at Them':
Animal Death in Contemporary Art" in *Killing Animals*. The Animal Studies
Group: University of Illinois Press, 2006, pp. 69–98.
4. See, for example, "Did Animals Sense Tsunami Was Coming?" in *National
Geographic News*, 4 January 2005. http://news.nationalgeographic.com/
news/2005/01/0104_050104_tsunami_animals.html Accessed 8 August
2011.
5. "Asia's Deadly Waves: Gauging Disaster; How Scientists and Victims Watched
Helplessly." *New York Times*, 31 September 2004, 1.
6. See Linda Spalding, *A Dark Place in the Jungle: Following Leakey's Last Angel
into Borneo*. Emeryville, CA: Seal Press, 2003, p. 124, in which she describes
how Chantek, an orangutan, learned to buy ice cream at the Yerkes National
Primate Research Center in Atlanta.

7. In this vein, see *parallax* 12:1 (2006), a special issue entitled "Animal Beings," in which editor Tom Tyler asks: "What kind of animal ... is this human being? In what kinds of animal being does the human animal engage? What is it to be, rather than to represent, an animal?" The issue pointedly "addresses the question of human beings as animal beings" (1).
8. www.rivingtonarms.com/exhibitions/2005/perishables.php Accessed 8 August 2011. A follow-up installation in 2007, called "Maria," featured photographs of Afro-Brazilian women dressed in clothes sewn out of cow placentas.
9. p. 40.
10. The full title is "Dovima with the Elephants – Evening Dress by Dior, Cirque d'Hiver, Paris," and it appears in Avedon's *Woman in the Mirror*. New York: Harry N. Abrams, 2005. A good online image is at http://img131.image-shack.us/img131/176/hiverparis19557kr.jpg Accessed 8 August 2011.
11. "Trunk Show." *W* 34:1 (January 2005), pp. 76–101.
12. pp. 47–50.
13. http://www.lasvegassun.com/news/2004/aug/31/vegasbeat—timothy-mcdarrah-with-pride-siegfried/ Accessed 8 August 2011.
14. http://www.earthtalk.org/magazine-archive/buying-nemo Accessed 15 February 2012.
15. Nagel's famous philosophical essay "What is it Like to Be a Bat?" *Philosophical Review*, 83:4 (October 1974), 435–50 attempts, somewhat unsuccessfully, to broach the topic of animal consciousness.

Bibliography

Abadzis, Nick. *Laika*. New York: First Second, 2007.

Adams, Carol. *The Sexual Politics of Meat: A Feminist-Vegetarian Critical Theory*. New York: Continuum, 1990.

Baker, Steve. *The Postmodern Animal*. London: Reaktion, 2000.

Bakke, Monica. "The Predicament of Zoopleasures" in *Animal Encounters*. Eds, Tom Tyler and Manuela Rossini. Leiden: Brill, 2009, 221–42.

Barbieri, Annalisa. "Exploring Photography: Personal Tours." Victoria & Albert Museum Web site. http://www.vam.ac.uk/vastatic/microsites/photography/guide.php?guideid=gu017 Accessed 8 August 2011.

Barnes, Julian. *A History of the World in Ten 1/2 Chapters*. New York: Vintage, 1990.

Bekoff, Marc. "Animals in Art: Nonhumans Benefit from Responsible Representation." *Psychology Today* blog, 21 November 2011. http://www.psychologytoday.com/blog/animal-emotions/201111/animals-in-art-nonhumans-benefit-responsible-representation Accessed 22 November 2011.

Benjamin, Walter. "The Work of Art in the Age of Mechanical Reproduction." Section X. E-text http://www.marxists.org/reference/subject/philosophy/works/ge/benjamin.htm Accessed 8 August 2011.

Berger, John. "Why Look at Animals?" in *About Looking*. New York, Pantheon, 1980.

Biles, Jeremy. "I, Insect, or Bataille and the Crush Freaks." *Janus Head*, 7:1, (Summer 2004) 115–31.

Bousé, Derek. *Wildlife Films*. Philadelphia: University of Pennsylvania Press, 2000.

Brookman, Philip, Marta Braun, Corey Keller, Rebecca Solnit, and Andy Grundberg. *Helios: Eadweard Muybridge in a Time of Change*. London: Steidl, 2010.

Butler, Judith. *Frames of War: When is Life Grievable?* London: Verso, 2009.

Chris, Cynthia. *Watching Wildlife*. Minneapolis: University of Minnesota Press, 2006.

Commoner, Barry. *The Closing Circle: Nature, Man, and Technology*. New York: Random House, 1971.

Conniff, Richard. "The Consolation of Animals." http://happydays.blogs.nytimes.com/2009/05/27/the-consolation-of-animals/ Accessed 8 August 2011.

Deleuze, Gilles, and Félix Guattari. *A Thousand Plateaus*. Trans., Brian Massumi. Minneapolis: University of Minnesota Press, 1987.

Freud, Sigmund. *Civilization and its Discontents*. Trans., James Strachey. New York: Norton, 1969.

Fudge, Erica. *Animal*. London: Reaktion, 2002.

Gold, Tanya. "A Goat's Eyes are so Beautiful." *New Statesman*, 17 May 2004, 32.

Hearne, Vicki. *Adam's Task: Calling Animals by Name*. New York: Knopf, 1982.

Hochman, Jhan. *Green Cultural Studies: Nature in Film, Novel, and Theory.* Moscow, ID.: University of Idaho Press, 1998.

Horyn, Cathy. "The Outfit's Great, but Do I Look Fat?" *New York Times,* 7 December 2004, B10.

Hribal, Jason. *Fear of the Animal Planet: The Hidden History of Animal Resistance.* Petrolia, CA: CounterPunch, 2010.

Ingram, David. *Green Screen: Environmentalism and Hollywood Cinema.* Exeter: University of Exeter Press, 2004.

Jaschinski, Britta. *Wild Things.* New York: PowerHouse, 2003.

—— *Zoo.* London: Phaidon, 1996.

Kammeyer, Kenneth. *A Hypersexual Society: Sexual Discourse, Erotica, and Pornography in America Today.* New York: Palgrave Macmillan, 2008.

Kipnis, Laura. *Bound and Gagged: Pornography and the Politics of Fantasy in America.* New York: Grove Press, 1996.

Langton, Rae. *Sexual Solipsism: Philosophical Essays on Pornography and Objectification.* Oxford: Oxford University Press, 2009.

Larson, Gary. *The Far Side Gallery 4.* Kansas City: Andrews McMeel, 1993.

Lévi-Strauss, Claude. *Totemism.* Trans., Rodney Needham. Boston: Beacon, 1963.

Lippard, Lucy R. *Partial Recall.* New York: New Press, 1992

Lippit, Akira Mizuta. *Electric Animal: Toward a Rhetoric of Wildlife.* Minneapolis: University of Minnesota Press, 2000.

Lomborg, Bjorn. *The Skeptical Environmentalist: Measuring the Real State of the World.* Cambridge: Cambridge University Press, 2001.

MacIntyre, Alasdair. *Three Rival Versions of Moral Enquiry: Encyclopaedia, Genealogy, and Tradition.* University of Notre Dame Press, 1990.

Miletski, Hani. *Understanding Bestiality and Zoophilia.* Self-published, 2002.

Mitman, Gregg. *Reel Nature: America's Romance with Wildlife on Film.* Cambridge, MA: Harvard University Press, 1999.

Moore, Marianne. *The Complete Poems of Marianne Moore.* New York: Penguin, 1967.

Mullan, Bob, and Garry Marvin. *Zoo Culture.* London: Weidenfeld & Nicolson, 1987.

Mulvey, Laura. "Visual Pleasure and Narrative Cinema." *Screen,* 16:3 (Autumn 1975) 6–18.

Nagel, Thomas. "What is it Like to Be a Bat?" *Philosophical Review,* 83:4 (October 1974), 435–50.

Orlean, Susan. *Rin Tin Tin: The Life and the Legend.* New York: Simon and Schuster, 2011.

Palmer, Chris. *Shooting in the Wild: An Insider's Account of Making Movies in the Animal Kingdom.* San Francisco: Sierra Club, 2010.

Pick, Anat. *Creaturely Poetics: Animality and Vulnerability in Literature and Film.* New York: Columbia University Press, 2011.

Ritvo, Harriet. *The Animal Estate: The English and Other Creatures in the Victorian Age.* Cambridge, MA: Harvard University Press, 1987.

——. *The Platypus and the Mermaid and Other Fictions of the Classifying Imagination.* Cambridge, MA: Harvard University Press, 1997.

Said, Edward. *Culture and Imperialism.* New York: Vintage, 1994.

Shepard, Paul. *The Others: How Animals Made Us Human.* Washington, DC: Island Press, 1996.

Sigel, Lisa. *International Exposure: Perspectives on Modern European Pornography, 1800–2000*. New Brunswick, NJ: Rutgers University Press, 2005.

Singer, Peter. *Animal Liberation*. New York: Random House, 1975.

Solnit, Rebecca. *River of Shadows: Eadweard Muybridge and the Technological Wild West*. New York: Viking, 2003.

Sowa, Michael. *Sowa's Ark*. San Francisco: Chronicle, 1996.

Tuan, Yi-Fu. *Dominance and Affection: The Making of Pets*. New Haven: Yale University Press, 1984.

Wilson, Edward O. *The Diversity of Life*. Cambridge, MA: Harvard University Press, 1992.

Index

Note: Page numbers in bold indicate illustrations.